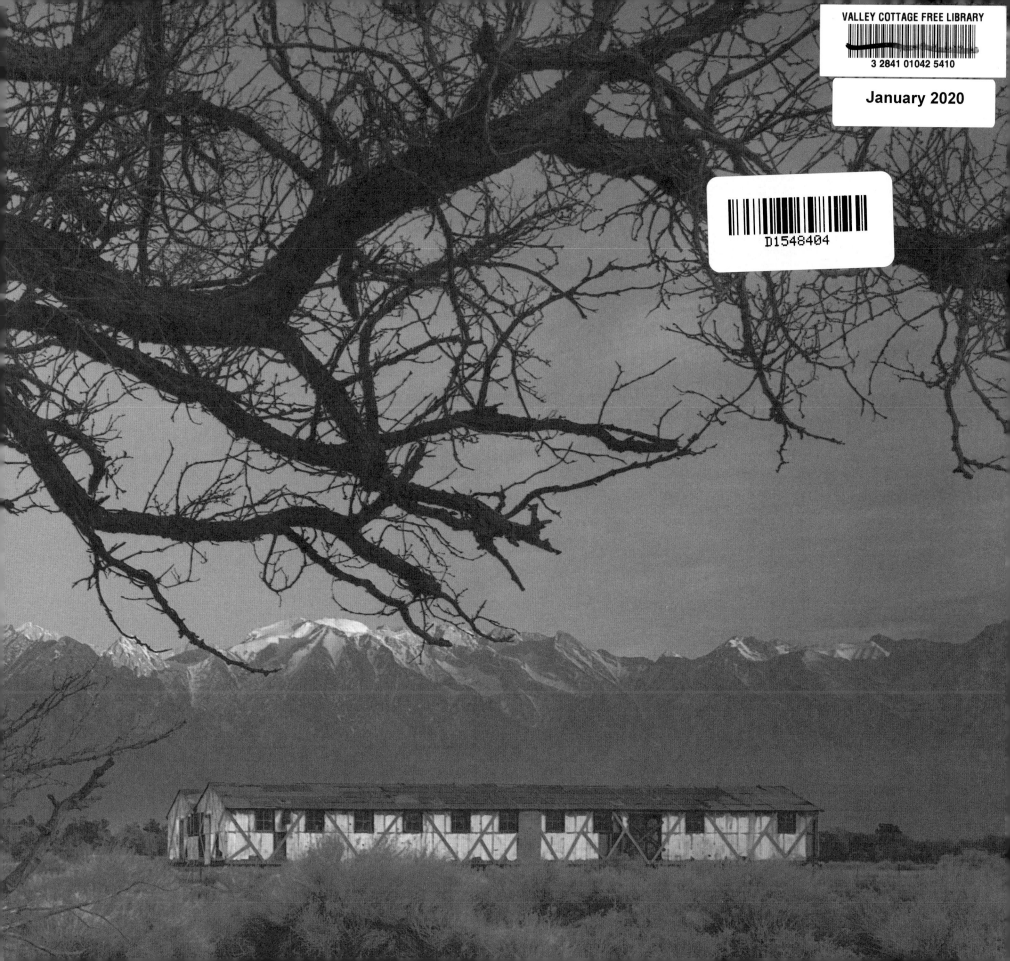

'The forcible relocation of U.S. citizens to concentration camps, solely and explicitly on the basis of race, is objectively unlawful and outside the scope of presidential authority.'

Supreme Court Chief Justice
John G. Roberts Jr., 2018

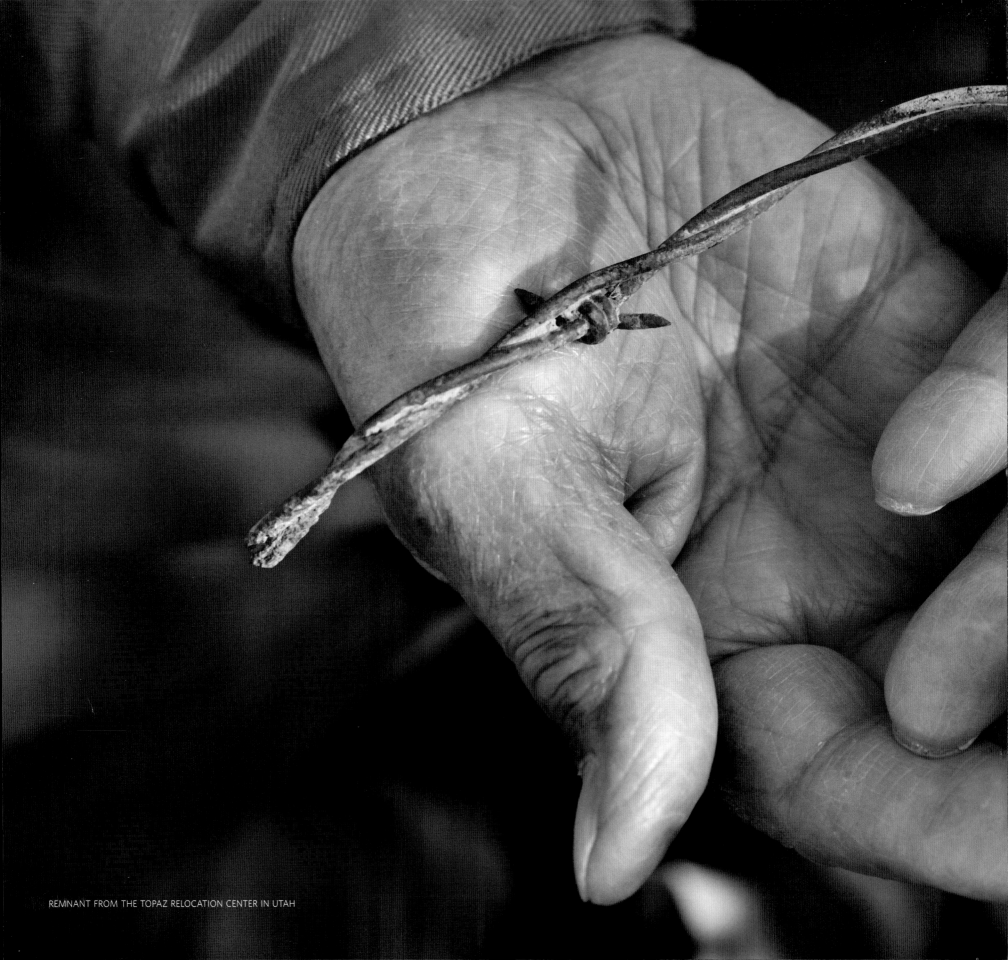

REMNANT FROM THE TOPAZ RELOCATION CENTER IN UTAH

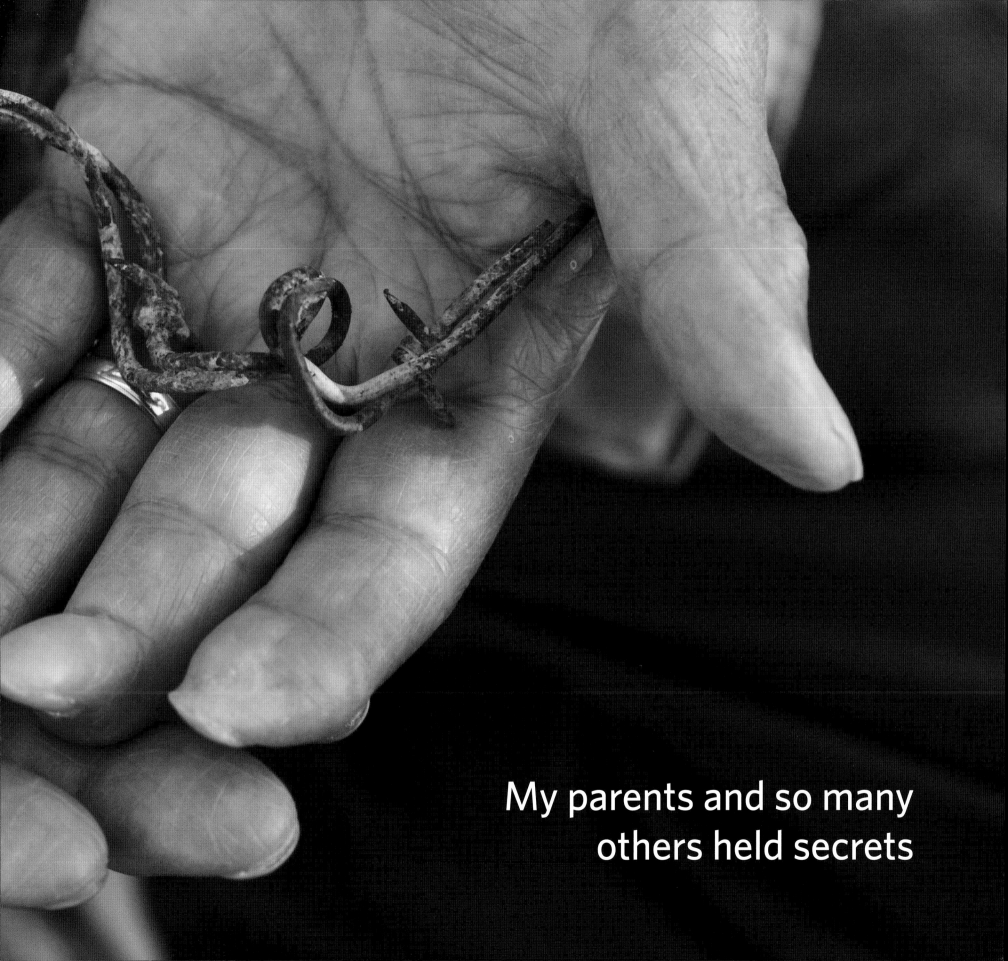

My parents and so many
others held secrets

about what happened
during World War II.

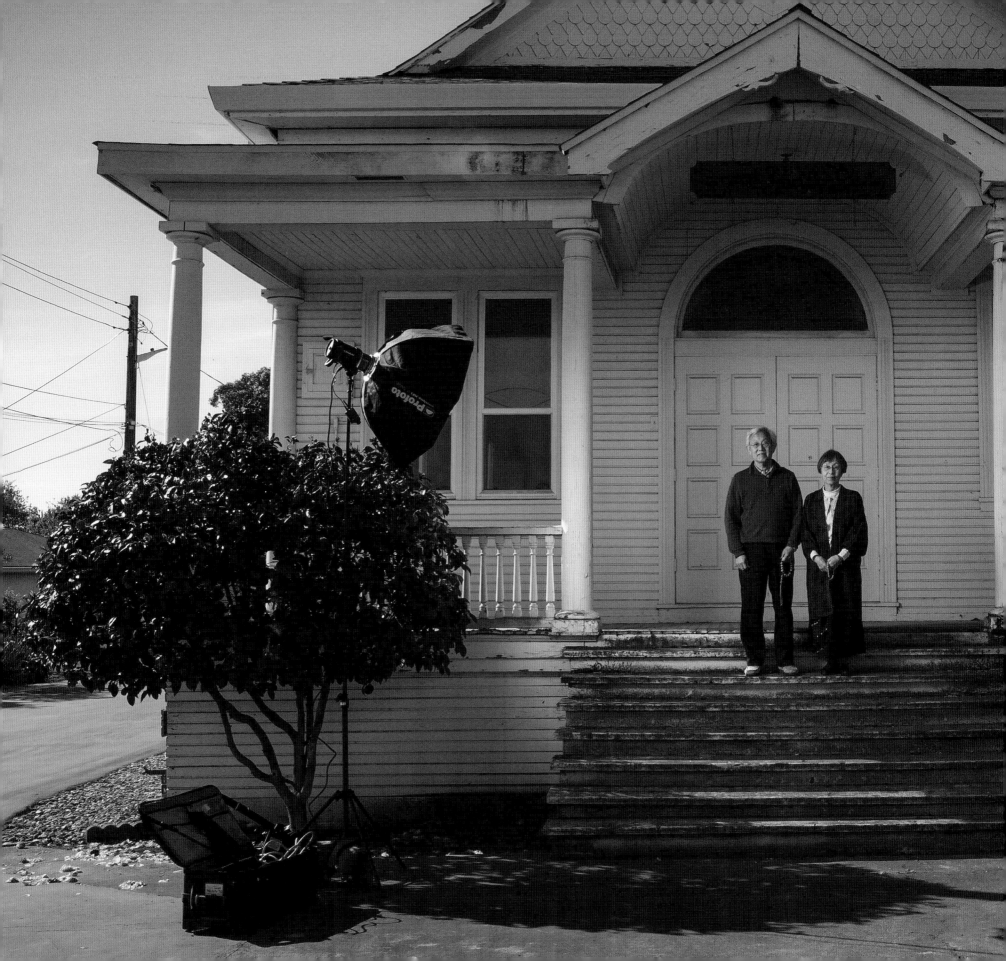

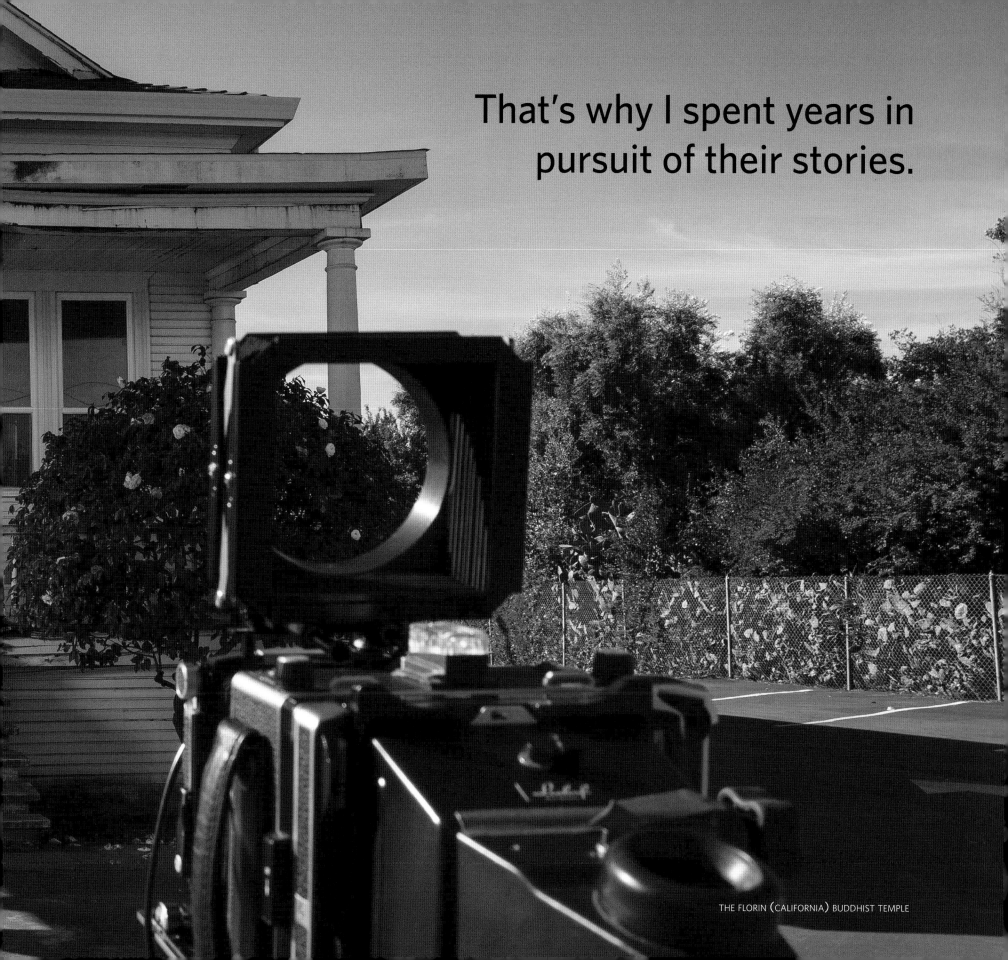

That's why I spent years in pursuit of their stories.

THE FLORIN (CALIFORNIA) BUDDHIST TEMPLE

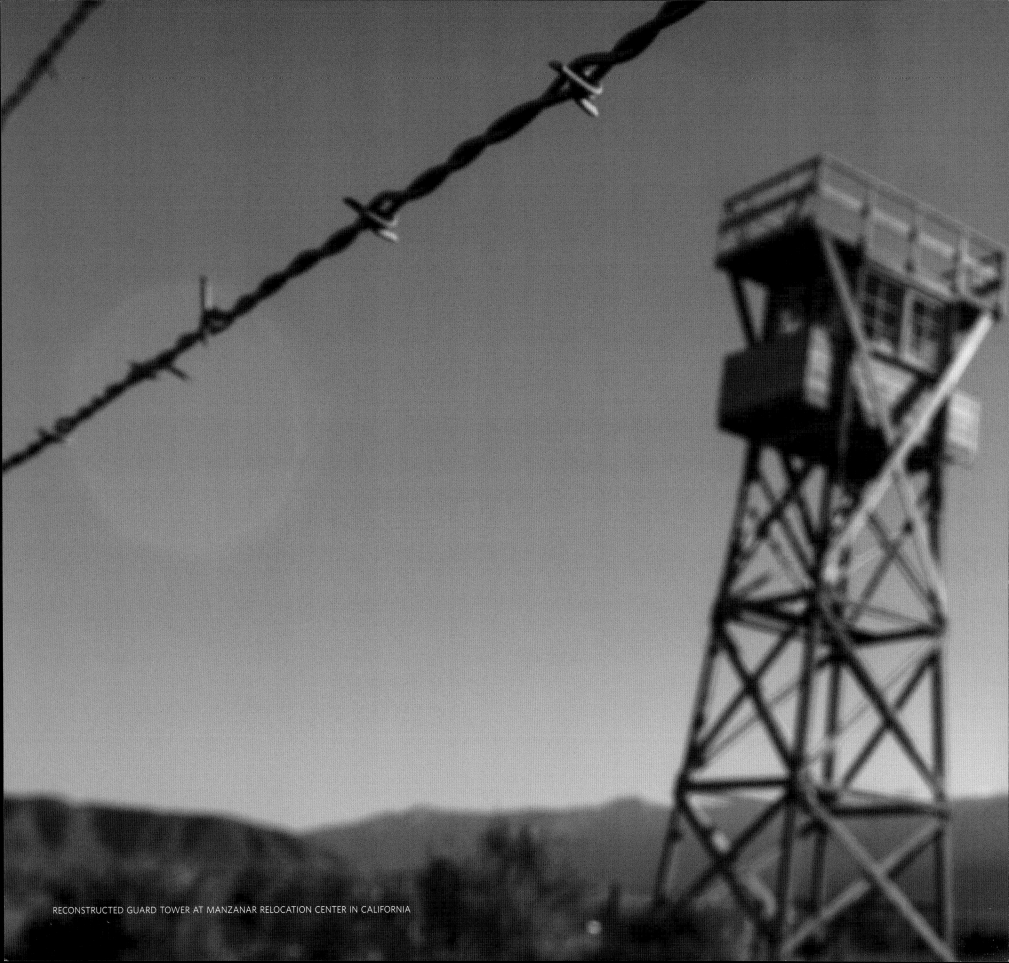
RECONSTRUCTED GUARD TOWER AT MANZANAR RELOCATION CENTER IN CALIFORNIA

BEHIND BARBED WIRE

Searching for Japanese Americans
Incarcerated During World War II

Words and Photographs by Paul Kitagaki Jr.

Photographs by Paul Kitagaki Jr. © 2019 Paul Kitagaki Jr.

Published by CityFiles Press, Chicago, Illinois

Produced and designed by Michael Williams
and Richard Cahan

Copy edited by Mark Jacob and Caleb Burroughs

ISBN: 978-0-9915418-1-2

First Edition

Printed in China

To my parents Paul Kiyoshi Kitagaki and
Agnes Eiko Kitagaki; daughters Jessica,
Naomi and Monica, and grandchildren
Riley, Brayden, Aden and Quinn. Also to
Uncle Nobuo Kitagaki, my Kitagaki and
Takahashi grandparents and extended
family. And to my wife Renée C. Byer, so
we'll never forget.

JONATHAN LOGAN
FAMILY FOUNDATION

Contents

Preface: *Gambatte!* 12

1 In the name of security 20 **2** Toward armed soldiers 44 **3** Japanese Americans banished 82

Names and numbers 148

Acknowledgments and reading list 150

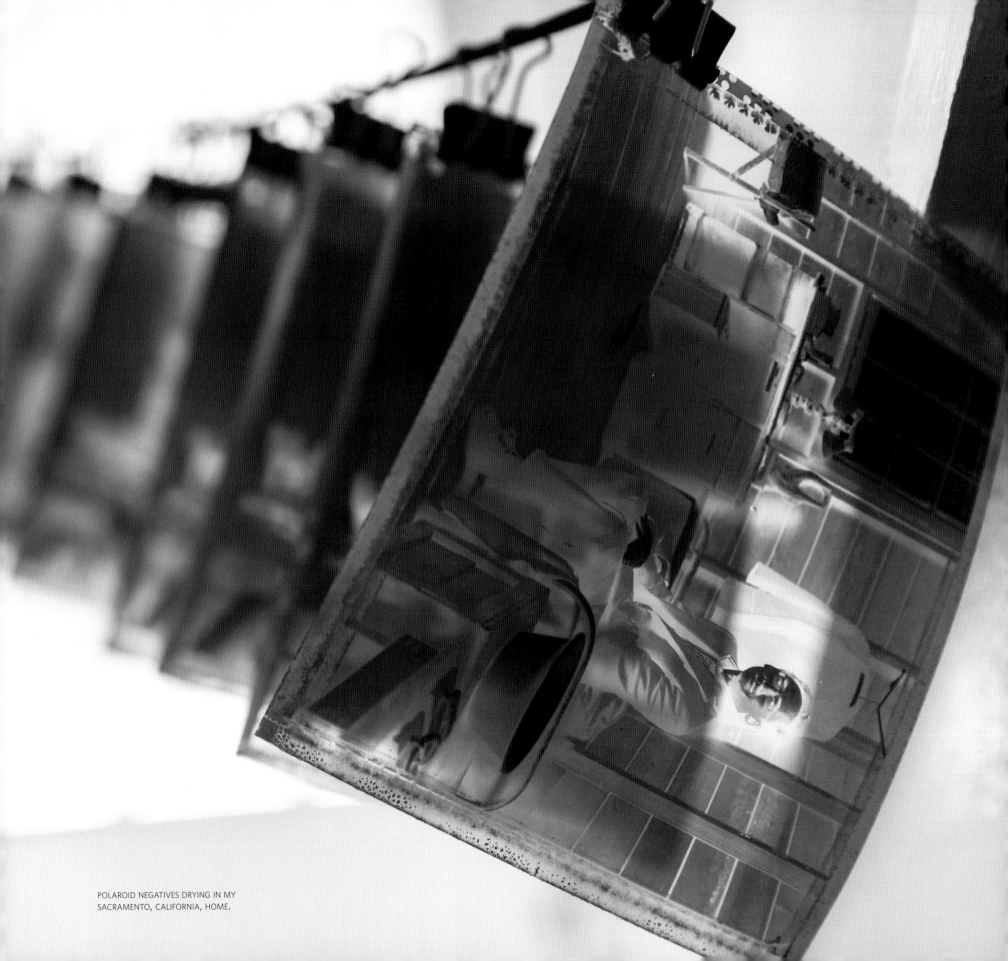

POLAROID NEGATIVES DRYING IN MY
SACRAMENTO, CALIFORNIA, HOME.

Gambatte!

Like many Sansei, or third-generation Japanese Americans, I learned in my American history class that my parents and grandparents were forcibly removed from their homes and taken to incarceration camps during World War II. Until then, not a word of what happened was ever passed down in family stories.

About 70,000 of the more than 110,000 ethnic Japanese Americans taken away were native-born Americans. They were given but a few days to settle their financial affairs and report for transport to desolate detention centers away from the West Coast after President Franklin D. Roosevelt signed Executive Order 9066.

I was a sixteen-year-old in that tenth-grade class in San Mateo, California, in 1970, and was shocked and angry at how my parents and grandparents were treated. They were Americans. How could they be locked up behind barbed wire many miles from their homes? And how could they have let me grow up in our racially mixed, middle-class suburban neighborhood in South San Francisco, in an area where dad and my uncle were teachers, without ever mentioning the executive order and how it had affected their lives?

The order deemed California and parts of Washington, Oregon and Arizona a military zone, and gave the government jurisdiction to move people of Japanese ancestry living in these states. (See map on page 152.)

As a boy, I watched World War II movies and TV shows like *Combat* and *Twelve O'Clock High*. I played army with the neighborhood kids and never thought much about my ethnicity. We were two Japanese Americans, a Puerto Rican, an African American and a few white kids who fought the Germans and Japanese.

There may have been snatches of conversation—"What camp were you in?"—overheard when my parents would meet another Japanese-American family. But I was an Eagle Scout, so the word "camp" had a different connotation, and its military meaning didn't register.

I spent most of my childhood living less than five miles from the Tanforan Race Track. We drove past it visiting relatives in San Mateo. But not a word was spoken about the four-and-a-half months my dad and his family spent imprisoned there, despite the fact that dad's older brother Mario was serving in the U.S. Army before the attack on Pearl Harbor. No one talked, either, about my grandfather, who was forced to sell his business, Arthur's Dye and Cleaning on Piedmont Avenue in Oakland, at a loss, giving up the home in back where his family lived.

The Kitagakis left what was called the Tanforan Assembly Center in September 1942 by train to their new prison: a place called the Topaz Relocation Center, which housed more than 8,000 people in the desert near Delta in central Utah. They would spend the duration of the war there before finally returning home to Oakland.

The Takahashis, my mom's family, were poor truck farmers in the San Jose area. In the 1930s, my grandfather suffered a paralyzing stroke and was bedridden. When orders came to move Japanese Americans away from the coast, the family hauled him to the incarceration camps—first to the Santa Anita Assembly Center north of Los Angeles, then to the Poston Relocation Center in the Arizona desert and their final desert stop in Utah at the Topaz Relocation Center—because they feared for his safety if he remained in San Jose. They left their meager possessions and their dog with neighbors. When they returned home in 1945, the neighbor refused to give back their property—or the dog. My mother, Agnes Eiko Takahashi, had two older brothers who served in the all-Japanese-American 442nd Regimental Combat Team, where my uncle, Staff Sergeant Tom Haru Takahashi, would be awarded a Bronze Star for bravery in France.

The revelation of Roosevelt's order in my American history class made me hungry for more. I found the book *American Concentration Camps* by Allan R. Bosworth and *Executive Order 9066* by Maisie and Richard Conrat. The first book opened my eyes to the fact that these were actually concentration camps. The other book struck me. It was the first time I saw emotional images of the incarceration. Many were taken by Dorothea Lange, whose pictures showed the humanity and suffering of people who looked like me. Somehow, she had the ability to capture the moment when a person's life changed.

In the late 1970s, as I started on my path as a photographer, I learned from my uncle, San Francisco artist Nobuo Kitagaki, that Lange had photographed my grandparents, father and aunt in 1942 as they waited for a bus in Oakland to begin their journey into detention. Several years later, while looking through 900 of Lange's photographs at the National Archives in Washington, D.C., I found the images of my family.

In one, my grandparents, Suyematsu and Juki (page 60) were smiling and talking to a Caucasian woman, family friend Dorothy Hightower, who I later learned had stored some of their personal property during the war. Staring at the camera were my father, Kiyoshi, then 14 years old, and my aunt Kimiko, age 12. Dad looked dazed, sad and shocked, as if he was wondering what would come next.

In another, taken that same day, Aunt Kimiko stood in front of a pile of luggage. She, too, looked stunned. What was she thinking, I wondered.

As I flipped through the boxes of images and searched for other photographs, I realized that they contained many untold stories of the incarceration, stories that needed to be shared before the storytellers were gone. I wanted to find out what happened to the people in these pictures. Maybe I could find the answers that my parents never gave me.

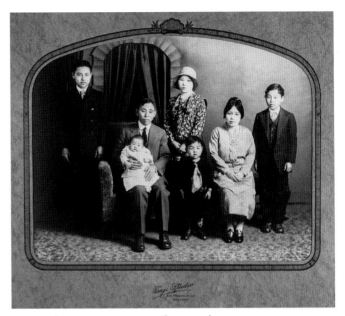

MY FATHER'S KITAGAKI FAMILY: MARIO (FROM LEFT), FATHER SUYEMATSU HOLDING KIMIKO, HISAYO, KIYOSHI (NOW CALLED PAUL), MOTHER JUKI AND NOBUO IN OAKLAND, CALIFORNIA. PHOTO BY TSUJI STUDIO.

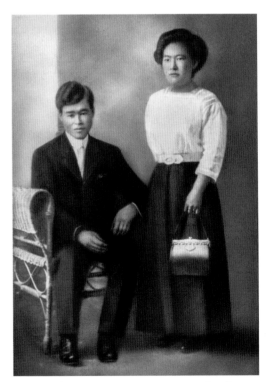

MY MOTHER'S GRANDPARENTS EIJIRO TAKAHASHI (LEFT) AND HARU TAKAHASHI IN SAN JOSE, CALIFORNIA.

The unknown faces embedded themselves in my soul, where they lay dormant, but not forgotten.

I started tracking down the subjects of these pictures in 2005. The task was daunting. My first subjects were members of my family. My mother refused to be interviewed. My father and aunt shared a few memories, but I could tell they did not want to get too personal. They mostly talked about how cold and dusty the camps were. They kept their feelings inside. They were part of the quiet generation.

Even though they had done nothing wrong, many of the Nisei or second-generation Japanese Americans didn't talk about their experiences because of the shame and pain they felt. They preferred to put the past behind them; they did not want to burden their children or others around them.

I still had high hopes when I created a huge poster with many of the government photos from the war years and took it to the Buddhist Church of Sacramento summer festival. I filled it with images taken in 1942 in Sacramento, and I hoped someone would recognize a relative or a friend. But nobody contacted me.

Unwilling to give up, I took the pictures to other churches, bazaars and senior lunches. Finally, somebody at the Sacramento Japanese United Methodist Church recognized Ted Miyata (page 41), the soldier who returned home to help his mother harvest strawberries before she was sent to a detention center. I soon connected with Ted's daughter, Donna Nakashima, who posed with her father's belongings.

Slowly, I built from there. It took me seven years to find twelve survivors, but then the process sped up. I knew that time was running out.

I found the name of Robert Takamoto (page 126), one of the boys at the barbed wire in Toyo Miyatake's famous photo, in a book. I found Robert Kaneko (page 106), dressed in a silly costume, in a newspaper article. Some people were in plain sight. Rachel Kuruma (page 33), the subject of Dorothea Lange's stunning school portrait, had worked as a dental assistant in my boyhood dental office. Arlene Damron (page 24) worked at Nichi Bei Bussan, a store I had visited many times in San Francisco and San Jose. And war hero Ben Kuroki was related to an aunt.

Some people contacted me when they saw my work published in newspapers and magazines and online, or when they saw the work displayed at events or at my exhibit: *Gambatte! Legacy of an Enduring Spirit.* A woman called to tell me that her family, the Fujiis (page 63), was sitting a few rows behind my family in Lange's photo of people being processed for shipment to detention centers. The children of Shinto priests (page 37) contacted me with their story. (I had been looking for them a long time.)

I spoke with anybody who would look at the historical photos to find more leads. Park

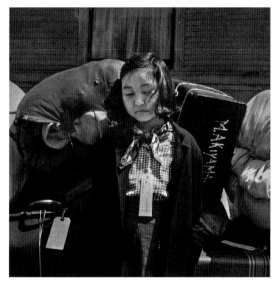

MY AUNT KIMIKO KITAGAKI WAITS TO BE PICKED UP IN OAKLAND, CALIFORNIA, MAY 6, 1942, ON WHAT WAS KNOWN AS "EVACUATION DAY." PHOTO BY DOROTHEA LANGE.

Service rangers at the Manzanar National Historic Site identified Walter Sakawye (page 102) as the baby with his grandfather in one of Lange's most famous photographs.

But the process was often quite difficult. Once I identified the people in the photographs, I had to find them and convince them to be photographed and interviewed about the experience. Sometimes it took months.

I had to photograph Mason Tachibana (page 120) three times. The first time, the emulsion from the Polaroid film I was using began melting in the summer heat. The second time, the out-of-date Polaroid film buckled, and caused focusing problems. In the process, we've become friends.

I traveled to Seattle to photograph Fumiko Hayashida (page 48), the subject of one of the most famous pictures taken during the war. When I made her portrait, she told me about an upcoming family reunion, so I returned to take a picture of her and the daughter she carried on the first day Japanese Americans were forced from their homes.

The same thing happened when I traveled to Portland to photograph Jerry Aso (page 67). The pictures looked good, but he told me he was going to meet with his brother, Bill Asano, at a family wedding. Since both were originally pictured in 1942 with their grandfather, I returned.

I photographed Hibi Lee (page 75) in her San Francisco apartment in front of two paintings—one by her mother and one by her father—of the incarceration. But I returned to take her to Hayward, California, to revisit the spot where she was picked up.

I had hoped to photograph George Sumida (page 113) playing the drums since that was the instrument he was playing when photographed in 1942. But he had sold the drums by the time I photographed him. Instead, I took him with his trumpet, another instrument he played in the Tule Lake detention center.

I photographed the Mochida family (page 64) at a family get-together in Vacaville, California. I expected to shoot them outside, in a setting similar to their 1942 photo, but it started raining as I was setting up, so I took them inside a garage. It was the first time the siblings had ever talked about their experiences.

It took me three years to find the names of three boy scouts saluting the flag at the Heart Mountain detention center (page 117) and locate them. I picked up Takeshi Motoyasu at his home in Sylmar, California. We drove about 35 miles to Monterey Park to get Jake Ohara. Then we drove about a mile to the home of Eddie Kato. The three, in their 80s, had not seen each other in seven decades, and I figured they would enjoy going to lunch together after the shoot so we could all talk about the camps. They demurred. They felt like they had little in common.

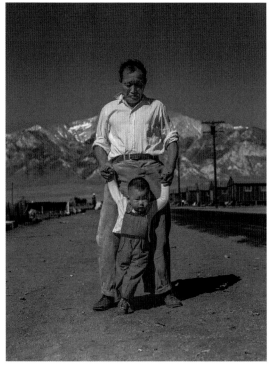

WALTER SAKAWYE LEARNS TO WALK WITH HIS GRANDFATHER AT THE MANZANAR RELOCATION CENTER ON JULY 2, 1942. PHOTO BY DOROTHEA LANGE.

I'll never forget the time I spent with Yukiko Llewellyn (page 52), the little girl photographed by Clem Albers in Los Angeles's Union Station. She was doing research at the Japanese American National Museum, and found records that indicated her father was still alive—contrary to her mother's assertion he had died during the war. I took her to Union Station, and then we drove to Manzanar, where she was able to find the exact spot where she lived. She gathered soil in a bag to save.

I photographed Jimi Yamaichi (page 145) in Tule Lake. He was one of the detention center's most sought-after docents. I waited during a pilgrimage for his tours to end, then photographed him in the jail that he helped build. He collapsed after a few shots. We helped get him to the hospital, and he recovered from a heart attack. I ended up photographing him again later that year at his home in San Jose.

On the morning that I photographed the two Pledge of Allegiance schoolgirls, Mary Ann Yahiro and Helene Mihara (page 29), who hadn't seen each other since 1942, my mom was having surgery less than a mile away. She died just a few hours later.

I learned something about the incarceration from each person I met. The secrets and pain that my parents didn't talk about. The 61 people I photographed each had a story to tell—from the first day of the pickups to the last days at Tule Lake. I photographed people who were babies, schoolchildren, parents and grandparents during the war. I shot communists and boy scouts. I met people who found true love in the camps and people who lost loved ones. I found war heroes and heroes who resisted the draft because they were denied their rights as citizens and were classified as enemy aliens.

Somehow, when their accounts are strung together and placed in the order that their original photographs were taken, the people I found tell a moving, coherent story of the incarceration. Some wanted to forget; some wanted to remember. Some lost everything; some found new direction. And all seemed determined to make sure it will never happen again.

When I found people who had been in the original images, most did not know they had been photographed or that a record of their experience existed in the National Archives and the Library of Congress. The War Relocation Authority, set up to oversee what was then called the internment or relocation of Japanese Americans, hired a small group of photographers to document what was going on. In the 1980s and early 1990s, the images had not been digitized and could only be examined in person. Moreover, the historic pictures taken by Lange and others including Clem Albers, Francis Stewart, Tom Parker, Pat Coffey, Bud Aoyama, Robert Ross, Ansel Adams, Toyo Miyatake and Carl Mydans included scant documentation beyond dates and locations. I had to identify most of the people in the photos, track them down and persuade them to talk about what happened.

Once I found a name, I had to figure out if the subject was still alive and where they

lived. Then I had to persuade the participant to talk about their experience. Many of the survivors found that difficult. I had to overcome the Japanese concepts of *enryo*—reservation, restraint, holding back—and *shikata ga nai,* which means "it can't be helped." As the men and women I met recounted their experiences, they were overcome with tears as long-suppressed memories surfaced. For many, talking with me was the first time they had ever shared their story with anyone. Several of their children asked me for transcripts of the interview so they, too, could learn long-held secrets.

Using a large-format Linhof Technika camera, similar to equipment used by photographers in the 1940s, and black-and-white film, my work is designed to mirror and complement work by my photo predecessors while revealing the strength, perseverance and legacy of the subjects. I also collected oral and personal histories of those I photographed.

Kiyoshi Katsumoto, who was 79 when I photographed him at his home, was eloquent. He recalled his family's number, 21365, and how it was etched into their belongings and labeled on their clothes and other belongings.

"We need to guard our freedoms and our constitutional rights very carefully and closely," he said. "It's still a matter of people, of their feelings, of their emotions, that are going to drive things."

Voices like Katsumoto's need to be heard. But as each year passes, we are losing the Nisei generation along with their untold stories.

This is an American story. Ethnic Japanese Americans were rounded up by Americans, forcibly confined in American prison camps guarded by armed Americans. After World War II, the incarcerated people returned to their American communities. In 1988, America formally expressed regret for the violation of their rights as American citizens.

As President Ronald Reagan signed the Civil Liberties Act of 1988 that apologized and granted reparations to the Japanese Americans who were incarcerated, he said three things led to the internment: racism and prejudice, wartime hysteria and the failure of political leaders to uphold the Constitution.

The thirteen years I've spent on this project has been a journey filled with sometimes beautiful, often painful recollections fueled by the generosity of many people who helped me identify and track down those sent to the camps and their descendants.

I've done this work so these people, their stories and this history will not be forgotten.

In looking for a Japanese word to capture the strength and spirit of those who survived that experience, I found it in *gambatte,* which means triumphing over adversity, never giving up and always trying to do one's best. It has come to define not only their spirit and this work, but also my life.

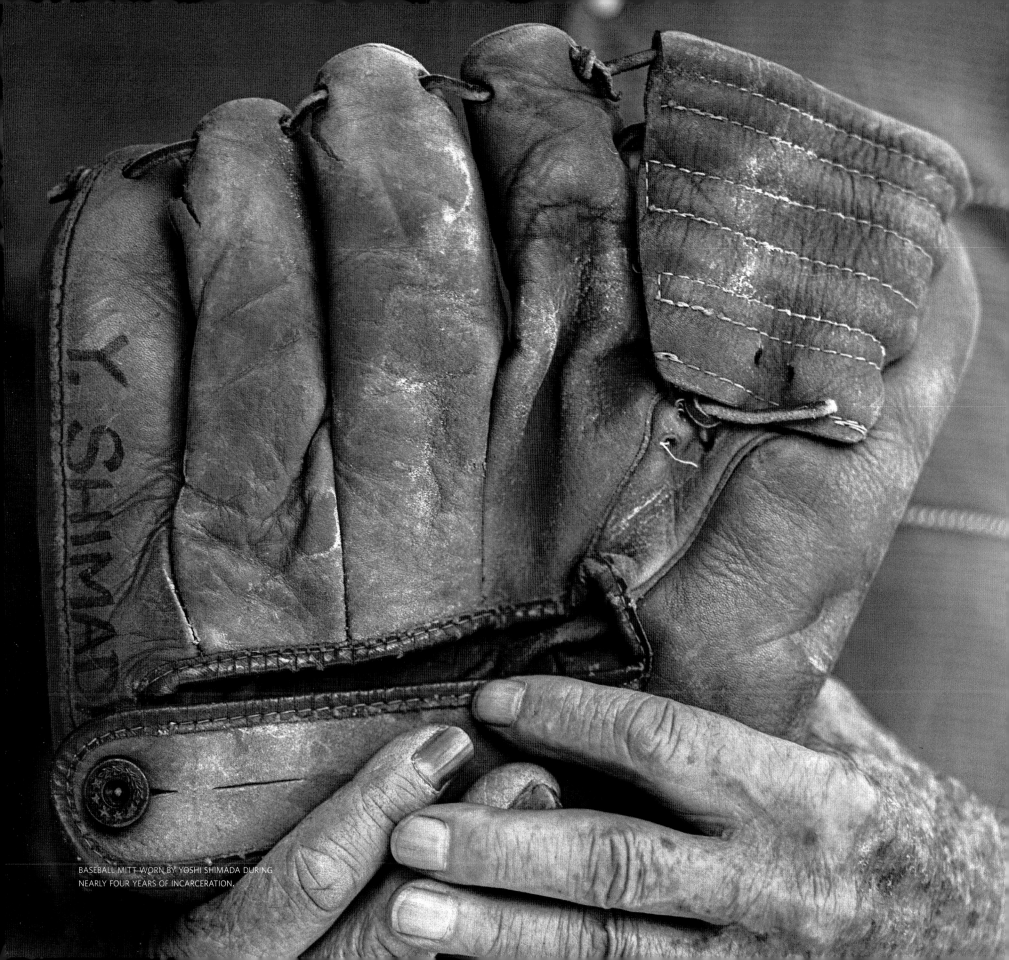

BASEBALL MITT WORN BY YOSHI SHIMADA DURING
NEARLY FOUR YEARS OF INCARCERATION.

This was once a strawberry patch farmed by a Japanese-American family. The family members, like more than 110,000 others, were told to pack their belongings, sell their possessions and abandon their homes at the start of World War II in the name of security. The field is a reminder of a way of life that ended suddenly and dramatically.

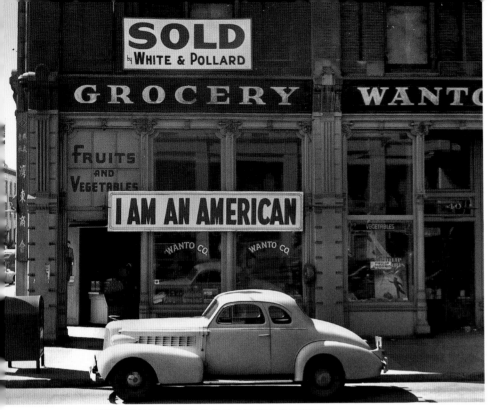

DOROTHEA LANGE, MARCH 13, 1942, OAKLAND, CALIFORNIA

The Wanto store, where Tatsuro Masuda made a courageous statement.

The family moved 150 miles east, hoping to avoid being picked up by the government.

The words—I am an American—are a declaration.

They formed a bold sign spread across the front façade of the Wanto Grocery at the southwest corner of Eighth and Franklin streets in downtown Oakland.

Tatsuro Masuda, a graduate of the University of California, Berkeley, created the sign. His father Torasaburo Masuda, first son of a samurai, opened the grocery store in 1900, and formed the Wanto Shokai market with partners in 1916. He became the sole owner in 1931, but died in 1934, when his daughters—Mineko, Yoshiko and Shimako—took over the store.

On February 19, 1942, President Franklin D. Roosevelt signed Executive Order 9066, which created a military zone along the West Coast that led to the forced removal of more than 110,000 people of Japanese ancestry from Washington, Oregon, California and parts of Arizona during World War II.

The Masuda family moved 150 miles east, hoping to avoid being picked up by the government, but they ended up sent to one of the ten detention centers, the Gila River Relocation Center in Rivers, Arizona.

Mineko's daughter, Karen Hashimoto, was born in 1942, and spent most of her first three years at Gila River. Her mother didn't talk about it.

"She only told me that to get cool I used to sit underneath a dripping faucet," Karen says. "And to this day, I cannot tolerate heat. She told me stories about my aunt walking several blocks to buy us ice cream. But by the time she came back, it was all melted. . . . And to this day, I can't stand dirt. And whenever I get in the car, I always have to have food with me, because maybe I was starved at the camp."

Silence about camp life was pervasive.

"I first started asking when it was the Korean War, because we had friends who were Korean and they weren't sent to any camp," Karen says. "So I wanted to know why we were sent to camp and they're not going anywhere."

Ted Tanisawa, born in Oakland after the war in late 1945, is the son of Yoshiko Masuda and Ben Nobuyoshi Tanisawa, who operated a flower nursery in San Lorenzo, California. The family left camp early because Ben got a defense job in Cleveland.

When Ted was growing up, the incarceration was not discussed. "The phrase was 'camp friends,'" says Ted, a retired teacher. "They would say, 'Oh, yeah, they're camp friends.' But there were never any open conversations about camp life."

Gerry Naruo, born in 1948 to another Masuda sister, Shimako, and Taka Naruo, recalls a trip he took to the closed camp at Manzanar.

"Some of the numbers are very mind-boggling," says Gerry, a retired engineer. "I read that after Gila River was populated, it was the fourth-largest city in Arizona. The scope of the size of these detention camps changed just somewhat my thinking about what it was like. I mean, there were so many people there it was like another city."

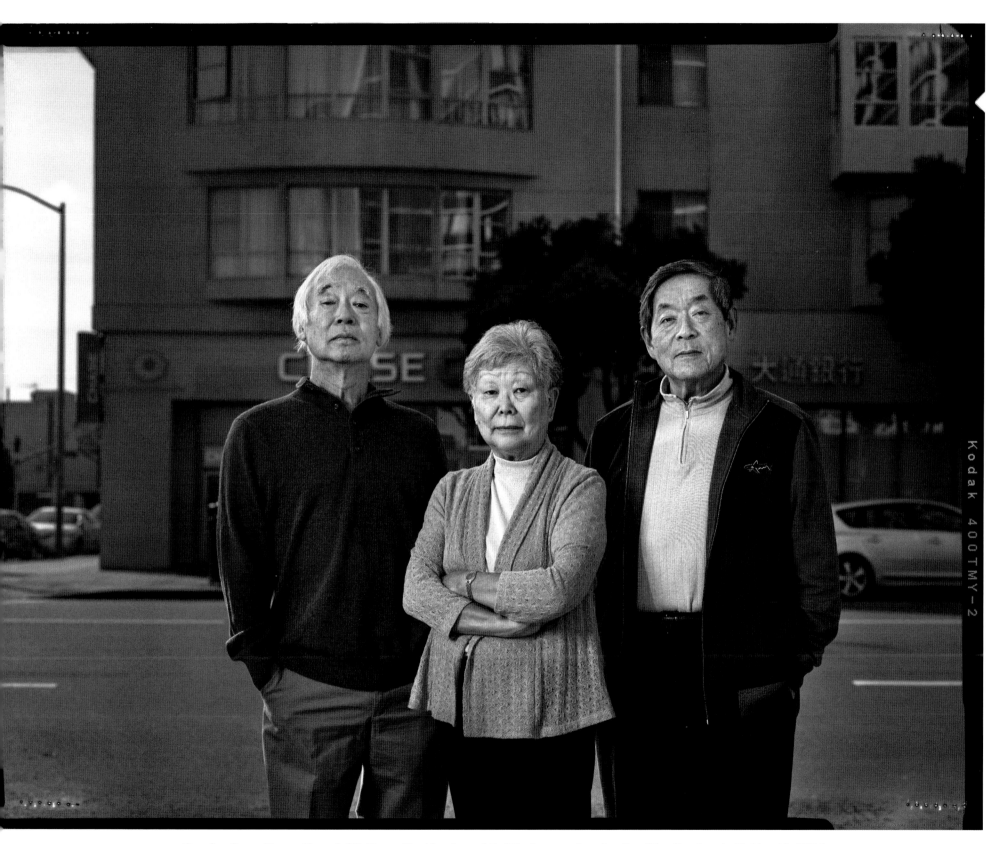

Cousins Gerry Naruo (from left), Karen Hashimoto and Ted Tanisawa return to site of family store in Oakland in 2016.

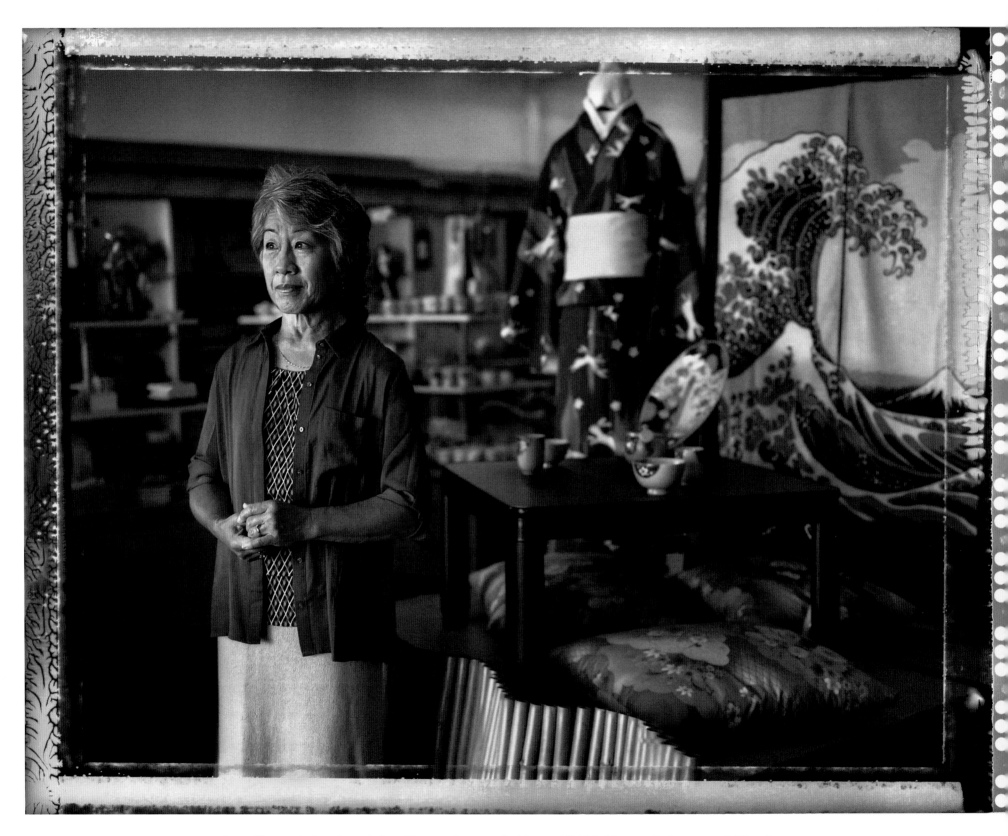

Dave Tatsuno's daughter, Arlene Tatsuno Damron, in 2014 at Nichi Bei Bussan in San Jose, California.

'Japanese would come in literally fresh off the boat wearing kimonos.'

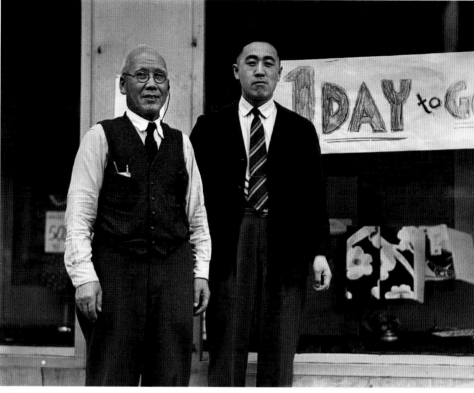

Shojiro Tatsuno (left) and Dave Tatsuno at the first Nichi Bei Bussan.

Days before they closed their business, the owners of the Nichi Bei Bussan store in San Francisco held an "Evacuation Sale" to dispose of their inventory.

They were among thousands who sold their belongings at greatly discounted prices before being forcibly removed from their homes.

Shojiro Tatsuno and son Masahara Dave Tatsuno were sent by the government to a nearby temporary detention camp known as the Tanforan Assembly Center and later to a permanent camp in Topaz, Utah.

Shojiro, a fifth-generation merchant, came to America from Nagano, Japan, and opened the store in 1902. Dave, who graduated from UC Berkeley with a business degree, helped run it.

"Japanese would come in literally fresh off the boat wearing kimonos," says Dave's daughter, Arlene Tatsuno Damron. "And when they left his store, they were wearing Western clothes."

After the clearance sale, the family had a problem: They were soon being shipped off to camp with no one to take care of their property. Then a well-dressed couple dropped by and offered to rent their house—a huge relief.

Fortunately, officials at Tanforan let Dave go back and check on the place. He found the couple using his family's belongings, which were stored in a locked room, and promptly alerted officials. The couple was evicted, replaced by Quakers who rented the house as a hostel and covered the mortgage. "That's how we had a house to come home to," Arlene says.

At the Topaz Relocation Center, her father, a home-movie buff, documented camp life on 8mm film—something prisoners were not supposed to do. But Dave got permission from a sympathetic official on the condition that he avoided shooting guard towers and barbed wire. His footage—of dust storms, icicles, lines of men and women outside the camp store, a solitary girl skating on a frozen pond—became a 48-minute film called *Topaz*, which was added to the Library of Congress' National Film Registry in 1996.

Arlene, born at Topaz, is the third-generation owner of her family's store. Dave returned to San Francisco in January 1945, and devoted himself to helping other returning Japanese Americans find housing and jobs. In 1946, he reopened the store and renamed it NB "because after the war, Nichi Bei Bussan was a little too ethnic," Arlene says.

In 1947, Arlene's 7-year-old brother, Sheldon, died during a routine tonsillectomy. Looking for a fresh start, Dave moved the family to San Jose, where he opened a second store. Arlene runs the San Jose business, which has reclaimed its original name and shifted its focus from Western merchandise to Japanese goods like apparel, gifts and housewares.

Arlene likened the effects of the war to the process of making fine samurai swords. Raw metal is forged at high heat, folded and hammered over and over. "That's the only way to create this thing of beauty and strength," she says. "Every time we have difficulties coming into our lives, we have the opportunity to turn things that are difficult into things that are much better."

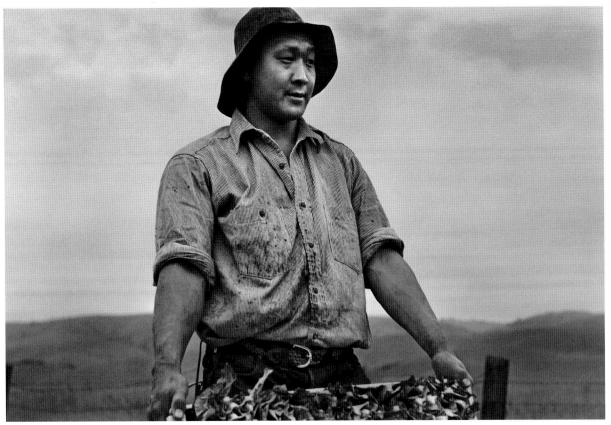

DOROTHEA LANGE, APRIL 9, 1942, CENTERVILLE, CALIFORNIA

Sam Mune carried a crate of cauliflower in Centerville, California.

He didn't want to go. America was his home and where his friends and family were.

Saburo "Sam" Mune, born in the United States, loved farming and baseball. But as war neared, his family considered returning to Japan.

He didn't want to go, says Sam's daughter, Paula Mune. America was his home and where his friends and family were. The family decided to stay.

Sam's first stop was the Tanforan Assembly Center in San Bruno, California. Then he was moved to the permanent camp in Owens Valley, California, known as the Manzanar Relocation Center. He was sent without his mother, who had tuberculosis and stayed behind with his younger sister, who had also come down with the disease. They remained in a sanatorium.

His mother died in the sanatorium. The family believes it was not death due to tuberculosis, but death due to a broken heart because of separation from her family.

After the war, Sam moved briefly to Chicago, then returned to California, married and began farming in Palo Alto. In 1959, he started Valley Produce, a grocery store in Santa Clara. Later, he and his brother grew vegetables, fruits and nuts on 100 acres in Brentwood, east of San Francisco.

He hated to talk much about the way he was treated during the war.

"They did not want us to be bitter," says Paula, a retired schoolteacher who farms and sells produce in Lakeport. "They wanted us to get on with our lives, to go to school and go to college and have a career—and not have this hanging over our heads," she says.

"I really think that's why they didn't talk about it a lot, besides it being a very Issei and Nisei Japanese thing. That generation, they hide their feelings or don't want to be too emotional. And my mother didn't want us to be bitter towards our government and feel sad or embarrassed or ashamed, so they didn't talk about it.

"But you can imagine if two or three years are taken from your life . . . you can imagine how demoralizing that would be.

"The only thing I can say is it made everybody stronger. It made everybody want to prove that they were loyal Americans. They wanted to stay in California."

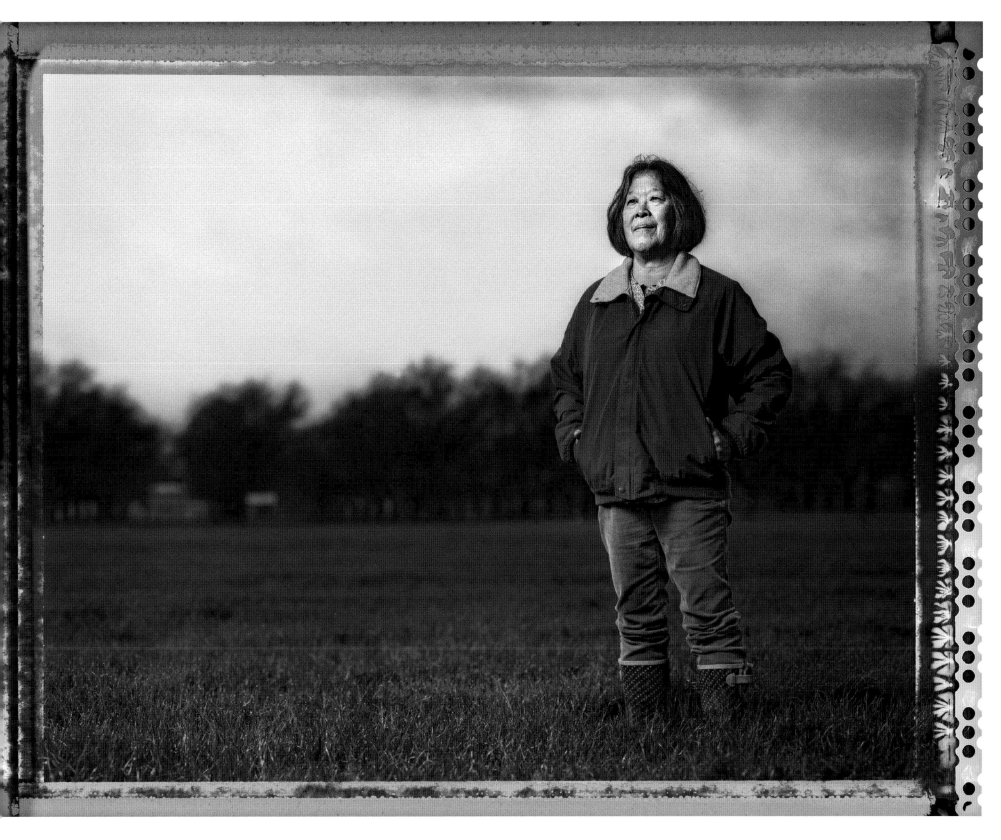

Sam Mune's daughter, Paula Mune, shows the Lakeport, California, family farm in 2014.

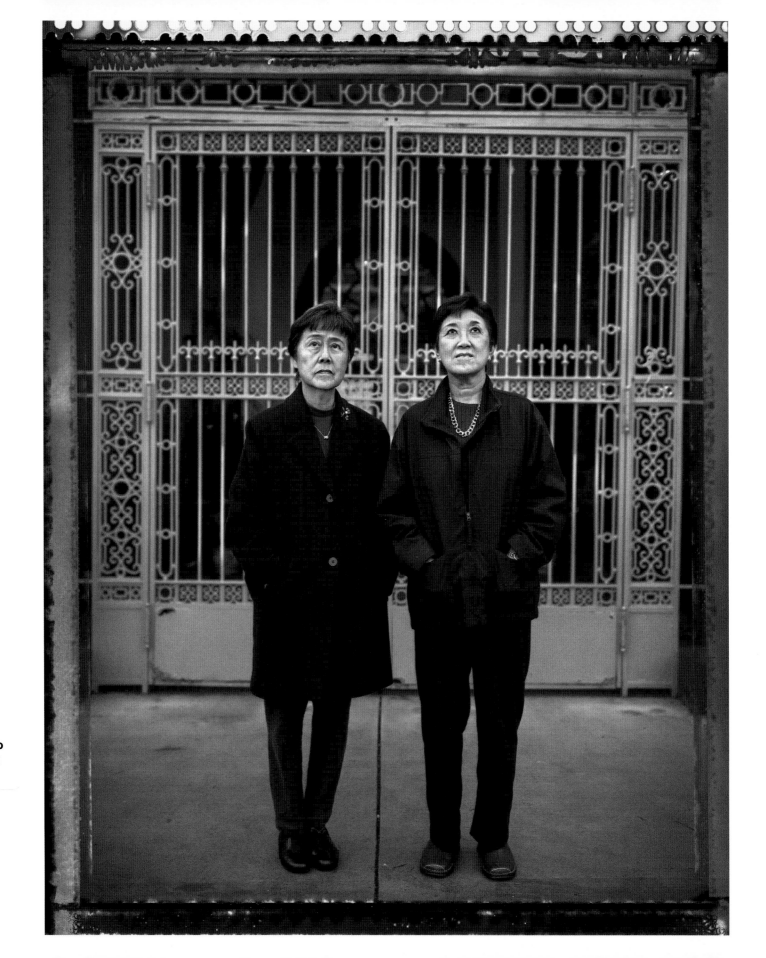

Helene Nakamoto Mihara (left) and Yoko Itashiki, now Mary Ann Yahiro, both 72 in 2007, at the entrance of their former school.

'These men in fedora hats came to the house and hurriedly took him out of the house.'

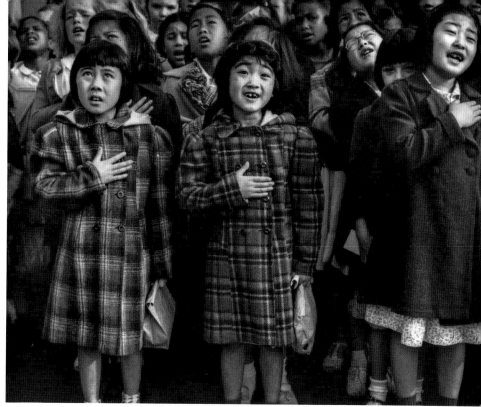

Hideno Helene Nakamoto (left) and Yoko Itashiki (center), both 7, at the Raphael Weill School in San Francisco.

They pledged their allegiance.

Hideno Helene Nakamoto and Yoko Itashiki, both born in the United States, took part in the flag-raising ceremony every morning at the Raphael Weill School in San Francisco.

But their families were devastated during World War II. Hideno's father, Jitsuzo Nakamoto, who owned the American Fish Market at 1836 Buchanan Street in San Francisco's Japantown, was picked up by the FBI and jailed. He was one of thousands of Issei, first-generation Japanese immigrants—religious leaders, Japanese language teachers and those who had any known connection to Japan—who were jailed in the hours and days after Pearl Harbor.

"These men in fedora hats came to the house and hurriedly took him out of the house," Hideno says. "I was at the top of the staircase, watching, and I remember the flashing lights, and he was gone. That's it. And we didn't see him for 15 months."

The family's oldest son, Katsumi, did not survive the incarceration. He was 18 months old when he died from hydrocephalus and sudden respiratory arrest on the last day of 1943.

The Nakamoto family was released from Topaz in September 1945. They moved to Salt Lake City and later returned to San Francisco, where Helene's father re-established the American Fish Market on the same property he had before the war.

In 1953, he became an American citizen.

Yoko's parents were also separated by the incarceration. Her father, Tarozimen Itashiki, stayed with the children while her mother, Fuku Ogura Itashiki, a Japanese language teacher, was taken by federal agents to Camp Sharp Park, a detention facility near San Francisco. Fuku died in her sleep of heart failure in the camp. Yoko never saw her 51-year-old mother alive again.

"It was pretty traumatic, because her body came back, and we had a funeral in Topaz," Yoko says. "It was really hard for me being a child seeing her like that when I hadn't seen her in a long time. But I don't have bitterness."

Yoko and her family followed her older sister out of Topaz and resettled on the North Side of Chicago. She graduated from Mundelein College (now a part of Loyola University) in Chicago after studying food and nutrition.

"You can't take freedom for granted, wherever you are," she says.

"You know, even in the United States, you really have to fight for your freedom."

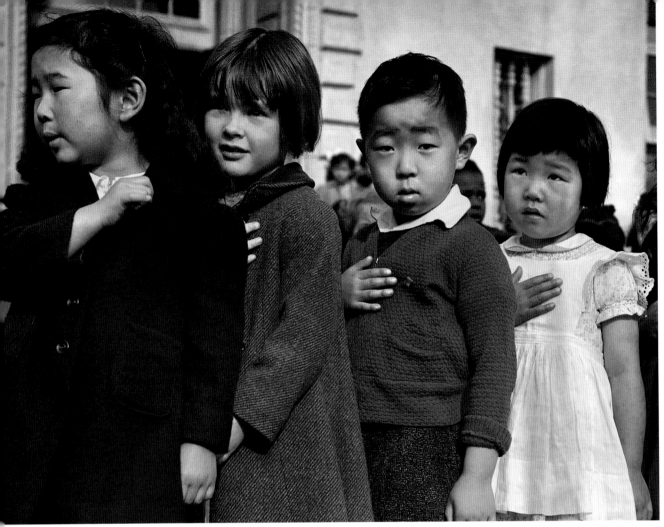

'My parents were just making the best of the situation and hoping it doesn't continue forever.'

DOROTHEA LANGE, APRIL 20, 1942, SAN FRANCISCO, CALIFORNIA

Joan Yamasaki, 5 (left), also recited the pledge at the Weill School.

Third-generation Japanese American Joan Yamasaki was one of the youngest children on the day that government photographer Dorothea Lange came to photograph the Raphael Weill School.

Soon after, she and her family were sent to the temporary detention facility at Tanforan, which was converted from a horseracing track.

She remembers only the smell of hay and manure and a hanging light bulb. After the permanent camps were built, her family was sent to Topaz in Utah.

Most Japanese Americans along the West Coast were first sent to one of fifteen temporary camps, or what were called assembly centers.

They spent up to six months in the temporary camps before being sent, usually by train, to the ten permanent camps in remote sections of California, Arizona, Idaho, Wyoming, Colorado, Utah and Arkansas.

The first of San Francisco's Japanese Americans were removed from their homes in early April 1942. Another group was picked up later that month.

In late May, the Weill School auditorium was used to hold the final group. Nearly three hundred people were put on six buses and taken under military guard to nearby Tanforan.

Even now, Joan doesn't like to talk about her childhood or what her parents went through trying to re-establish their lives after the war.

At Topaz, she says, "The winters were cold and the summers were hot. Very hot and very cold and snow. I was happy, because you are a child, and you are being shielded from any headaches.

"My parents were just making the best of the situation and hoping it doesn't continue forever."

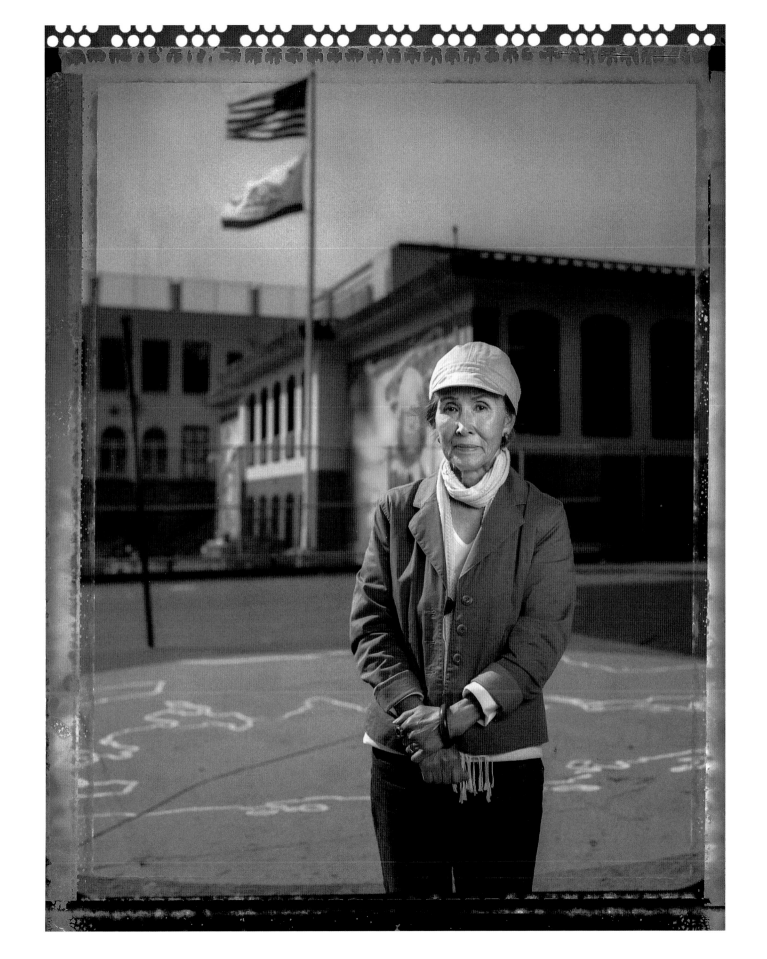

Joan Yamasaki Matsuoka, 75 in 2012, stands on the playground of her former school.

Rachel Kuruma, 85 in 2016, at her home in San Francisco.

Families did not want to be caught with any possessions from Japan because it might indicate a connection or loyalty to their homeland.

Rachel Kuruma, 11, in the courtyard of the Raphael Weill School.

Rachel Kuruma didn't know about the bombing of Pearl Harbor until she was returning from Fisherman's Wharf with her brother and his girlfriend.

On their way home, they noticed newspapers being sold all over San Francisco. The word "war" was everywhere.

Life changed quickly. Rachel recalls her father, in tears, sitting in front of the fireplace with "these Japanese religious things" and "little shrines." He tore them up and watched them burn. Families did not want to be caught with any possessions from Japan because it might indicate a connection or loyalty to their homeland.

The family was first sent to Tanforan and later to Topaz, where her father, Saichero, passed away. Rachel and her family lived in Block 6, 9B.

When dust storms blew, their living quarters would fill with dust, making Rachel feel as if she couldn't breathe.

Her answer was to hide under the bed and wait for the storm to pass. She remembers the military-style showers. "My mother would get me up about 2 o'clock in the morning and then get a tub and take me there because by the morning or in the middle of the day, there was no more hot water."

After the war, Rachel lived with relatives in Oakland before returning to San Francisco, where she finished high school. She wanted to go on to college, but her mother told her she couldn't afford it. She managed to attend Lux College in the city, with a little financial help from her brother, Kazuo.

Like many Japanese Americans in the area, Kazuo worked for the Simmons Bedding Company. Her mother did housecleaning for the same woman who had employed her before the war. Her other brother, Toby, worked for a chemical company before transferring to an office job.

At the age of 21, Rachel began work as a dental assistant on San Francisco's Geary Street. Forty-four years later, she retired.

Sometimes people ask her about the incarceration, wondering how the government could treat someone born in the United States that way.

"I can't say I had a good time, but I have nothing to complain about," she says.

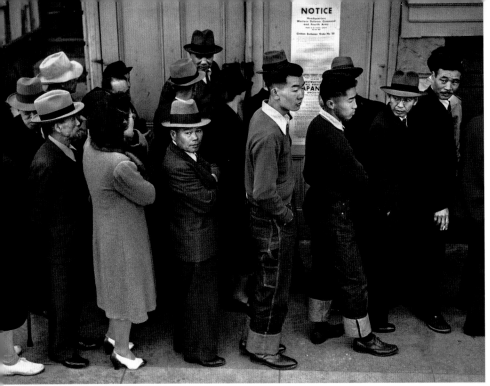

DOROTHEA LANGE, APRIL 25, 1942, SAN FRANCISCO, CALIFORNIA

Shinichi Suzuki (right) at the Japanese American Citizens League.

President Roosevelt was 'totally, totally wrong' when he ordered the removal and imprisonment of Japanese Americans.

Every single man, woman and child of Japanese ancestry who lived in California, western Washington, western Oregon and southern Arizona was forced to register their names and addresses with the government in early 1942.

Shinichi Suzuki was one of the more than 110,000 Japanese Americans caught up in the federal government's effort to secure the American border. Government leaders feared that Japanese living in these states might collaborate with the Empire of Japan and commit espionage or sabotage.

The 42-year-old Suzuki arrived in San Francisco as a teenager. He was a gymnast who had performed for the emperor of Japan. In early 1942, Suzuki was living in San Francisco's Japantown with wife Fukiye and sons Yasukazu, Seiji and Saburo, each of whom were born in the United States and were American citizens by birth.

Like other first-generation Issei, Suzuki was not permitted to gain citizenship under laws at the time. It was not until the 1950s that Issei could become naturalized U.S. citizens.

The Suzukis were sent to Tanforan and then Topaz, where Shinichi worked as a chef in the mess hall. After the war, he returned to San Francisco, working as a cook and later as a day worker, doing gardening and other chores in private homes.

Shinichi loved to fish and built a surf rod with his name on it, which he stored when he left for the camp. But the pole and other family belongings were stolen while he was gone.

"After the war, he was riding a bus in San Francisco," says son Seiji. "And he spots this guy with a fishing rod and he looks at it and says, 'That's my rod.' I think my father had guts to challenge the guy. It's sitting in my garage today."

Shinichi died in 1989 followed by Fukiye five years later. Their three sons have mixed memories of camp life.

Yasukazu, 84, who worked as a designer and draftsman, recalls delivering the Topaz newsletter for his block and joining the Boy Scouts. "I used to love to walk, so I'd go out of camp, take a hike down the road to the ditch where I learned how to swim," he says. "So for me, it was really an adventure."

Seiji, 80, a retired electrical engineer, recalls the beauty of Utah. He met his future wife in the third grade at camp.

Saburo, 78, recalls catching lizards and horned toads, and tagging along with his father. "He used to love to go out beyond the fence, do some fishing, hunting for arrowheads. After a while all the guards left, so there was nothing around except the barbed-wire fence, which we could just walk through," he says. Saburo did a little bit of everything after the war, including buying a gas station.

They also remember the prejudice that the family encountered after the war when they tried to rent a home. "They would say, 'Well, we wouldn't mind, but I'm sure our tenants would object,'" Seiji says.

President Roosevelt was "totally, totally wrong" when he ordered the removal and imprisonment of Japanese Americans, Seiji says. "They didn't take all of the Italians or the Germans from the East Coast," he says. "Well, had they done that, they would have vacated the East Coast. Yeah, in that respect, it gets me a little upset."

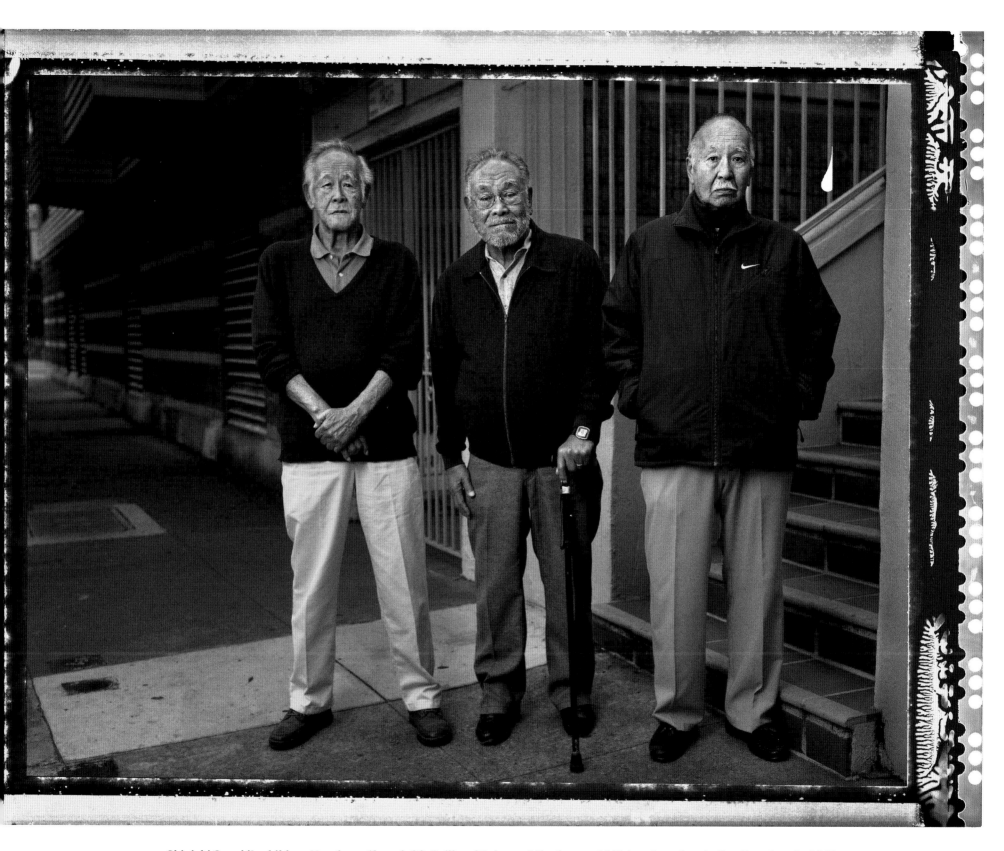

Shinichi Suzuki's children Yasukazu (from left), Seiji and Saburo at the former JACL headquarters in San Francisco in 2015.

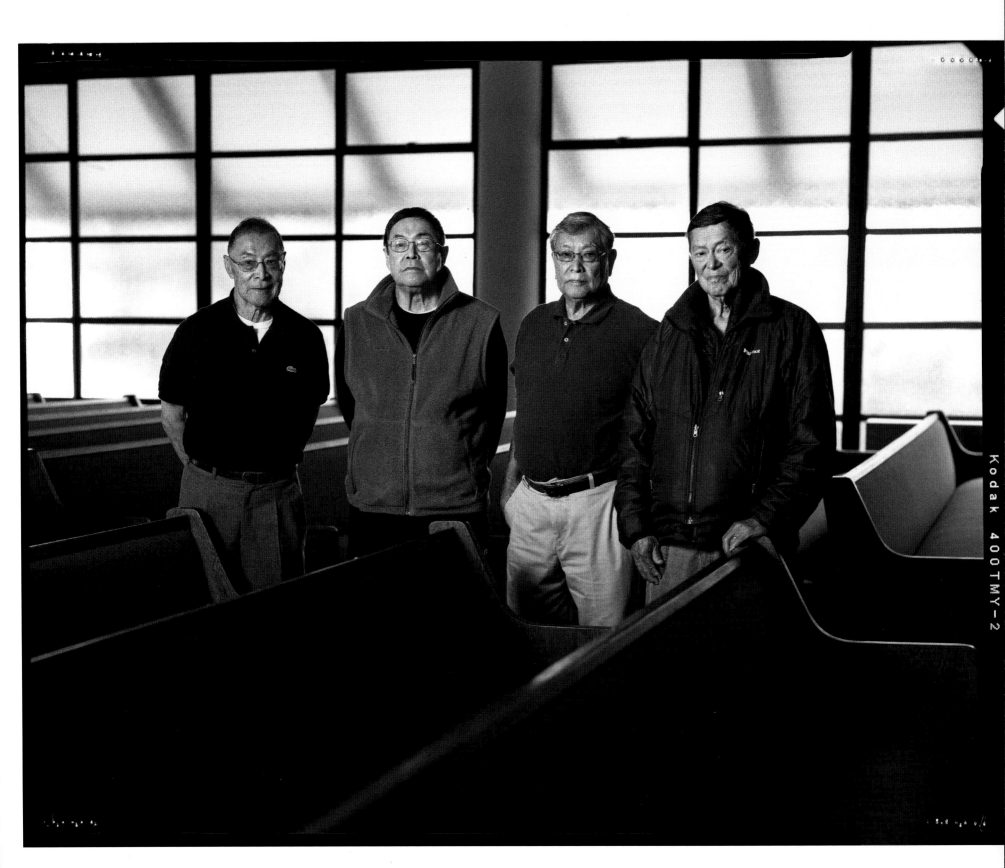

Brothers Saburo (from left), Koichi, Hiroshi and Nobusuke Fukuda inside San Francisco's Konko-Kyo Church in 2017.

'As he was giving his sermon, three big, white FBI agents came in and interrupted the whole proceeding and arrested my father.'

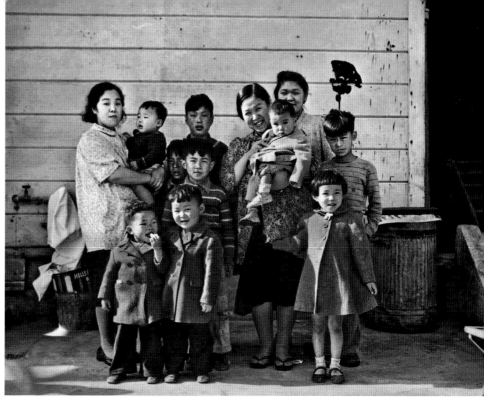

Families of two Shinto priests at the Konko-Kyo Church.

Before they were forcibly removed from their homes in San Francisco, the families of two Shinto priests were photographed at the Konko-Kyo Church on Bush Street in San Francisco.

The mother on the right was Shinko Fukuda, holding Hiroshi. She was pregnant with her seventh child, Koichi. Nobusuke was to her right and Makiko was in front of him. Michisuke stood to her left with Yoshiro in the middle and Saburo below him.

The father of the family was Rev. Yoshiaki Fukuda, a minister of the Konko faith who arrived in San Francisco from Japan in 1930 to establish a church in Japantown.

The reverend spent almost six years in Department of Justice detention—an ordeal that started on December 7, 1941, when he was speaking at the Konko-Kyo Church of San Jose.

"As he was giving his sermon, three big, white FBI agents came in and interrupted the whole proceeding and arrested my father," says Saburo, who was born in San Francisco in 1934. "I remember driving back to San Francisco that evening. I heard sirens, and there were fires burning in the immediate Japantown area. Later I found out that many families were trying to burn anything they thought would incriminate them as being a collaborator or spy for the Japanese."

The Fukudas were taken to live in a horse stall at the former Tanforan horseracing track, where Koichi was born in June 1942. Then they were sent to Topaz in Utah, and reunited with Yoshiaki in 1944 at a camp run by the Department of Justice in Crystal City, Texas.

After the war, their father faced deportation because the government believed he had maintained a pro-Japanese stance during the war. But an attorney helped him win his case. He became a citizen in 1952.

One son, Yoshiro, died in Topaz of kidney disease at age 11. "They didn't have medical care for him at that time in camp, so he pretty much died of ill treatment," Saburo says. "He just wilted away."

Saburo's sister Makiko committed suicide in 1962 by jumping off the Golden Gate Bridge soon after graduating from college and getting married. "You always wonder what influence did the camp have on her," Saburo says. "How did it affect her coping ability? So many questions and no answers."

The camp years were formative. "I became more of an optimist," Saburo says. "I always looked at the way things were operating and for a way to do it better."

The years after camp were also pivotal, says Koichi, who became an art director and commercial artist. "We didn't have that much parent supervision because, for most of us, the parents of our generation were busy trying to get readjusted to living back in the city after losing everything. And so we were left more or less on our own."

Saburo became a physical therapist, Hiroshi pursued a pharmacy career and Nobusuke worked in social services and then as a juvenile probation officer.

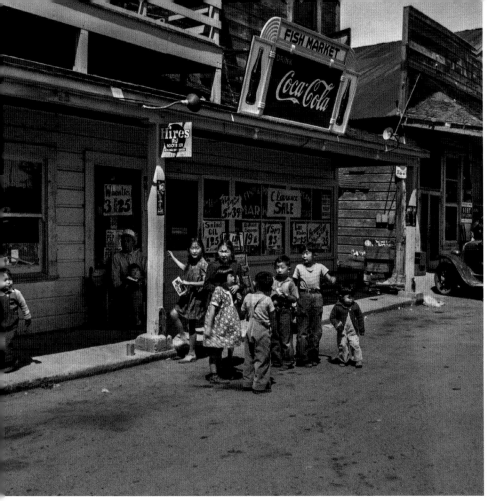

Ouchida and Ogata families in front of the Florin Road grocery store.

'I think his dreams of a pretty good financial life were shattered by the war.'

Two days after this 1942 photograph was taken, the Ouchida and Ogata families were sent to a temporary detention center in nearby Fresno, California.

Before the end of World War II, they would spend years in the Jerome Relocation Center in Denson, Arkansas, and the Gila River Relocation Center in Arizona.

The father of the Ouchida clan, Harold, was a second-generation Japanese American who ran a successful produce shipping company called Northern California Farms, specializing in strawberries and grapes. The Ogata family ran a thriving grocery store on Florin Road, not far from where this picture was taken. Florin was a rural community just outside Sacramento at the time.

When the families were taken away, berries were left rotting in the field, and twenty trucks from the shipping business were left behind.

The Ouchidas were fortunate. A neighbor, Mary McCumber, cared for the family house while they were away, so the family had a home to return to after the war.

But Harold Ouchida lost his company during his incarceration.

"I think his dreams of a pretty good financial life were shattered by the war," says son Lester. At Harold's memorial service in 1964, the minister referred to him as "the Japanese mayor of Florin."

Lester still remembers what returning home to California was like at age eight. He could hear the women cry as they approached Florin Road on old Highway 99.

"They said, 'Florin Road, we are home,'" he says.

The Ogatas were not as fortunate. Canned goods on the grocery store shelves were left behind. The family's paneled truck, offered for $50, had no buyers.

After the war, the family moved to Michigan and managed a peach orchard and started a landscaping business. Yonemitsu Charles Ogata and Margaret Tsukamoto were able to buy twelve acres on the eastern shore of Lake Michigan. They grew tomatoes, cabbage and raspberries on the farm while living in the town.

Most of the family remained in Michigan. Daughter Arlene was among those who missed California enough to move back, heading west in 1952. Through it all, the family did not talk much about the incarceration.

"I think our generation just wanted to forget, just not think about it, pretend like it didn't happen," Arlene says.

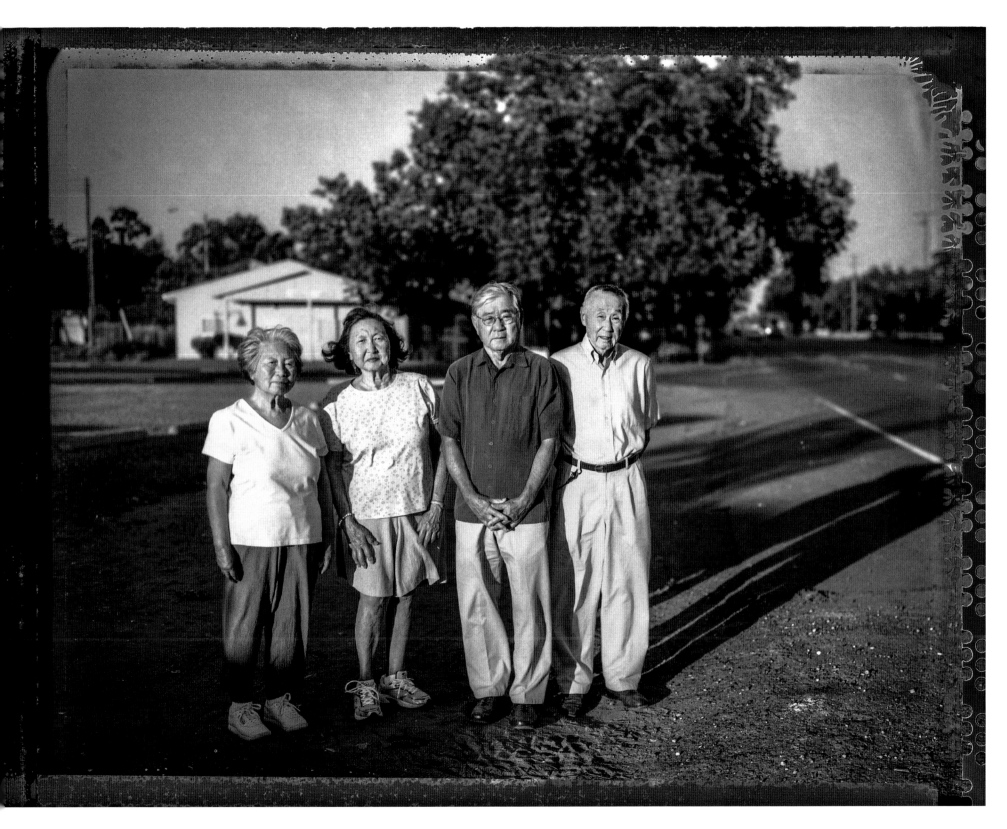

Lucille Yokota Ouchida (from left), Arlene Ogata Keunji, Lester Ouchida and Earl Ouchida on Florin Road in 2012.

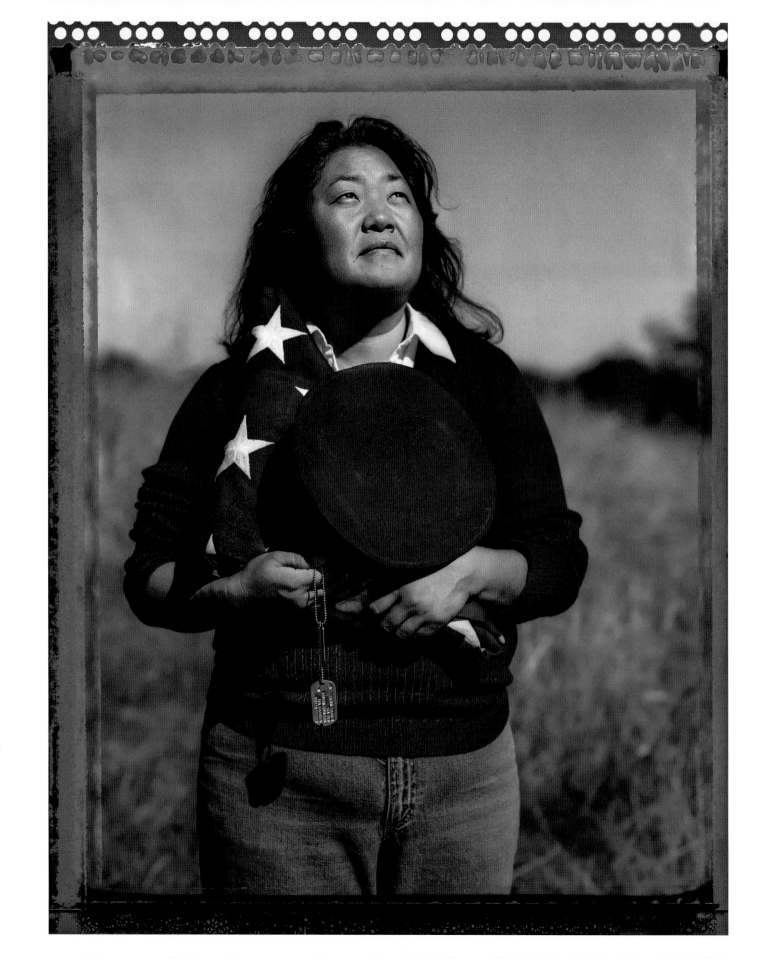

Ted Miyata's daughter Donna Nakashima returns to the field in 2007. She held the Army dog tags that belonged to her father and the flag presented to her family at his funeral.

'Even though they call it internment camp, my mother corrected me and said, "No. It was a concentration camp."'

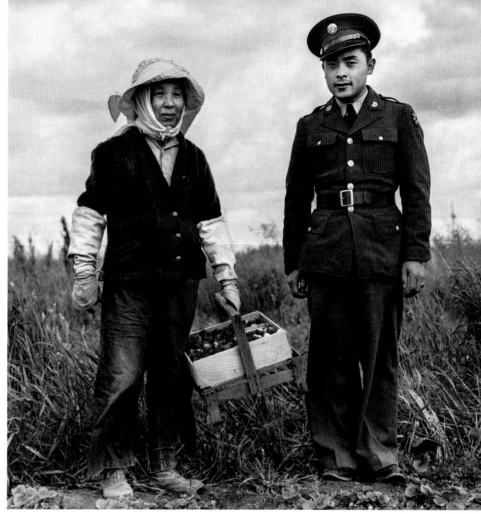

DOROTHEA LANGE, MAY 11, 1942, FLORIN, CALIFORNIA

Ted Miyata and mother, Nami, in the family's strawberry field.

The photograph of Ted Itsuno Miyata, dressed in uniform, standing with his mother, Nami Miyata, is difficult to explain.

Ted, an Army private from Camp Leonard Wood in Missouri, had just returned to California on furlough to help his mother pack her belongings before she was forcibly removed from her home in Florin, California.

The photo of Ted and Nami has been published widely. "I see it everywhere now," says Ted's daughter Donna. "I think my grandmom and dad look happy."

Nami sailed to America in 1904 from Hiroshima, Japan. In 1920, her husband died in a car accident, leaving her to raise six children. At first, she worked in a strawberry basket factory. Later, she grew strawberries on a three-acre plot that her children leased so she wouldn't have to work for someone else.

Ted, born in Sacramento as the youngest of Nami's children, volunteered for the military in July 1941 at age 23, and served as a medic in the highly decorated all-Japanese American 442nd Regimental Combat Team in Europe. "My father joined the Army to prove that he was an American," says his daughter Donna.

After the war, Ted moved to Chicago, attended the University of Illinois, became a pharmacist, married Irene Tamayo Fujii and raised a family.

He owned a drugstore on the South Side of Chicago and worked at Ravenswood Hospital.

Ted was a caring, empathetic parent, says Donna. He helped support Donna and her older sister Sharon. "My grandmother did raise six kids by herself," says Donna. "That's why my dad feels for single moms like me and my sister. He knows what we have to go through."

Donna's mother, Irene, was incarcerated at the Tule Lake Relocation Center in Newell, California. After Donna moved back to California in the 1980s, her parents visited and sometimes joined former members from the Buddhist church in Florin for the long drive to Tule Lake reunions. "I wanted to go," Donna says, "but my mom said, 'No.' She said it was a bad memory for them.

"Even though they call it internment camp, my mother corrected me and said, 'No. It was a concentration camp.'"

DOROTHEA LANGE, MAY 12, 1942, FLORIN, CALIFORNIA

Reverend Sho Naito locked the Florin Buddhist Temple before his new life as a prisoner.

'We didn't even know what was happening to him.'

The Buddhist temple that Reverend Sho Naito bolted on the day that he and his community were forced to leave during World War II looks much the same.

Sho, 54, sailed to America because he wanted to spread Buddhist teachings. His four children were born in Sacramento, but Sho returned to Japan with his family in 1939 and was assigned to provide religious services to Japanese soldiers in China. Soon after, Sho was sent back to California, assigned to a temple in Florin. The rest of his family didn't return to the United States until 1950.

"The old Nisei, they always say, 'Which camp did you go to?' You start from there, see?" says Sho's son, Kiyoshi. "So I say, 'Well, I was in Japan, so I didn't go to any camp.'"

Five months after the war started, Sho was sent to the Tule Lake detention camp. When released, he worked in a restaurant in New York. Meanwhile, his family struggled in Japan.

"After the war, we had nothing to eat," says Sho's daughter, Yasuko Fukuda. "Not only food. We didn't have matches, we didn't have salt, we didn't have sugar."

Sho worked at the Alameda Buddhist Temple in 1948 and later became acting bishop at Buddhist headquarters in San Francisco. In 1950, he borrowed $900 to get his family back to the United States "Actually, during and after the war we didn't even know what was happening to him," says son Kiyoshi. "There was no communication for several years."

After 11 years in Japan, Yasuko and Kiyoshi returned to California with poor English skills, but they learned quickly. After high school, Kiyoshi attended UC Berkeley, where he graduated in 1959. His father gave the benediction. It was the first time the university asked a Buddhist minister to officiate.

Sho's final assignment was in Seattle. His children say he didn't talk about the incarceration. But he loved to drive, and he would take visitors to see the Tanforan Assembly Center. He died in 1964.

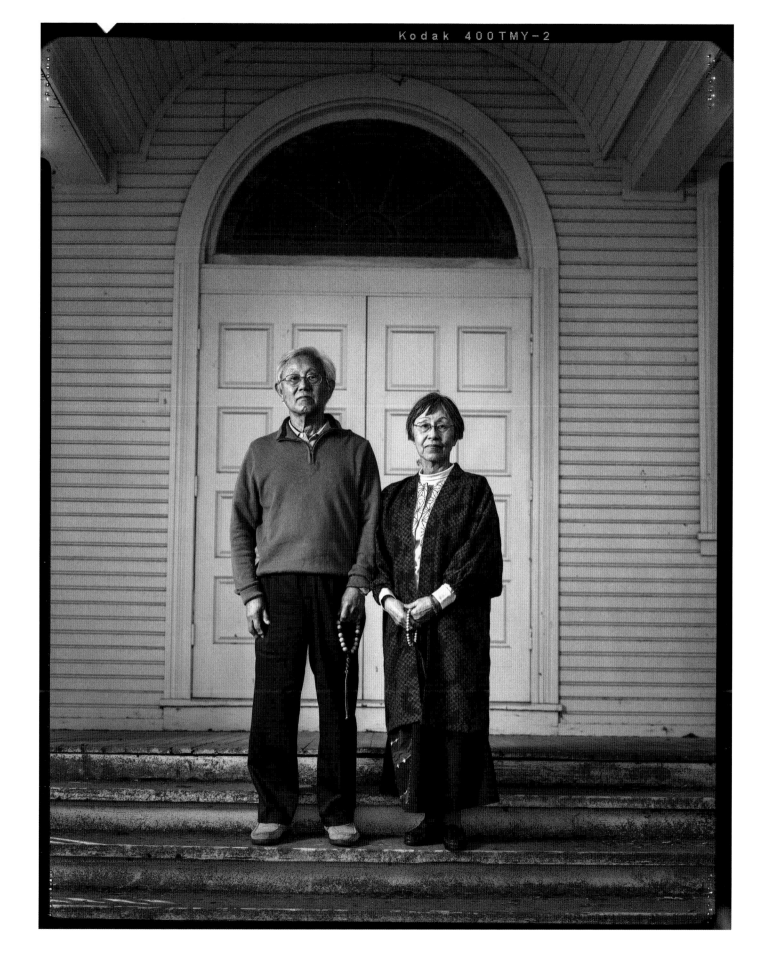

Reverend Sho Naito's children Kiyoshi Naito and Yasuko Fukuda at the Florin Buddhist Temple in 2016.

43

People filled this railroad station platform in 1942 with their belongings and their fears. They stepped onto the tracks toward armed soldiers and waiting trains. They had no idea where they were going or for how long.

TRAIN DEPOT, WOODLAND, CALIFORNIA

The Hayashidas on Bainbridge Island. They are: Susan Hayashida Fujita (from left), Hisa Hayashida Matsudaira, Yasuko Hayashida Mito, Natalie Hayashida Ong, Hiroshi Hayashida, Francis Kitamoto Ikegami, Lilly Kitamoto Kodama, Tomiko Hayashida Egashira, Frank Kitamoto, Fumiko Hayashida and Neal Hayashida.

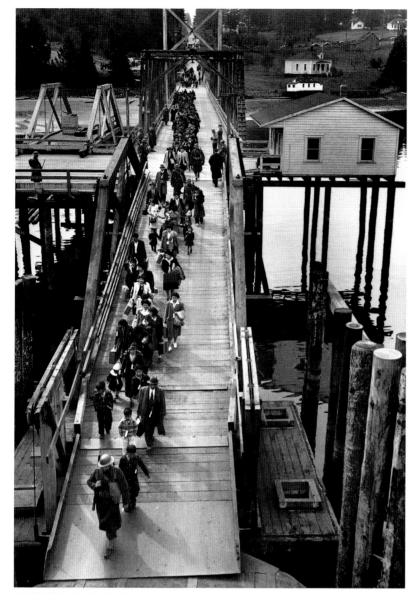

Japanese Americans led by the Hayashida family walked to the ferry.

The removal of Japanese Americans from the West Coast began on March 30, 1942, when 227 men, women and children, led by the Hayashida family, walked down the Eagledale Ferry landing on Bainbridge Island, Washington. They were ordered to take a ferry to Seattle and board a train to the Manzanar Relocation Center in California.

Almost 75 years later, Frances Hideko Kitamoto Ikegami recalls that walk with clarity.

'My mother made it kind of like an adventure.'

"What I remember is my mother made it kind of like an adventure," she says. "I think she had us all pack our own suitcases, and we were each given one toy to select. So I selected a doll and carried it with me. I just remember getting a lot of attention from the soldiers, and soldiers carrying me as we walked down the ferry dock. I was quite independent, so a lot of times I just walked alone.

"I do remember the soldiers on the train," she says. "They were very, very kind to us, and these soldiers were from New Jersey, so they had an accent. One of them, I'm sure, had a guitar or something, so he'd sing us some songs, they'd tell us stories, they read us books."

Frank Kitamoto remembers his father, also named Frank, didn't have his birth certificate because it was destroyed by fire after the 1906 San Francisco Earthquake. He was arrested and sent to the Department of Justice internment camp in Missoula, Montana.

His father later said it was because officials found a .22-caliber rifle and some dynamite on the family's land. But Frank's wife, Shigeko, wondered if the father was arrested because he worked for Friedlander's Jewelers in Seattle and would sell jewelry to Japanese sailors. There was a hint that the government was watching him as a possible spy.

After the war, young Frank denied at first that he was of Japanese ancestry.

"I was at the University of Washington, spending a week at a lab school for youth group leaders," he says. "After a week, this woman came up to me and says, 'You know, it's the first time I've ever spent any time with a person who's Japanese, and you're just like everybody else.' And it floored me because I'd spent the whole week there and I was the only person there who was Japanese, and I'd forgotten I was Japanese."

Frank became interested in the history of the incarceration after graduating from dental school. The island started an oral history project to help residents better understand their background.

"No one told us that the Issei here were pioneers and that they cleared most of the land on the island," Frank says. "I just always thought I was a foreigner. We didn't want our children to go through the same type of things we did in the public schools."

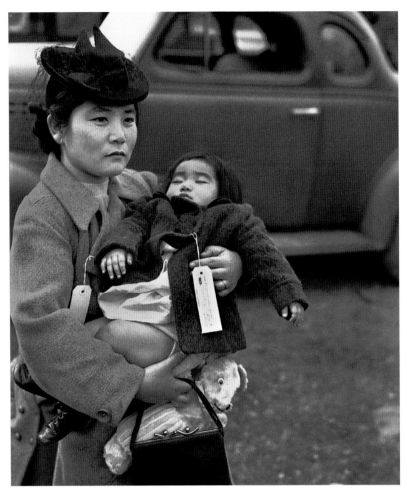

Fumiko Hayashida, 31, carried baby daughter Natalie Kayo to the ferry.

'I realized that I now had the face of the enemy.'

One of the iconic photographs of the incarceration was of Fumiko Hayashida carrying her sleeping 13-month-old girl to a waiting ferry on the first day of the forced removal of Japanese Americans during World War II.

For decades, until the 1990s, the name of the woman and the baby were not known.

Fumiko Hayashida left her home on Bainbridge Island, Washington, with her children, three-year-old Neal and baby Natalie. Her husband, Saburo, had been arrested by the FBI because he possessed dynamite for clearing tree stumps and a rifle used on the farm. Both were considered contraband.

Fumiko told a congressional committee about being forced to march toward a ferry that took her from home.

"We arrived in Seattle, boarded an old train and rode two days with the blinds shut to the hot California desert," she said. "It was a horrible trip. I had two young children, and in 1942 there was no such thing as disposable diapers."

Fumiko and her children—like all who followed—wore identification tags with family numbers. "I realized that I now had the face of the enemy," she said.

The Hayashidas were sent to Manzanar in California and then to the Minidoka Relocation Center in Hunt, Idaho.

When the family returned from the camp in August 1945, they discovered the farm had been poorly maintained and the strawberries were ruined. Saburo, reunited with the family, got a job at Boeing and spent a year commuting before the family moved to Seattle so he could be closer to his job.

Even so, says Fumiko's daughter Natalie Kayo Ong, "We were fortunate that we had the house and land to come back to. People who rented or had mortgages they couldn't pay—they were the ones that lost."

Natalie grew up an activist. She spent much of her adult life in Texas, serving a decade on the El Lago City Council and as the town's mayor pro tem.

"I heard my father say [incarceration] did disperse the Japanese and it did give more opportunities to get away from the farm for the younger generation," Natalie says. "I think education was pretty important, and it might have happened anyway."

Natalie supported the Japanese American Citizens League when it launched a campaign to get a formal apology from the government and reparations of $20,000 for each camp survivor. "And I was happy to speak out after 9/11," she says, "When people were talking about interning those that looked like those that did the bombing."

"Hey, wait a minute," she said, "that's wrong, and it's happened to me."

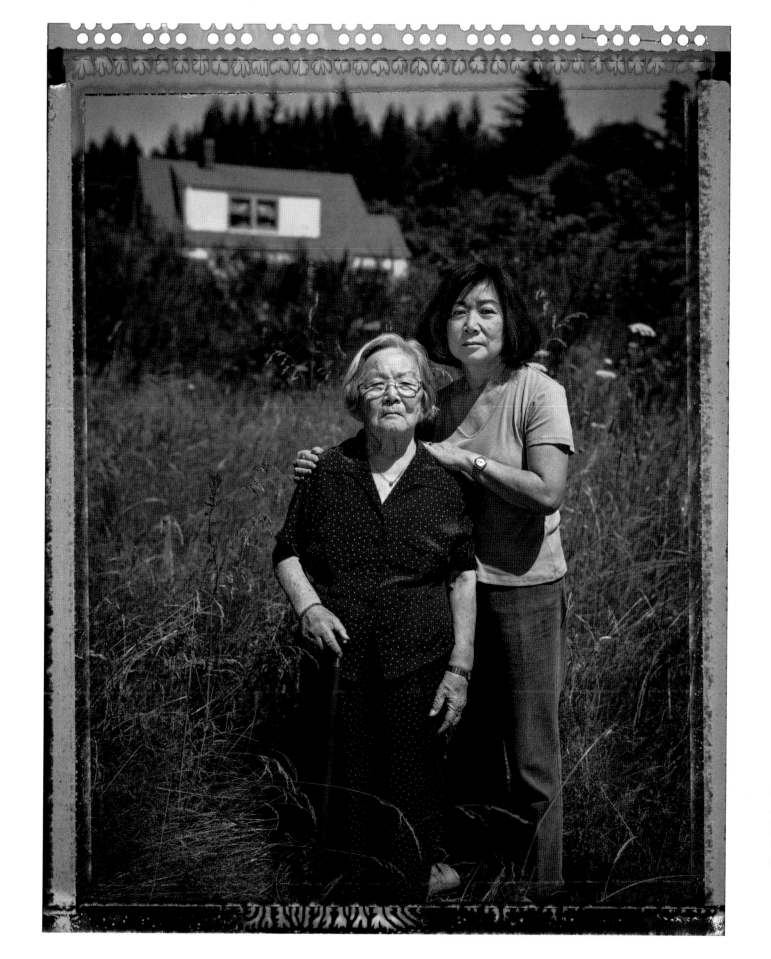

Fumiko Hayashida, 95, and daughter Natalie Kayo Ong, 66, in 2006 on the Bainbridge Island, Washington, farm where they lived before their forced removal.

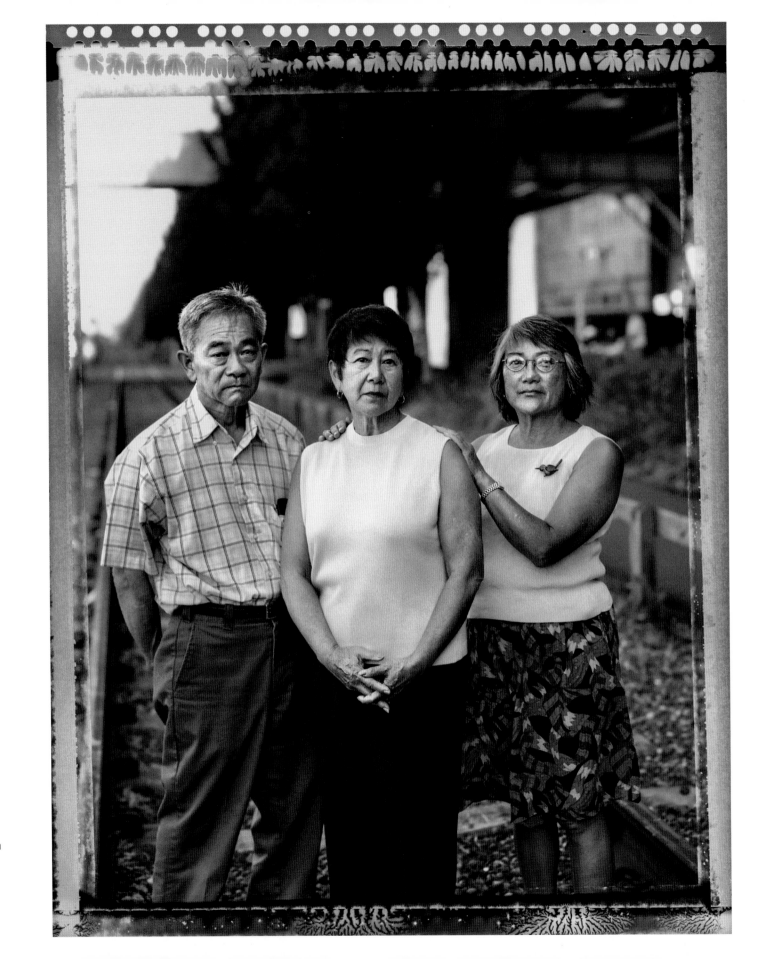

Hiroshi
Hayashida, 67
(from left),
Toyoko Susan
Hayashida Fujita,
66, and Yasuko
Hayashida Mito,
69, return to the
same railroad
track in Seattle in
2006.

'I thought, my God, why are we giving the victory sign.'

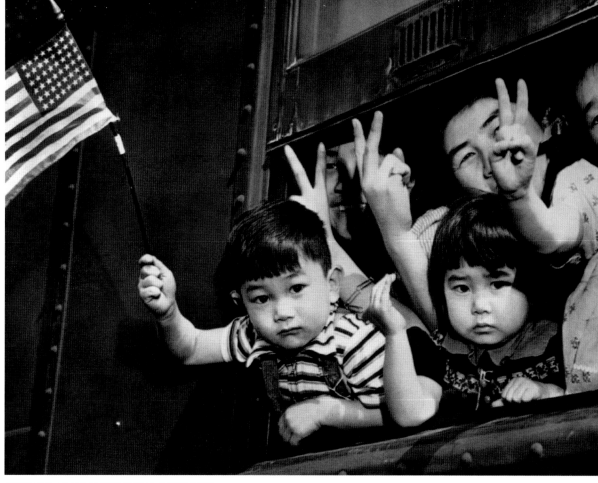

Hiroshi Hayashida, 4 (from left), departed on a train with sisters Toyoko Susan, almost 2, and Yasuko, 5. Mother Nobuko Hayashida is in back.

Toyoko Susan Hayashida can hardly believe the photograph of her family leaving Seattle by train to Manzanar.

"I thought, my God, why are we giving the victory sign," she says. "To me, it seemed rather odd that my brother was waving an American flag and we were giving the victory sign. And here we were being taken off to a camp being imprisoned."

For Susan, the camp experience was vivid and scarring. "I remember the howling of the dust storms," she says, "and cracks in the floor, and the dust would come up through the floor, and how stifling that was. Mom stuffed paper in the cracks to try and keep the dust out."

The howls of coyotes in the desert frightened her. "And the walls were so thin; I could take a pencil and drill a hole in the wall."

Susan, sister Yasuko and brother Hiroshi never talked about the incarceration after they left the camp. Their father, Ichiro, was first sent to a Department of Justice facility in Missoula, Montana, but would eventually join the family at Manzanar. Yasuko says she was afraid of her father when he returned because he had been in prison.

After the war, their parents returned to Bainbridge Island, in large part because they still owned property.

"They had something to come back to," Hiroshi says. "A lot of the younger people had gone to Chicago and other places back east, away from the coast, so they weren't managing as well. The older people who had land just stayed, but I don't know exactly how they survived."

Hiroshi went to trade school and worked in the sheet metal industry, married and lived in Seattle. But each year he'd take his vacation time to return to the family harvest on the Bainbridge Island farm.

Susan, who became a cosmetologist, has two daughters. She talked to them about incarceration in the camps. They accept it, but when their friends hear about it, the response often is, "What? Can't be. Didn't that happen like generations ago? Generations and generations ago? Your mom couldn't have been there."

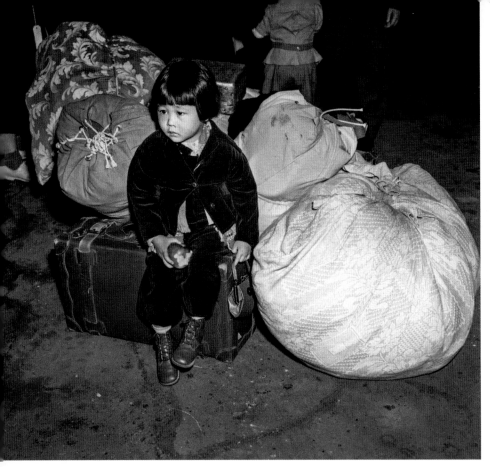

Yukiko Okinaga, 2, at the Union Railroad Station.

'She got me this red corduroy outfit. And she got me those lovely shoes.'

Looking at the famous photograph of Yukiko Okinaga waiting in Los Angeles' Union Station for a train that would take her and her mother to the Manzanar Relocation Center, Yuki wonders why her mother dressed her so elegantly.

"She got me this red corduroy outfit. And she got me those lovely shoes," Yuki recounts. "I said, 'You bought those for me for the evacuation?' She said, 'Yes, because you didn't have anything to wear.'"

Her mother, Mikiko, was 24 at the time. Born in Wyoming, Mikiko was sent to Japan as a girl to be raised by her grandparents. She was eighteen when she boarded a ship for Hawaii to marry Jacob Hideto Okinaga in a match arranged by her family. They divorced after moving to Los Angeles, where Yuki was born. Mikiko told Yuki that her father died in the war. In truth, he, too, was incarcerated at Manzanar, where he remarried. Meanwhile, Mikiko entered the camp with another man.

Yuki was oblivious to the family drama at the time ("Peyton Place," she calls it now). She has a child's memories of incarceration—of celebrating holidays in the mess hall where the kids would get candy and watch movies, and sneaking into the garden and eating tomatoes and watermelon.

Her mother never talked about the camp, even when Yuki asked her about it to write papers for school. "She said, 'They don't need to know that.' She thought it ruined her life. She came to the United States for a better life and never got it."

Among the last Japanese Americans released, she and her mother left in October 1945 for Cleveland, where they were sponsored by a Japanese-American family. Her mother worked as a cleaning woman and later a seamstress.

"I got beat up at school," Yuki recalled. "It wasn't real bad, 'cause they were kids my age. I got to be a real fast runner."

As a girl, she spoke only Japanese, but later her mother insisted that she speak only English. "I had to pretty much deny that I was Japanese," she says. Today, she says, "I speak Japanese like a 10-year-old."

Yuki attended Lake Forest College in Illinois and graduate school at Tulane University in New Orleans, where she earned a master's degree in theater. She returned to Illinois when her husband, Don Llewellyn, landed a faculty post at the University of Illinois. She helped establish the school's Asian American Cultural Center, and taught about the incarceration.

Yuki believes what happened to Japanese Americans in the 1940s could happen again.

"No matter how much people say, we have to learn from our mistakes," she says. "People you elect into power are the ones that are able to do things like that. But I don't see the numbers showing that the young people are voting, and that saddens me. That's the only way you can control what's going to happen."

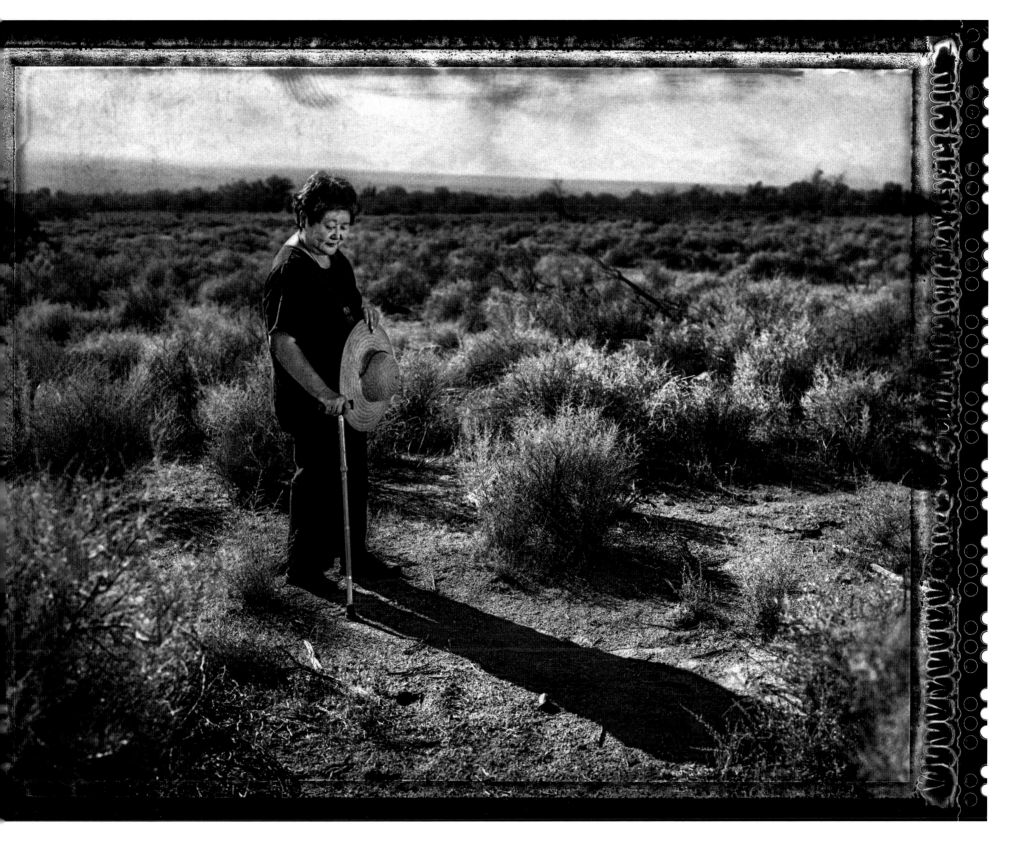

Yukiko Okinaga Llewellyn, 66 in 2005, on her first visit to the Manzanar Relocation Center since the incarceration.

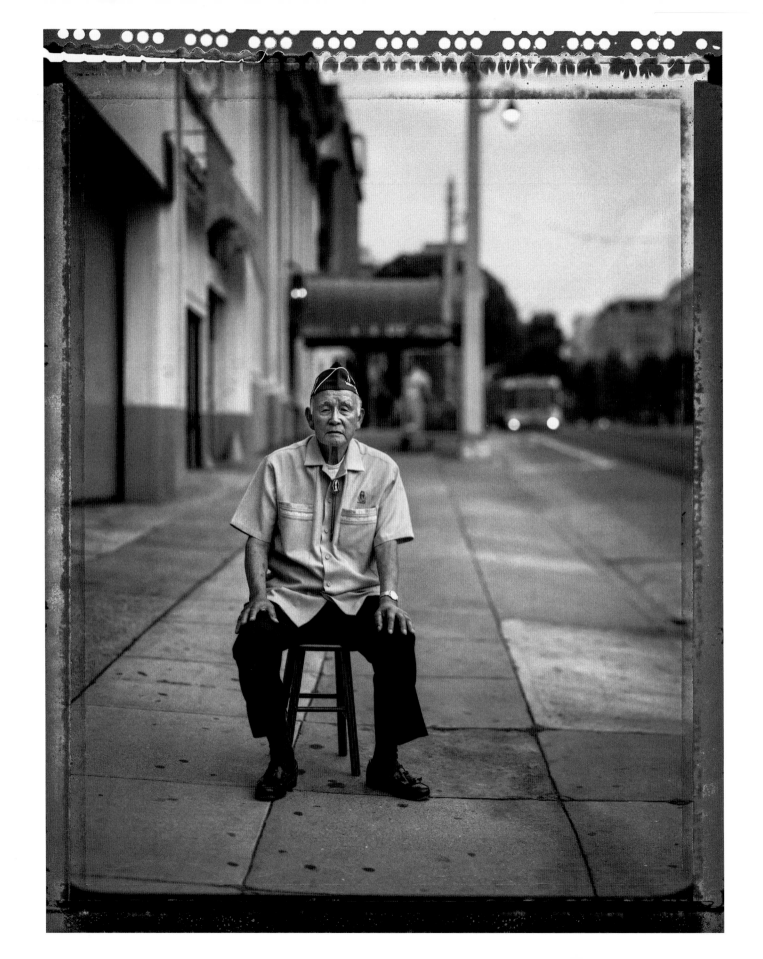

Mits Kojimoto, 85 in 2008, outside the same building in San Francisco where he waited for a bus to take him to the Santa Anita Assembly Center.

'Where are my friends, the teacher that passionately taught us about democracy, about our rights?'

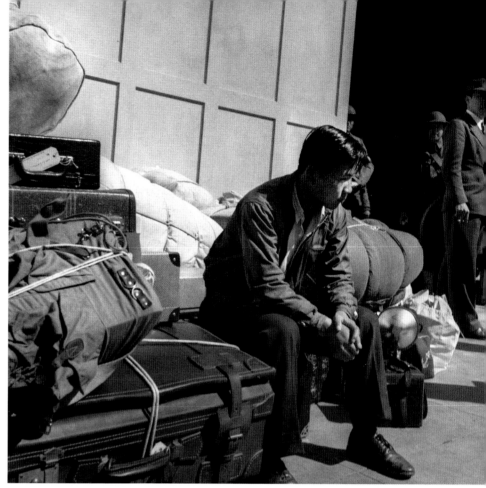

DOROTHEA LANGE, APRIL 6, 1942, SAN FRANCISCO, CALIFORNIA

Mits Kojimoto, 19, contemplated his situation as he waits to be picked up.

As he sat among his personal possessions at 2020 Van Ness Avenue in San Francisco, Mitsunobu "Mits" Kojimoto was part of a contingent of 664 residents of Japanese ancestry headed for the huge Santa Anita Assembly Center in Arcadia, California.

"That was the big day of our young lives," Mits says. "We were being kicked out of San Francisco. It was kind of shocking because as you grow up, you think you are going to have certain rights of life, liberty. And to be sitting there was very disheartening."

So much, he says, was going through his mind.

"I was really wishing that somebody would come and save us," he says. "Where are my friends, the teacher that passionately taught us about democracy, about our rights? Where is the judge, the governor, all these people that told us that we did have rights?"

Santa Anita was the largest temporary detention center. It housed more than 18,000 Japanese Americans for several months while the permanent camps were built.

Mits' father, Katsujiro Kojimoto, came from Wakayama, Japan, to start a new life and seek his fortune. He arrived in San Francisco before the 1906 Earthquake, and Mits was born as an American citizen.

While at Topaz the 19-year-old Mits signed up for the U.S. Army.

"I felt I'm going to volunteer, why not? If not, what would have happened regardless? We were behind barbed wire. We should put our best foot forward and volunteer. I wanted to show loyalty to my country."

But, he says, it was "a very degrading time" because he

and the men from the camp were treated harshly. "It was very heartbreaking."

Mits joined the 442nd Regimental Combat Team and became a machine gunner in H Company. A staff sergeant in 1945, he received the Bronze Star for his actions near Bruyeres, France. Company H was led by Willie Kiyota, and Mits says the unit owed him "a special tribute."

"I was lucky enough to survive every campaign," he says, including Rome to Arno, Rhineland, Northern Apennines, the Po Valley and the rescue of the "Lost Battalion."

After the war, Mits married and raised three children, but he never talked to them about his time in the camps.

Mits says he was struck by the events of 9/11 and its aftermath. Instead of Japanese Americans being singled out, Muslim Americans became targets.

"After 9/11, here we go again," he says. "As soon as something happens, lock them up. To do it indiscriminately . . . it was unbelievable. They would go down the same path as we did."

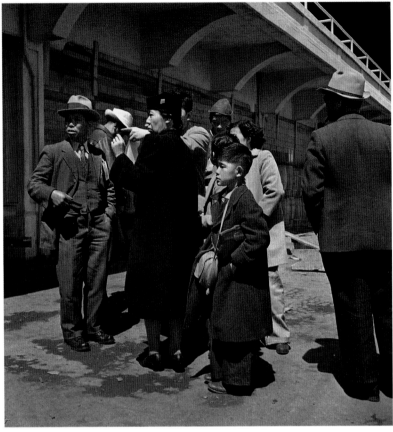

Andrew Nozaka, 8, at the Tanforan Assembly Center.

'My father believed in America, in democracy, in capitalism.'

Andrew Toyoaki Nozaka was just a boy, but old enough to remember the day that changed his family's life.

On December 7, 1941, his father, Shigeharu, took him to the San Francisco Zoo. On the way home, Andrew saw people hawking newspapers. While he didn't fully understand the news, he knew "something like war had broken out."

For the Nozakas, the consequences were swift. Shigeharu, a native of Tottori Prefecture who emigrated in 1908, was arrested the next day at his San Francisco office. He managed a trading company with close business ties to Japan, a connection that aroused the FBI's attention.

Andrew went with his mother, Toyo Ichiki Nozaka, and older sister Alice Haruko to the temporary camp at Tanforan and then to Topaz in Utah. Like other incarcerated children, Andrew focused on school, friends and activities like drawing and sports. "But you really miss certain things," he says—like ice cream, a rare treat in the camp that made him feel "more free and civilized."

His father was taken to Department of Justice internment camps in Montana, Texas and New Mexico. He communicated with his children in letters, urging them to study and obey their mother. Not until 1944 was Shigeharu Nozaka permitted to join his family in Utah.

"My father believed in America, in democracy, in capitalism," says Andrew. "Here were all these things, true blue, but he couldn't become a citizen, irony upon irony."

After the war, the family returned to Berkeley. When Shigeharu was arrested after Pearl Harbor, it had fallen to his mother to settle the family's business affairs. Toyo, a Methodist minister's daughter from Kagoshima Prefecture near the bottom of Japan, rented out their house through an agent, a cleric who arranged for shipyard workers to stay there. Through the war, the family's possessions were untouched.

In 1940, Shigeharu was a successful trader in his peak earning years. But he suffered a stroke after the war, and "was never able to get back on his feet," his son says. "It made me realize I was not going to have a life of ease." Neither would his mother. To support the family, she worked as a domestic into her 70s.

Andrew remembers the hostile postwar climate toward Japanese Americans. "When December 7 came around each year, it was very uncomfortable to go to school," he says. "My self-esteem was never so low. I wanted to be white. It wasn't until the 1970s that I no longer thought about it."

In 1956, he graduated from UC Berkeley with an engineering degree.

Drafted by the Army, he served for two years, mostly in El Paso, Texas, teaching electronic missile guidance. He went on to a career as an engineer specializing in metallurgy.

The incarceration changed the family forever, Andrew says, but they persevered.

"I think that was what all Nisei had in them. That's the legacy my sister and I have: *Gambatte*."

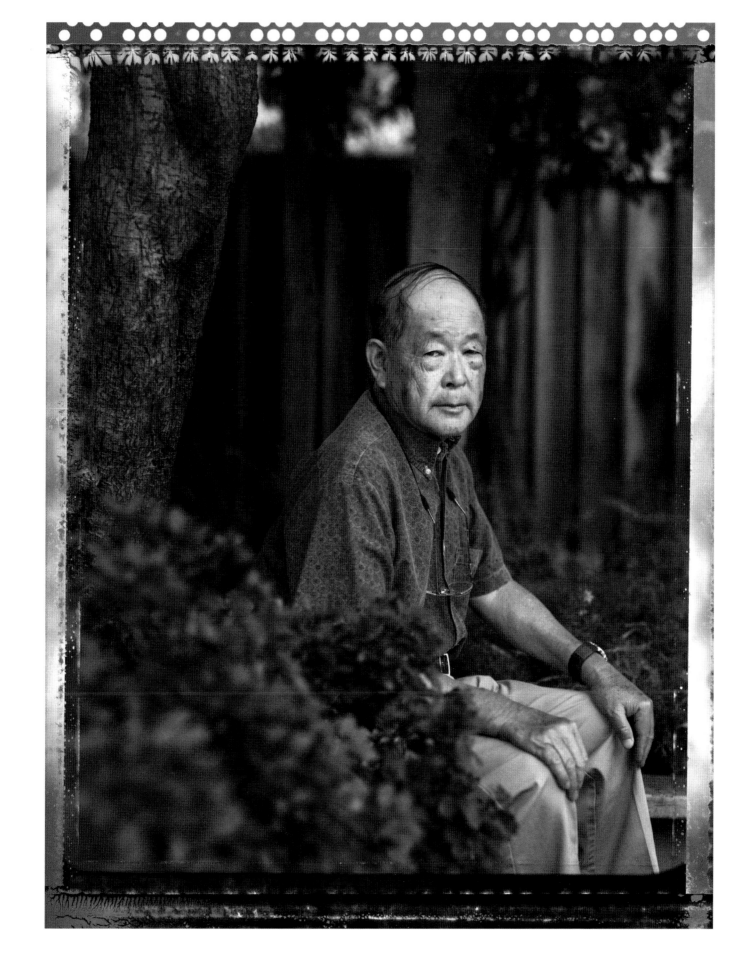

Andrew Nozaka,
79 in 2012, at
his Saratoga,
California, home.

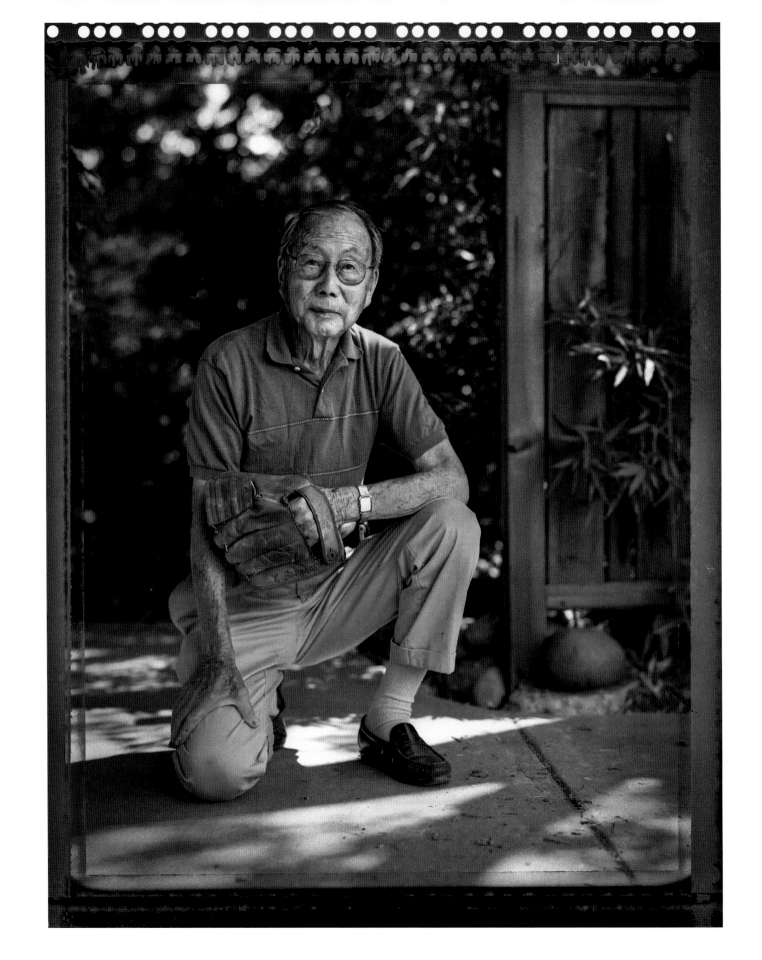

Yasuke
Shimada's son,
Yoshi, in 2008
in Walnut Creek,
California, with
the baseball
mitt he used as
a boy during his
incarceration.

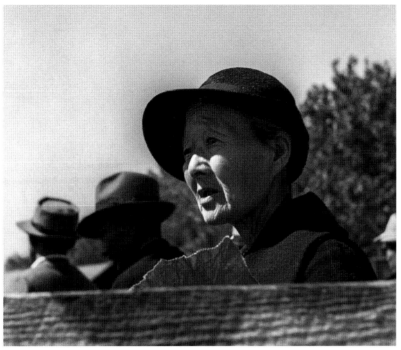

Yasuke Shimada arrived at the Turlock Assembly Center.

The photo of Yasuke Shimada trudging from the train toward the Turlock Assembly Center in central California tells the story of first-generation Japanese in America, according to her son, Yoshi Shimada.

"She was 57 but looked 70," says Yoshi. "The picture shows how the Issei had suffered. They got up early and worked from morning until night. It was a hard life."

Yoshi, then 18, followed his mother into the camp. His parents emigrated from Wakayama, Japan, to the Vacaville area of California, where they were farmers. He was born in California. While loading Japanese-American captives onto the train in Vacaville, the military police brandished bayonets. One touched Yoshi. "I felt the tip," he says. "If I made one wrong move I could have been stabbed."

From Turlock, the family was taken to the Gila River Relocation Center in Arizona. In 1943, Yoshi and his brother answered no to two questions on a government questionnaire asking if they would serve in the U.S. military and foreswear allegiance to Japan. The survey was an attempt to recruit volunteers for the army and determine the loyalty of the inmates.

By answering no to the two questions, the Shimadas were deemed disloyal and sent with about 12,000 others to Tule Lake, renamed the Tule Lake Segregation Center.

'I felt the tip. If I made one wrong move I could have been stabbed.'

"All the people who said no-no were actually not disloyal," Yoshi says. "They had reasons." In some cases, Issei parents wanted the option of returning to Japan; in others, families didn't want to be separated. And some second-generation Nisei, born in the United States, felt the questions were inappropriate for U.S. citizens.

Camp was difficult. Yoshi's mother died of a heart attack at Gila River in November 1942, only a few months after her photo was taken. And his niece, just 8 months old, caught a cold and died at Tule Lake in 1943.

One of the few items Yoshi kept from camp is the baseball mitt he wore when he led Tule Lake to a victory over the Manzanar traveling team in 1944.

As a child, Yoshi aspired to be a doctor because he wanted to help people: "I saw so many people getting sick, and there were no doctors," he says. He planned to attend college, but the war intervened and college was out of the question.

In spring 1946, his family left Tule Lake for Lodi, California, where he picked asparagus, peaches and pears, and saved money to marry his girlfriend from camp, Amy Kasano.

They moved to Berkeley, where he started a landscaping business, building a clientele in the Berkeley Hills, Piedmont and other East Bay communities. He and his wife lived with her family for ten years until he saved enough to buy a house in Walnut Creek.

"It turned out all right," Yoshi says, "but my only regret is that I wish that I had gone for some kind of college degree just for my personal satisfaction."

He is convinced that higher education is the only way to counter discrimination "That's what I tell my sons: 'I don't care if you become a janitor or gardener. Get that degree so at least you have something to fall back on.' So both of them, I made sure they graduated college."

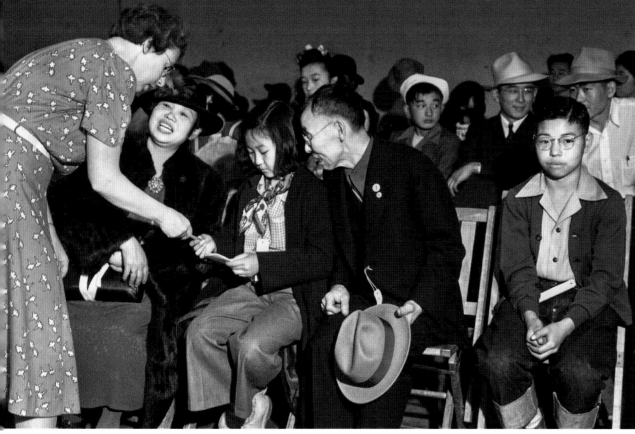

Their father quickly shut down his household and his laundry business.

The Kitagaki family at the Wartime Civil Control Administration. Kimiko, 12, accepted a pamphlet from family friend Dorothy Hightower. Brother Kiyoshi, 14, sat at right.

On December 7, 1941, Kiyoshi Kitagaki and his sister Kimiko went to see a movie at Oakland's Paramount Theater. Only when it was over did they learn that Japan had attacked Pearl Harbor.

Their father, Suyematsu Kitagaki, who arrived in America from Japan in 1904, quickly shut down his household and his laundry business, selling off equipment and entrusting family belongings to a Buddhist church and sympathetic non-Japanese friends.

While in detention, Suyematsu, his wife, Juki, and their children pursued the arts and crafts interests that ran in the family. Suyematsu, who apprenticed as a carpenter in Japan, gathered scrap lumber to make traditional platform sandals, or geta, with straps sewn by Juki.

Kiyoshi brought a radio primitive enough to get past the official restrictions that barred most radios, and enjoyed music by Tommy Dorsey and Benny Goodman. His brother Nobuo made sure the few possessions he was allowed to bring included a phonograph and a recording of *Madame Butterfly*. He helped start a library and worked on the *Totalizer* newspaper at Tanforan. After the family was transferred to Topaz in Utah, he joined the staff of the camp's arts magazine, *Trek*.

In 1944, Kiyoshi was allowed to leave Topaz for Des Moines, Iowa, where he finished high school. Soon after, his sister Kimiko left camp for Des Moines. "How happy I was to leave," she says. "There was sadness, too, for I was leaving my parents."

After the war, Suyematsu and Juki returned to Oakland. They couldn't afford to re-establish their laundry business, so Suyematsu found work cleaning houses. He and Juki could not buy a house, so their children pooled resources and bought them one.

Kiyoshi—following the path of his brothers Morio and Nobuo who served in the Army—enlisted in the Army Air Force. While in the service, he converted from Buddhism to Christianity. With his new faith came a new name: Paul, which was given to him by his minister.

While serving in New Mexico, Paul Kiyoshi Kitagaki met Agnes Takahashi, whom he married the day after his discharge.

Paul returned to the Bay Area, enrolling at San Francisco State College. He went on to teach high school in San Francisco, where he found young people's knowledge of American history incomplete. Told that his teacher's family had been imprisoned for their Japanese heritage, one student replied, "You're jiving me."

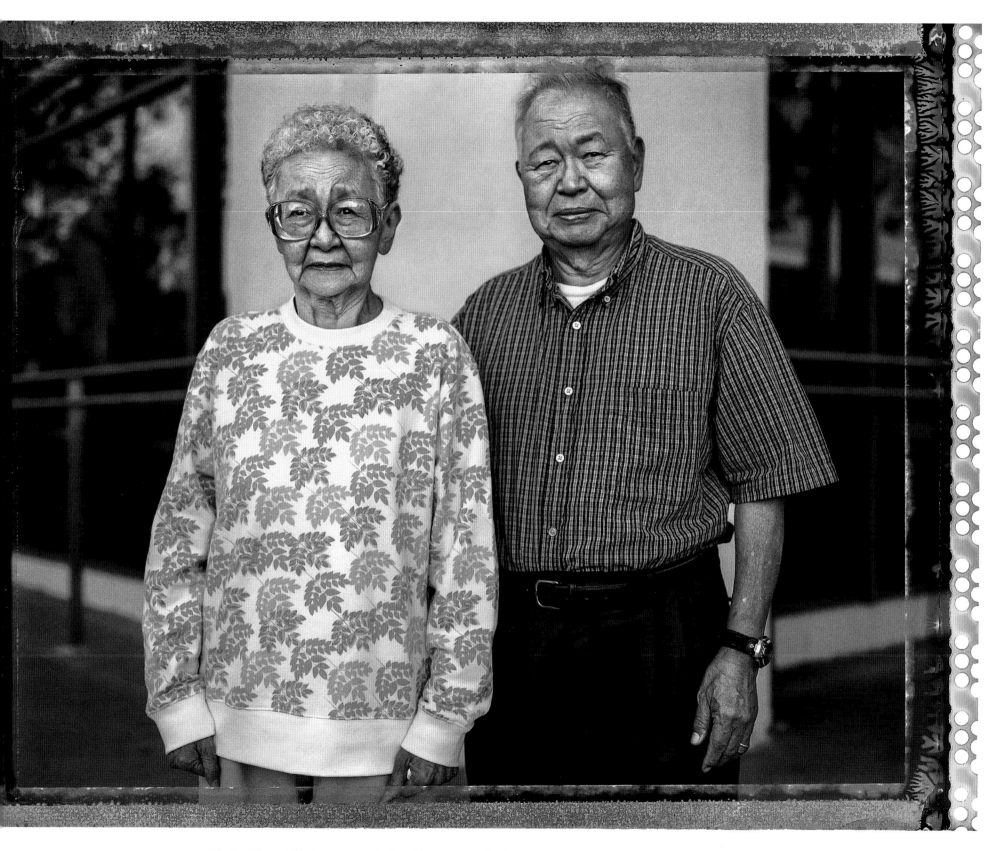

Kimiko Kitagaki Wong, 74, and Kiyoshi, 77, now called Paul Kitagaki, return to the site in Oakland in 2005.

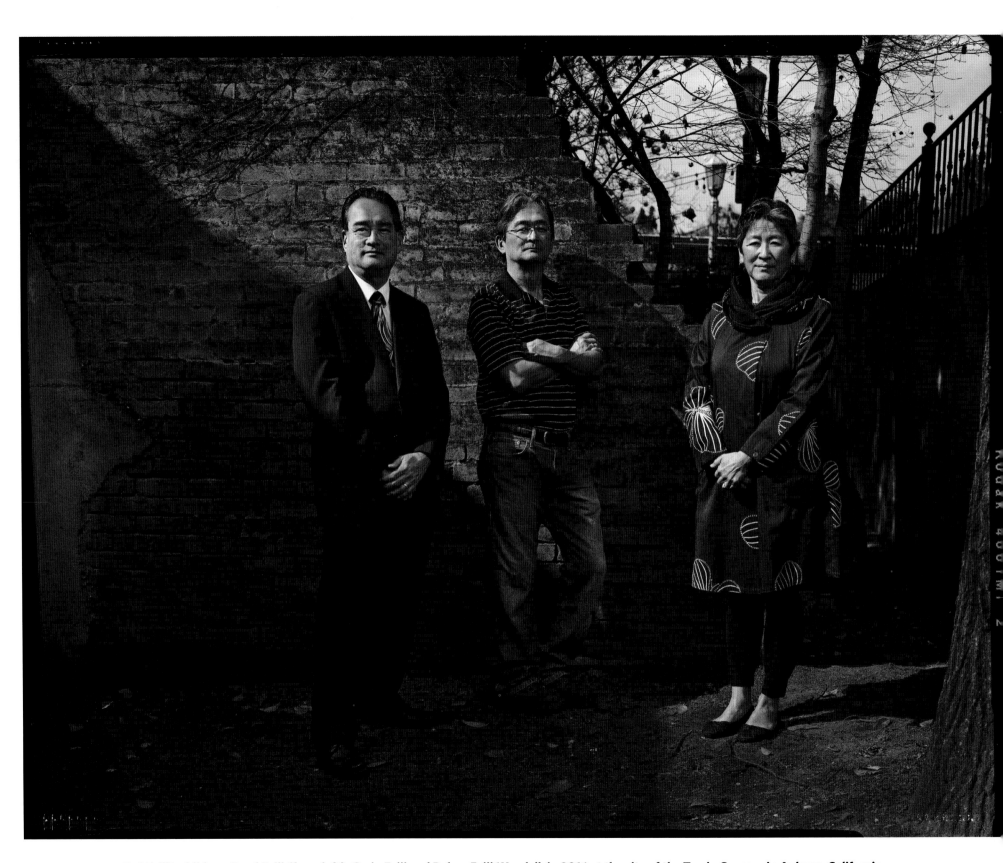

Ted Fujii's children, Reed Fujii (from left), Craig Fujii and Robyn Fujii Woodall, in 2016 at the site of the Tsuda Grocery in Auburn, California.

'Racism and fear drove the original order. I'm afraid it could happen again.'

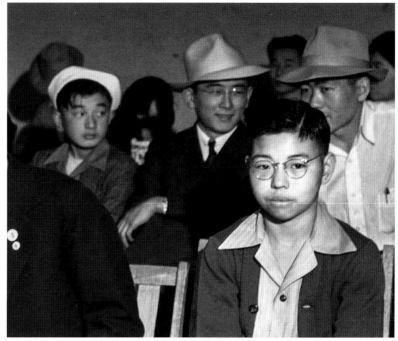

DOROTHEA LANGE, MAY 6, 1942 OAKLAND, CALIFORNIA

The background of the photo on page 60 shows Dewey Fujii (in sailor hat) to the left of brother Ted Fujii (in light fedora).

A few rows behind the Kitagaki family at the Wartime Civil Control Administration station in Oakland sat 14-year-old Ryunosuke Dewey Fujii and his 18-year-old brother Tetsuro Ted Fujii.

The Fujii family farmed in East Oakland and sold the flowers and vegetables they grew. But then the incarceration changed everything.

Tetsuro's daughter, Robyn Fujii Woodall, says her father talked about how desolate life in Topaz was. "When the wind came up, the dust from the desert landscape would rise and it would just choke you," she says. "So they would run for the showers or put handkerchiefs over their mouths."

But there were aspects of camp life that Tetsuro appreciated. "He mostly liked to talk about being able to get out and be a hired hand on a local sugar beet ranch or farm," she says. "They worked so hard that the local farmers really liked hiring these young Japanese men."

Tetsuro left Topaz for Chicago, where he became a machinist and met his future wife, Dorothy Tsuda, on V-J Day, the day the war in the Pacific ended. They were married in 1947, moved to Salt Lake City and then to Auburn in central California. Dorothy's brother restarted Tsuda Grocery, and Tetsuro became

his business partner.

Ryunosuke, meanwhile, worked for a photochemical supply company in Chicago and then set up a branch in Southern California.

Dorothy Tsuda Fujii, who declined to be photographed, says she and her family were on the move during the war—from Tule Lake in California to Jerome in Arkansas to Gila River in Arizona.

"We were just at the prime of our life and we had this experience, and then you just feel downgraded," Dorothy says.

Says daughter Robyn of her parents, "I find it remarkable that they don't seem to harbor any resentment about it. The effect it had was that they became very insular with the Japanese community."

Robyn, a nursing instructor, says Dorothy wanted her children to marry Japanese. "But out of the three of us, we're 0 for 3. All of us married *hakujins* [white people]. I don't think that's atypical."

Reed Fujii, a journalist at the *Stockton Record,* compared the context in which Roosevelt's Executive Order 9066 occurred to the state of the country today.

"Racism and fear drove the original order," he says. "I'm afraid it could happen again."

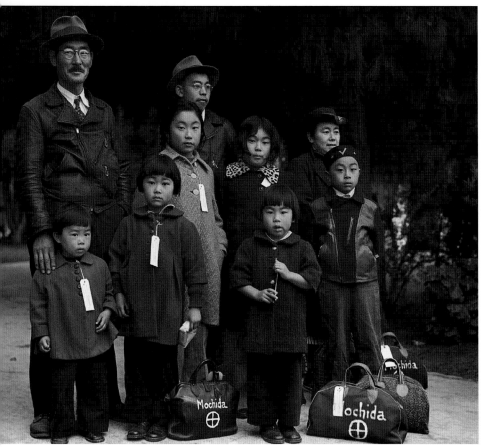

The Mochida family waited together. Front row: Hiroko, 3 (from left), Miyuki, 6, Kayoko, 7, and Tooru, 10. Back row: father Moriki, 45 (from left), Satsuki, 12, cousin Hideki, Kikue, 11, and mother Masayo, 41.

Before World War II, the Mochida family patriarch, Moriki, operated a nursery and five greenhouses in Northern California, raising snapdragons and sweet peas with help from the whole family.

That came to an end when they were shipped to Tanforan and later to Topaz.

For a kid, that wasn't all bad. Before Pearl Harbor, Tooru recalls, "I had to wake in the morning, open the fence to the greenhouses—that was my job—and right after school I had to come home." At Topaz, "They taught me how to play baseball and basketball."

But his sister Miyuki has vivid memories of her family's struggles during the incarceration. "Our parents' pride and dignity were taken away, and they didn't want it to reflect on the children," she says. "Now that I'm older, I think how brave these people were."

'Our parents' pride and dignity were taken away.'

In this picture, father Moriki displays a slight smile. "Yeah, he's smiling, like there was no problem," says Hiroko. "I guess he was accepting what was going on," she says. "Same with my mother. She had a peaceful look. It's just the kids had an apprehensive expression."

The family was split by the war. Two older siblings, raised in Japan by their grandparents, were stuck there after Pearl Harbor—and the distance persisted for years. "Some developed the feeling of abandonment," Hiroko says. "But it was the war."

After the war, the Mochidas returned to California, settling in San Francisco, where Moriki, then 48, became a maintenance man. His wife, Masayo, 44, worked as a housekeeper.

Hiroko grew up a wanderer who roamed the West—Wyoming, Montana, the Badlands—partly because she and Moriki had shared hours watching the western movies he loved. "My father was quite an adventurous man, so I could have gotten that from him."

Among her cousins was Fred Korematsu, whose advocacy would help bring about government reparations. He was "the independent one," Hiroko says, not close to her and her siblings. Yet they had something in common. "I was all out, adventuring and exploring," she says. "Fred was exploring and standing up for his rights."

Moriki, who was once been so enthralled by the American West, seemed to sour on America later in life. He served in the Army during World War I and was promised citizenship, but never got it. In the 1950s, he got a shot at citizenship—but passed. "I guess he got embittered," Hiroko says.

Wife Masayo, by contrast, spent a decade learning English and earned her citizenship after the war.

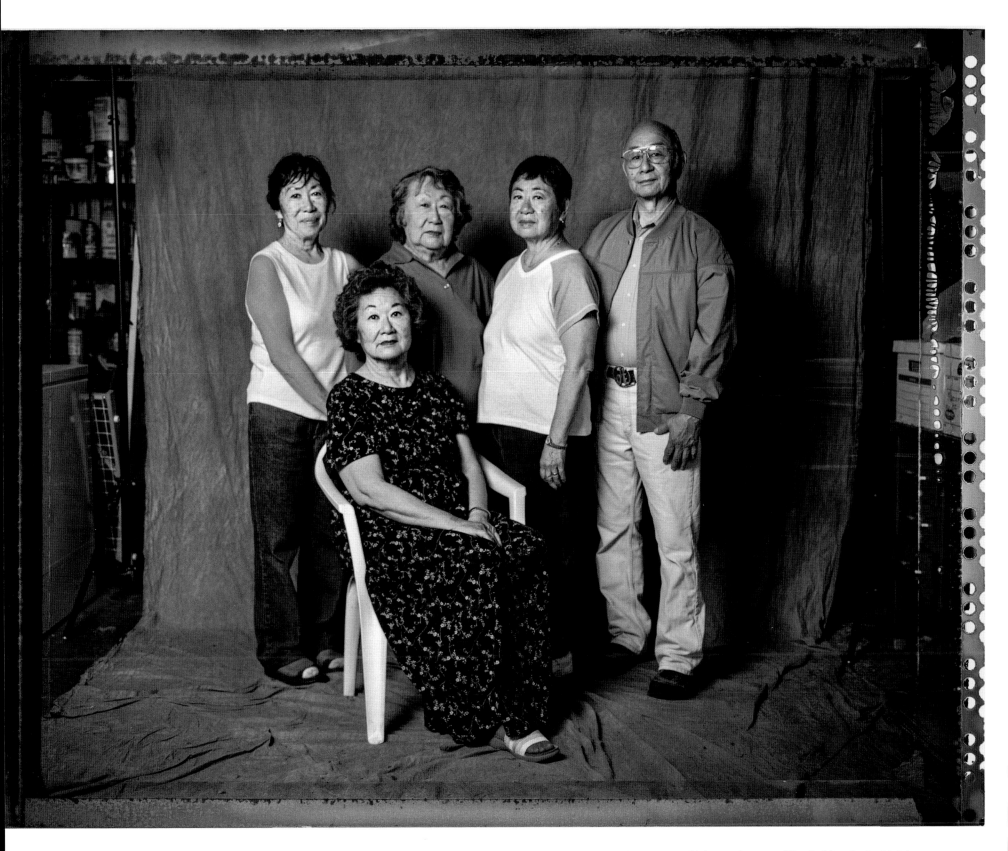

Hiroko Mochida, 69 (from left), Miyuki Hirano, 72, Kayoko Ikuma, 71, Satsuki Mae Ward, 75, and Tooru Mochida, 73, in Vacaville, California, in 2006.

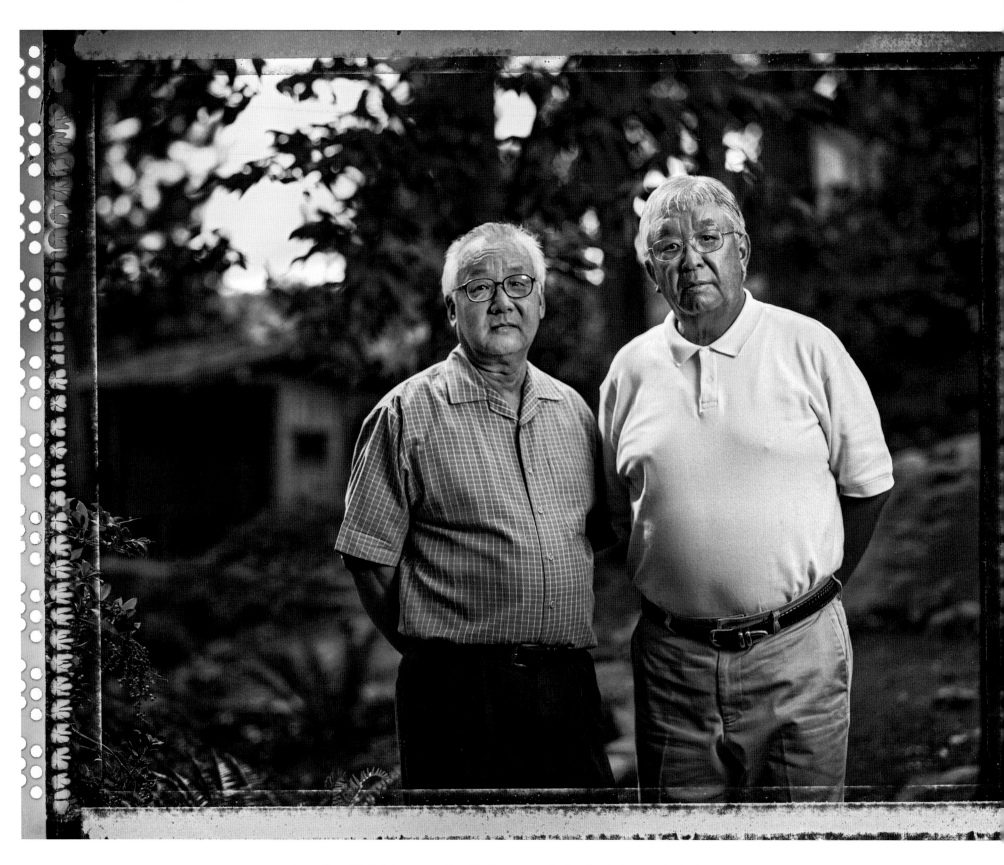

Jerry Aso, 67 (left), and brother Bill Asano, 70, in Portland, Oregon, in 2006.

'And just when he was about to find his pot of gold, the bomb drops and wipes him out.'

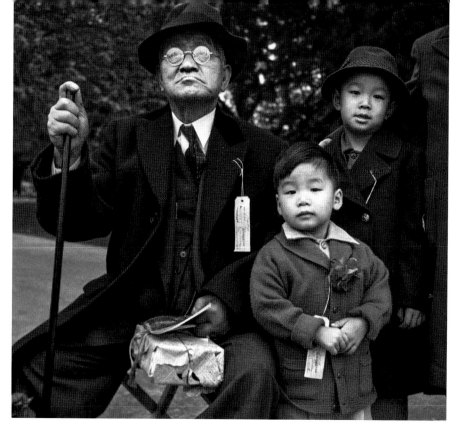

Jerry Aso (center), 3, brother Bill, 6, and grandfather Sakutaro Aso, 70.

Sakutaro Aso left Japan for America because he heard the streets in San Francisco were paved in gold, according to his grandson, Shigeo Jerry Aso. He worked as a carpenter, but long dreamed of owning a business.

One day, he boarded a streetcar that took him to Hayward, California, where he opened a laundry. His first pickups and deliveries were by bicycle. The Mt. Eden Laundry eventually employed 30 people. "And just when he was about to find his pot of gold, the bomb drops and wipes him out," says grandson Sadao Bill Aso.

After Pearl Harbor, Sakutaro Aso sold the business. His family was shipped to Tanforan, then to Topaz and finally to the detention camp in Amache, Colorado, known as the Granada Relocation Center.

Bill remembers the moment when the photo was taken. "It was a cloudy day, I remember everybody was getting ready to go. The strange part of it is we were all dressed up."

Adds Jerry, "Grandpa is in his go-to-church clothes with a tie on. I even have a little flower boutonnière. It's very clear that we will not do this and be ashamed of how we look. We will have pride in how we look."

Both brothers sensed their grandfather's feeling of loss. "My grandfather realized that something terrible was happening,"

Bill says, "and his life was never going to be the same." Says Jerry, "His dreams of coming to the United States, of making a life, of having his children working in this business, to support them all, were totally dashed."

Bill and Jerry's father, George Aso, had a calling. A gifted orator, George led a Seventh-day Adventist group at Topaz, and became a preacher after the war. Their grandfather clashed with George because he converted to Christianity despite Sakutaro's objections.

After the war, Bill experienced racism first hand. As his family checked into a cheap hotel, they encountered drunks who shouted, "Get those goddamn Japs out of here." That was a disturbing moment. "For the first time I really felt like an outsider." Bill and his brother became dental professionals. Bill built an orthodontist practice and Jerry became a dentist. Along the way, Bill Aso changed his last name to Asano.

Their grandfather cleaned houses for a while, but later lost his legs to diabetes.

Toward the end of his life, Grandfather Sakutaro became a Christian, baptized by his son. "It was a shock to everybody," Bill says.

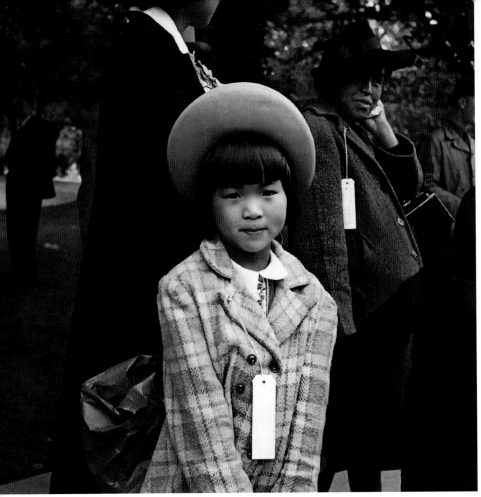

Mae Yanagi, 7, waited for transport to the Tanforan Assembly Center.

Joining the Mochida family, grandfather Sakutaro Aso and many others on the streets of Hayward, California, was Mae Yanagi, dressed in her best clothes as she waited with her pregnant mother to be bused to the Tanforan Assembly Center.

Mae was one of eight children of Kinuye and her husband, Satsuo. Born on the Japanese island of Kyushu, Satsuo immigrated to the United States in 1916 by way of Mexico. He worked at a Los Angeles hotel before moving to Hayward on the East Bay outside San Francisco, where he started Meekland Nursery in the 1920s.

By 1941, the nursery boasted four or five greenhouses growing carnations. Kinuye's specialty was floral arrangements and orchids. "It was hard work," Mae recalls. "All but the youngest kids pitched in."

After Pearl Harbor, Satsuo arranged for a businessman to care for their house and nursery. The family spent several months in a Tanforan horse stall before being sent to Topaz in Utah.

Mae remembers the dust.

'He never accepted the premise that they were doing it for our benefit.'

"It was everywhere, I mean thick, maybe four or five inches, you could not get away from it."

Her father built furniture and room dividers for privacy in their Topaz barracks. Everyone was issued a cot, but detainees had to improvise if they wanted anything else.

The family adapted and accepted the conditions in Utah. "I think for so long it was like internment didn't exist because we didn't talk about it. We were too young to understand what was going on and how to deal with it, the internment."

Mae has not forgotten her first Utah winter. "That was my first experience in snow, and it was exciting." But the novelty soon faded as the snow mixed with the thick desert dust. "It would get kind of mucky. You'd tamp down on it and then it became like a crust."

After the war, the Yanagis returned to Hayward with plans to re-establish their nursery. Satsuo entrusted their house and business to a local businessman, but that trust was betrayed. "When we got back, it had been sold," Mae says. "Somebody else was living there."

The family settled in nearby Berkeley, where Satsuo started over as a gardener. Mae's mother, Kinuye, took jobs as a domestic. In the summer, she worked on fruit farms with relatives.

Mae attended high school in nearby Albany, graduated from UC Berkeley, and taught school in Berkeley and Mountain View, California. She moved briefly to the Washington, D.C., area, when her husband got a job with the Labor Department. They returned to the West, and Mae taught in Sacramento until retiring in 1994.

The incarceration took the heaviest toll on her father. "He had the most difficult time with the relocation," she says, "and he never accepted the premise that they were doing it for our benefit. For many years he was very angry."

Mae wishes her family had talked about what they went through. "It certainly would have made it easier, because it would acknowledge that it had happened."

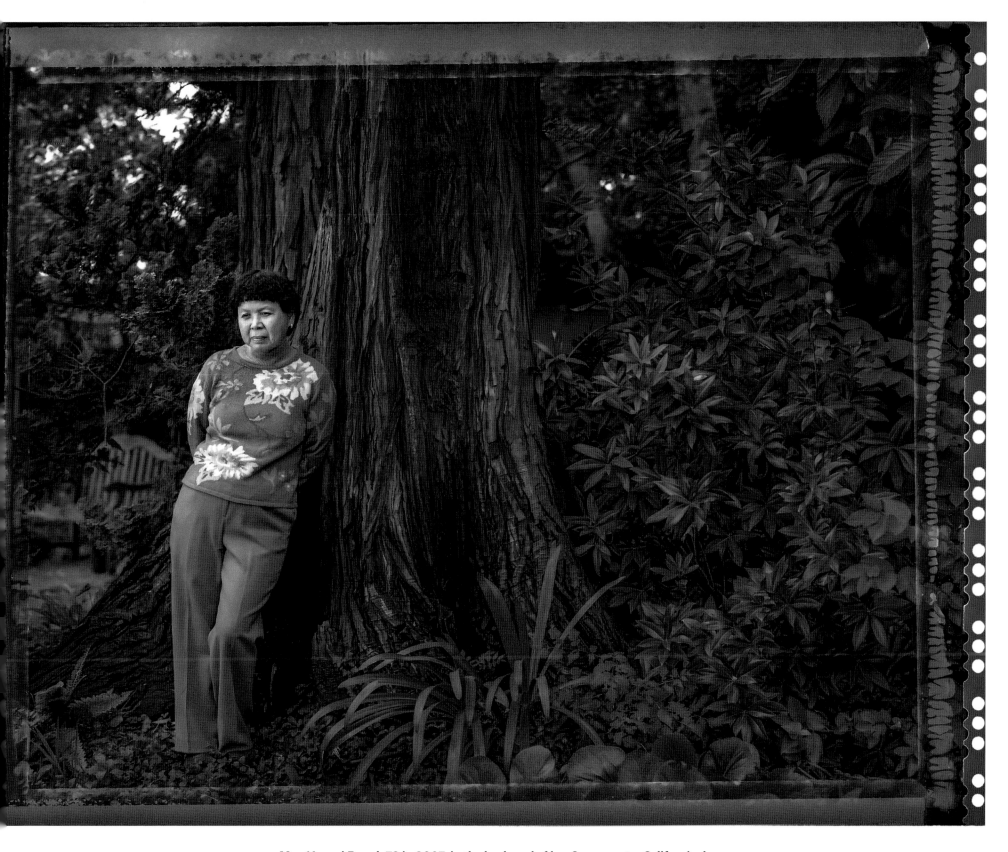

Mae Yanagi Ferral, 73 in 2007, in the backyard of her Sacramento, California, home.

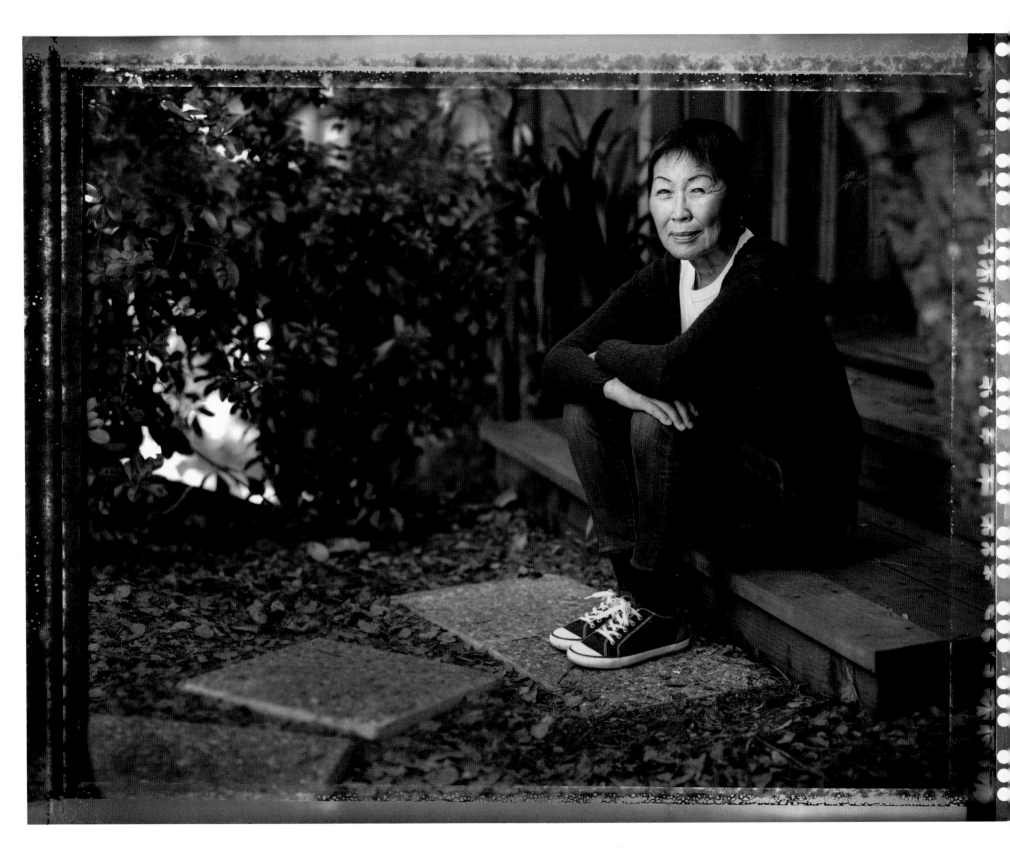

Jane Yanagi Diamond, 75 in 2014, in Carmel, California.

'I taught U.S. History, but I couldn't talk about the internment.'

Standing right behind Mae Yanagi in the photo on page 68 was her mother, Kinuye Yanagi, who came to downtown Hayward with her husband, Satsuo, and three other children: Miyeko, 17, Frank, 5, and Jane, almost 3. Kinuye was pregnant. Her son Yoshio was born two weeks later in a horse barn at the temporary detention center of Tanforan.

From there, the family was shipped by train to a more permanent camp in Utah.

"We were in this train and the shades were pulled down," says Jane, now Jane Yanagi Diamond, "and I remember that it was very hot, and my mother had marshmallows to feed us. So we got sicker than heck in that train. And then it was in the desert someplace the train stopped."

"Someplace" turned out to be the Topaz Relocation Center.

The family lived in a room in Block 9 that was divided down the middle by a piece of hanging cloth for some semblance of privacy. They kept chamber pots in the closet so they wouldn't have to go to the outhouses at night. Jane and her siblings spent some of their time in Topaz going to school. Her older brothers, Keishi and Tak, graduated from high school.

After the family's release, Jane's father found work as a gardener and her mother cleaned houses.

"We lived in Berkeley on Sacramento Street, and my little brother and I were the only two Japanese kids in the area. And, of course, my mother and father were cleaning our schoolmates' houses and gardens. So that was not a pleasant thing for me." Jane says she encountered "a tremendous amount of prejudice" in the Bay Area.

Other children tormented Jane and her siblings. "I learned this as a kid that you just can't keep yourself in gloom and doom

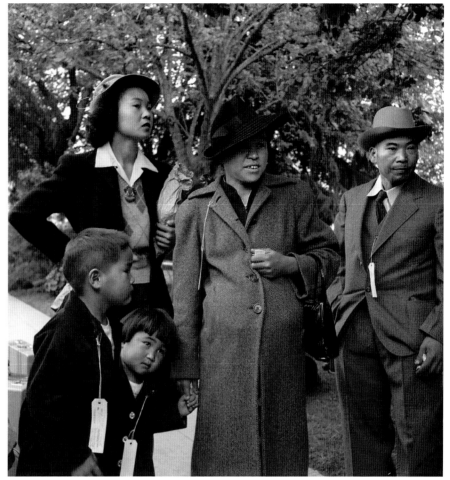

DOROTHEA LANGE, MAY 8, 1942, HAYWARD, CALIFORNIA

Jane Yanagi, 2, peeked out as her family waited for the bus.

and feel sorry for yourself," she says. "You've just got to get up and move along, and I think that's what the war taught me."

When the children called her names, Jane got tough. "They said it, and I'd beat them up. If they said it to my little brother, I'd beat them up. I became as tough as my mother. So they stopped."

That credo of toughness carried over to her adulthood as a high school guidance counselor and teacher.

"You know, when I was counseling," she says, "I would say to the kids when they'd come in with their sad stories, I'd say, 'I know it's tough, but you know, it's going to toughen you up and it's going to be a lot easier to make it, because you'll know that you can do it.'" But she found herself having trouble talking about her experience. "I taught U.S. history, but I couldn't talk about the internment," she says. "My voice would get all strange.

"I think I'm able to talk better about it now."

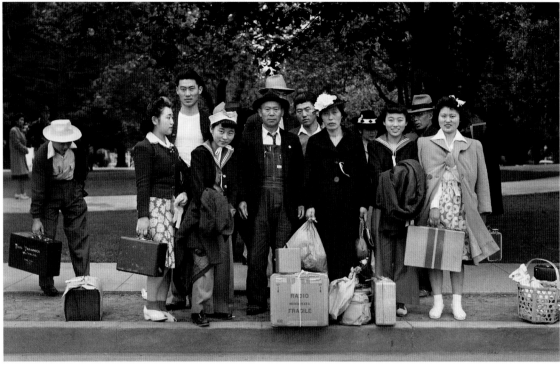

Kimiko Takeuchi, 17 (in flowered skirt), and her family wait for a government bus to take them away.

'We were not too happy about talking about it.'

Kimiko Takeuchi stood with her family along a curb in downtown Hayward, California.

Her family formed the front row of a small group of people waiting to be picked up for the Tanforan Assembly Center. Her father and mother—Tamehisa, 59, and Chika, 54—held the center spot. Her siblings ranged in age from her 13-year-old twin sisters to her 25-year-old brother.

Kimiko was a junior in high school when Pearl Harbor was bombed. Her parents emigrated from Kanagawa, just south of Tokyo, to California, and her father held a job on a San Leandro farm that grew tomatoes, peas and cucumbers. She and her older siblings all worked there.

When she packed for Tanforan, she brought two suitcases that held a pair of kimonos among her clothes. From Tanforan, the family was sent to Topaz in Utah, where Kimiko was able to indulge her passion for dance.

Dance helped her: "It does help you take your mind off things a lot," she says. "It was kind of like an escape."

Despite the barbed wire and confinement of camp life, Kimiko says, "I didn't feel like I was in jail. Maybe some of the other people felt that way."

She remembers the community feeling at Tanforan and Topaz. "When you're all in camp, you're all together and you can meet each other," she says. But she also remembers the indignity of camp life. Inmates were forced to stuff hay into canvas bags to create makeshift mattresses. She remembers the smell. It was pervasive.

After the war, the Takeuchi family returned to San Leandro. Kimiko's father returned to his job on the farm. And the family returned to their tiny house.

Kimiko moved to San Francisco to learn how to type. She worked as a domestic in the city's wealthy Presidio Heights neighborhood and as a waitress at the Hotel Carlton.

That is where she met Jimmy Wong, whom she planned to marry.

Her parents were distressed because her future husband was Chinese American, but Kimiko persisted. "They had to accept it," she said. "They can't throw me out."

The Wongs raised four children in San Francisco's North Beach neighborhood near Chinatown. The couple never discussed Kimiko's experience during the war.

"We were not too happy about talking about it," she says. "I guess we didn't think it was that important because we were like kids, you know."

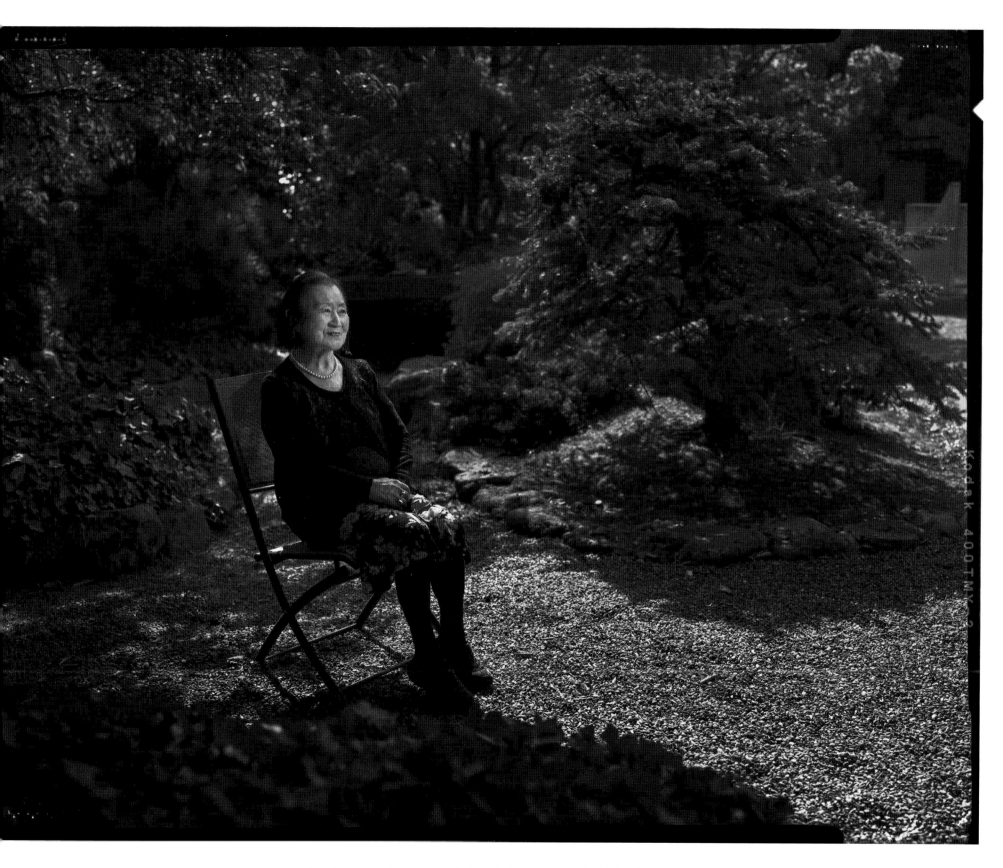

Kimiko Takeuchi Wong, 92 in 2017, at her Hayward, California, home.

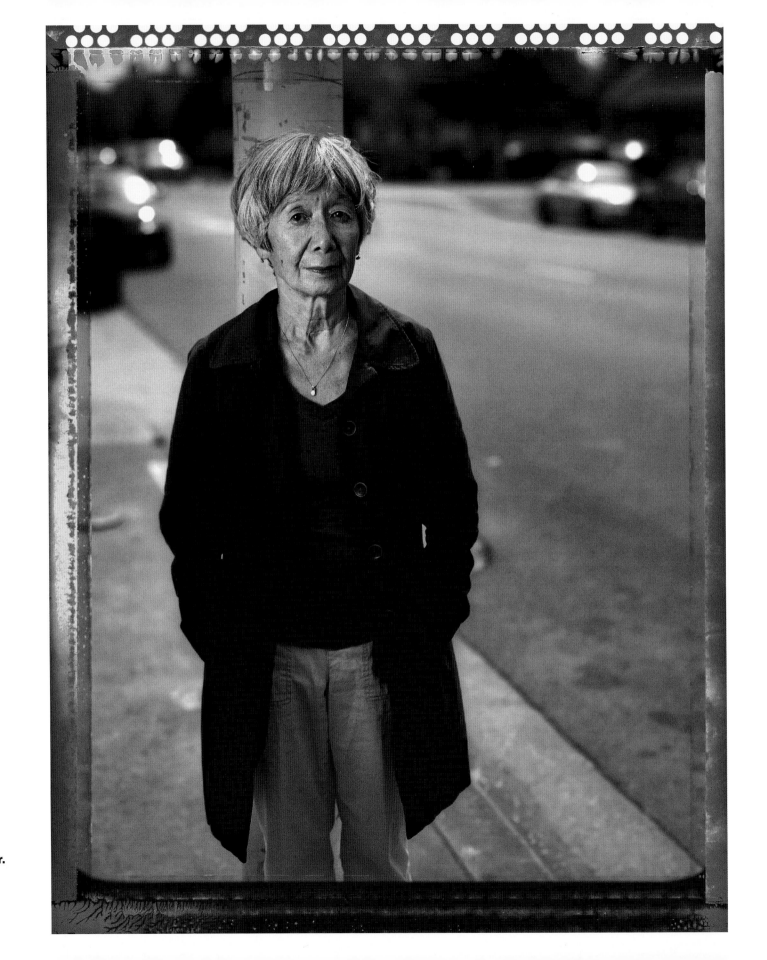

Ibuki Hibi Lee, 75 in 2012, on C Street in Hayward, California, where she and her family were picked up and taken to the Tanforan Assembly Center.

74

'We saw big piles of hay in the room, and we thought it was for the horse to eat.'

Exactly seven decades after being picked up by bus and forcibly removed from Hayward, Ibuki Hibi Lee returned to her hometown.

In 1942, she stood with her mother, Hisako Hibi, and was accompanied by her father, George Matsusaburo Hibi, and her brother, Satoshi. She clutched a doll.

Hibi was 5 on that spring day. The family lived in a horse stall in the converted Tanforan racetrack. "We saw big piles of hay in the room, and we thought it was for the horse to eat," Ibuki says. "We were told it was to stuff mattresses for sleeping."

Her father, an artist, was born in Shiga Prefecture in central Japan. At age 20, he immigrated to the United States, landing in Seattle in 1906 and later moving to the San Francisco Bay Area.

He enrolled at the California School of Fine Arts (now the San Francisco Art Institute) and contributed drawings and cartoons to newspapers from San Diego to Seattle. He was one of the founders of the East West Art Society, and gained a following with his oil paintings and prints.

While in school, he met and married another artist, Hisako Himizu. Together, Hisako and George set up art schools at Tanforan and later at Topaz, and documented the family's experience.

Hisako produced 70 paintings of camp life that later were exhibited at the Japanese American National Museum in Los Angeles. George painted, too. On the back of one of one of his paintings, he wrote a poem, "Topaz 1945."

It was a hard winter in Topaz and the snow lies deep
Big coyote came out of the desert right up to the camps
And no one dared to get out of the doors.

The coyote was a metaphor for the FBI.

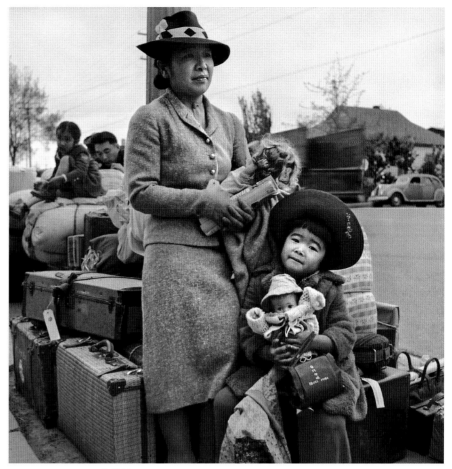

DOROTHEA LANGE, MAY 8, 1942, HAYWARD, CALIFORNIA

Ibuki Hibi, 5, and mother Hisako with belongings.

George Hibi stopped painting soon after his family moved from Topaz to New York City's Hell's Kitchen. Unable to support themselves as artists, George and Hisako did odd jobs—including painting plates and even cribs. George's last job before his death from cancer in 1947 was painting lampshades.

Hisako supported herself as a seamstress, and became a U.S. citizen in 1952. Daughter Ibuki kept her mother's work alive by editing *Peaceful Painter: Memoirs of an Issei Woman Artist,* published in 2004.

"She said this is the best country in the world," Ibuki says of her mother, who died in 1991.

Ibuki, who kept her doll, studied nursing and became a physical therapist. She never forgot about her time in detention.

"You have to think of camp from the view of injustice," Ibuki says. "And it was really an injustice to Japanese Americans and those who were citizens. It had to do a lot with economics, racism and politics."

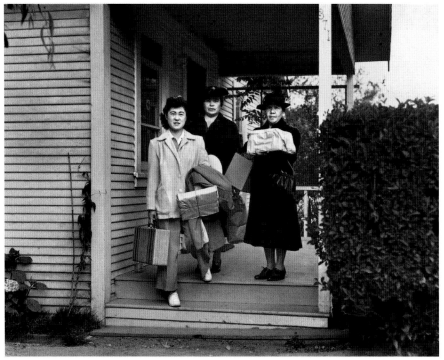

Tomoe Otsu led mother Yoshino Otsu (middle) and Sugino Ushijima from their home.

The day after Dorothea Lange photographed families waiting in Hayward, she traveled down the East Bay to Centerville (now part of Fremont, California) to witness another day of forced removal.

Lange started her morning photographing a family leaving their home. Here she saw 25-year-old Tomoe Otsu leading her mother, Yoshino Otsu, and a family friend, Sugino Ushijima, to the location in town where they were ordered to report.

Tomoe was working as a beautician when the war broke out. Her mother arrived in the United States in 1913 from Fukuoka, Japan, as a picture bride. Young women were sent to the United States via matchmakers to marry immigrant laborers. Yoshino became a single parent when her husband died. She and daughter Tomoe moved into the home of the Ushijimi family in Centerville hoping to avoid the incarceration. Instead, they were sent to Tanforan, Topaz and finally Tule Lake.

At Tanforan, Tomoe met Susumu Tomine while playing music at a friend's house. It was love at first sight. Tomoe borrowed a dress, and they were married on September 15, 1942, while still in the temporary detention center. They went on to Topaz as husband and wife.

"When they'd speak of anything, they're all positive things,"

says their son, Eugene Tomine. "They went to dances. My father worked in the kitchen and my mother worked as a waitress, and they got $16 a month for working. My dad was quite an artist, so he would paint watercolor calendars."

When they were transferred from Topaz to Tule Lake, the people on their block threw a party for them. "They had these little invitations and a little program for the party, and they sang 'California, Here I Come' and 'Sing, Sing, Sing' and 'Auld Lang Syne' in Japanese and 'Aloha Oe,'" Eugene says.

After the war, Susumu became a gardener and Tomoe raised their family. As for their children, Amy taught in elementary school, Naomi was employed as an executive account manager, Chris worked as a professor of civil engineering, and Eugene became a lawyer.

He looks back at the incarceration and gives credit to the second-generation Japanese who stood up in the camps against the military draft.

"I give a lot of credit to the resisters," he says. "They really had a hard time, and even today I think they're still looked upon with disdain in the Japanese community, certainly in the Nisei community. They were really the courageous ones. We never learn. We don't learn from history, and it probably could happen again. It wouldn't surprise me if it did happen, but I certainly hope it doesn't, that there are enough people that would stand up against it."

She and her daughter moved to Centerville hoping to avoid the incarceration.

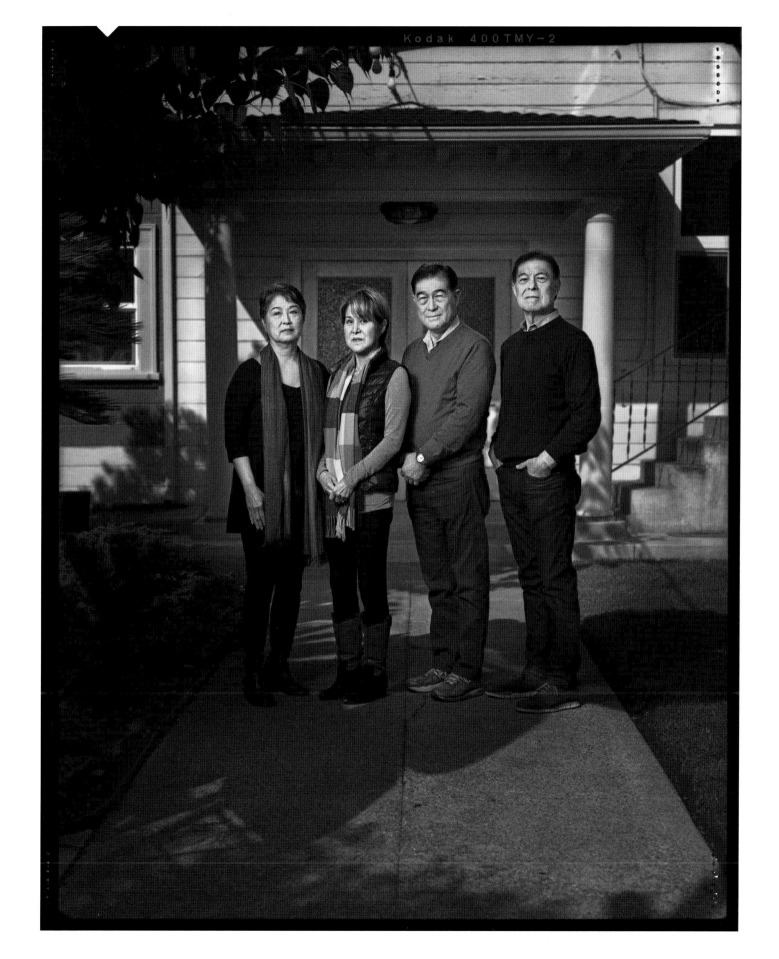

Kodak 400TMY-2

**Tomoe Otsu
Tomine's
children: Amy
Tomine (from
left), Naomi
Ellis, Eugene
Tomine and Chris
Shinya Tomine
in Alameda,
California, in
2016.**

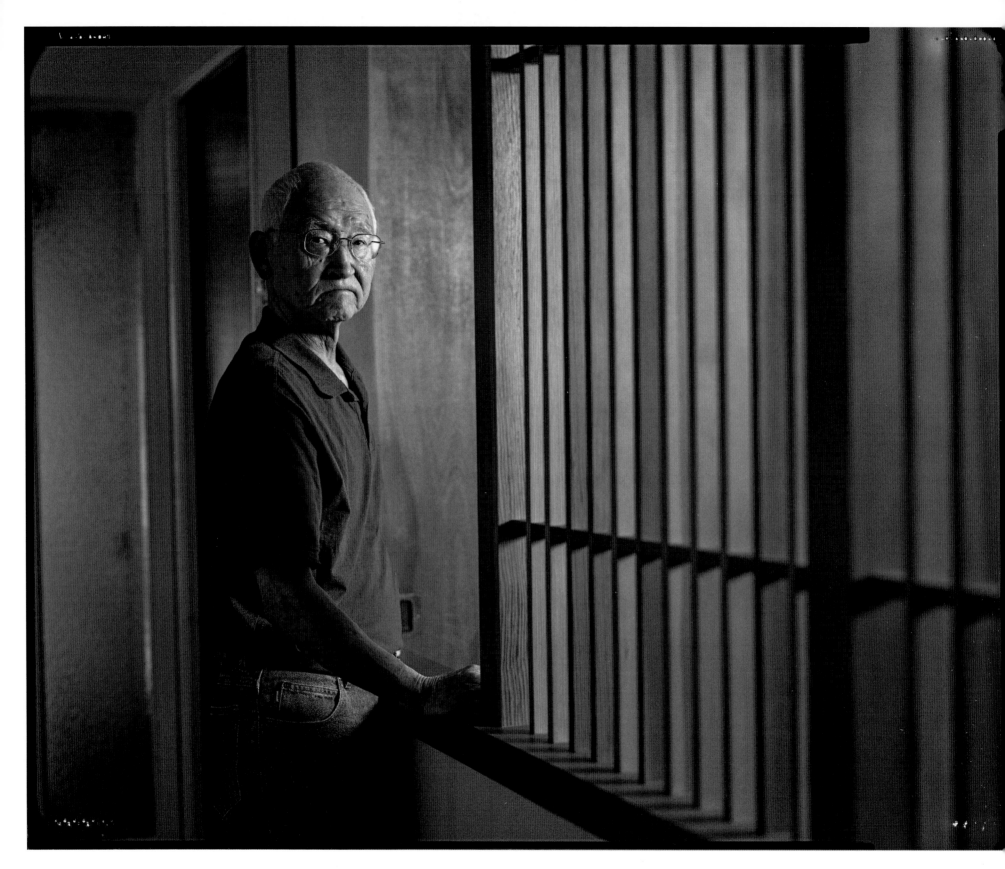

Kiyoshi Katsumoto, 79 in 2015, in his El Cerrito, California, home.

'That's what we were reduced to. A number.'

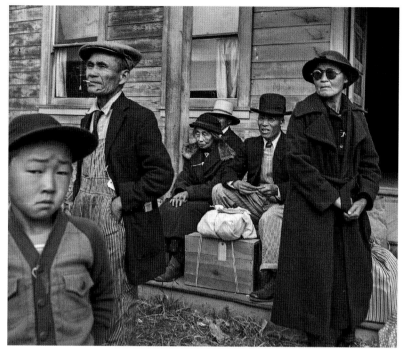

Kiyoshi Katsumoto, 6, waited with others in Centerville, California.

Japanese Americans were lining the streets of Centerville waiting to be taken to Tanforan by the time Dorothea Lange arrived with her camera.

Six-year-old Kiyoshi Katsumoto stood in front of his second cousin, Kizuro Ogata. Ogata's wife, Sute, sat on the steps of a house wearing a black hat and fur collar, next to widower Heihachi Kumamoto.

Kiyoshi, a second-generation Japanese American born in Oakland, was living on a farm that his family was sharecropping in Decoto, now part of Union City.

"I remember that photograph quite well," he says. "We had all been ordered to go and assemble in Centerville. I was more bewildered than anything else, because this was all a new experience."

He had begun kindergarten a few months earlier. Soon after Pearl Harbor, the principal of his school put Kiyoshi on his lap and had him sing "God Bless America" in front of the school assembly.

Kiyoshi's family lived in military-style barracks constructed at Tanforan rather than in the stables. But he explored the former horse barns one day, peeking into one dimly lit stable and seeing a woman wailing on a cot. He noticed horsehair embedded in the wall. "With all the manure and everything else and the rain, it was just a sea of muck," he says. "It just stank terribly."

His memories of Topaz are just as vivid. Like everybody else, he remembers the dust blowing through the floorboards and working its way into the inmates' hair and clothes. He remembers the mattresses stuffed with straw. His family's number was 21365, he says. They lived in Block 36, and he walked to his school in Block 42.

"That's what we were reduced to," he says. "A number."

Kiyoshi's parents were stoic. He remembers his mother saying, *"Shikata ga nai,"* "It can't be helped."

"It was a concentration camp by any means or any name you want to put on it," he says. "I mean, we were prisoners. We did not have freedom to go and walk wherever we wanted to. We were confined within the borders of the barbed wire and guard towers."

After the war, the family resumed sharecropping in California on the farm of Peter Decoto, who visited the family at Tanforan a few times, bringing oranges and other treats. The Katsumotos reclaimed the two new tractors and other equipment they had purchased before the war. The tractors were in bad shape because a neighbor had worn them out.

"I consider myself lucky that we were going back to a place that was predominantly Mexican and Spanish," Kiyoshi says. His friends rescued him when a white kid was shoving him around. "They beat the tar out of this guy, and it's the last time that anybody ever bothered me," he says.

After he graduated from high school, Kiyoshi took over the ten-acre Fremont farm that his family bought. He got a degree from San Jose State in 1964 and a Ph.D. in chemistry from UC Berkeley in 1968, the same year he got married. He worked at Chevron for 29 years.

"We need to guard our freedoms and our constitutional rights very carefully and closely," he says. "It's still a matter of people, of their feelings, of their emotions, that are going to drive things."

'It was very hard on my dad. How do you start a new life out with nothing?'

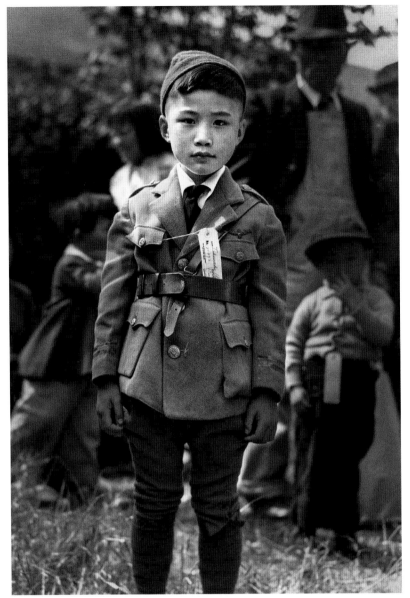

Mamoru Takeuchi, 6, dressed in an Army uniform.

Mamoru Takeuchi was trimming roses with his father in their garden in Alvarado, California, when they heard about Pearl Harbor. "We were listening to it on the radio," Mamoru recalls. "At that time, my father said, 'God, these Japanese people are stupid. Don't they realize how big America is? They're never going to win the war.'"

Later that day, a car pulled up to their driveway. Men in suits came into the house and took away his father, Jingo Takeuchi. Jingo, who left Japan at 18 in 1906, ran a produce stand and taught at a Japanese language school—which is likely why he was under suspicion. Like thousands of other Japanese-born men and women in America, Jingo was accused of being a spy in the first few days after Pearl Harbor.

Months later, Mamoru, his mother and three younger siblings were sent to Tanforan and then to Topaz. In 1944, the family was taken to the Department of Justice's Crystal City camp.

His mother died a month after the war ended, just before the family was to be released. "And she was saying, 'Thank God, we could go home now,'" Mamoru recalls.

"It was very hard on my dad," he says. "How do you start a new life out with nothing? He lost everything because of the war happening. Lost his land; he lost everything. So he was, I would say, a lost person at that time without being able to recover."

Jingo became a landscape gardener in Los Angeles and focused on getting his kids to adulthood. He died at age 66, when Mamoru was 18 and a senior in high school.

"You know, when I really got to know my dad was after World War II," Mamoru says. "By then, he was a broken person basically." Mamoru married at age 21 and bought a service station garage in Santa Barbara, which was a largely white Southern California town. It wasn't a welcoming place.

This is what he would hear: "You're a Jap. Get out of here. We don't want you."

But Mamoru understands what was behind the hatred. "These people's children were killed in the Pacific wars, so it's a big, deep prejudice against Orientals at that time, or Japanese," he says. It took a long time, roughly ten years, before the racial antipathy dissipated and he was considered a part of the community.

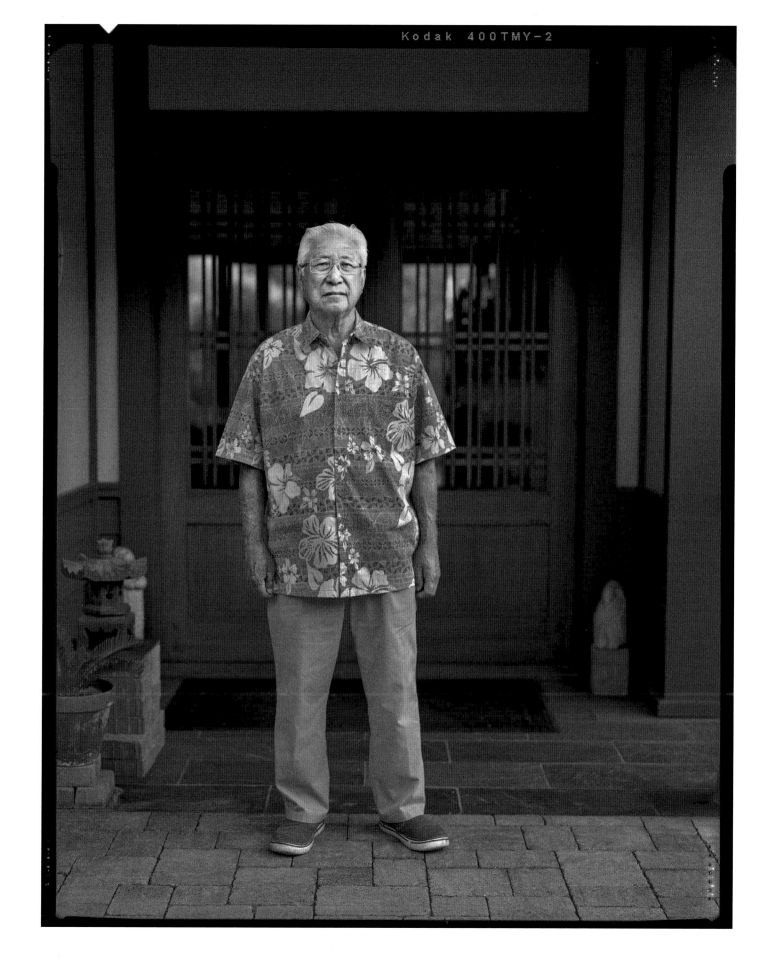

Kodak 400TMY-2

Mamoru Takeuchi, 80 in 2016, at his home in Santa Barbara, California.

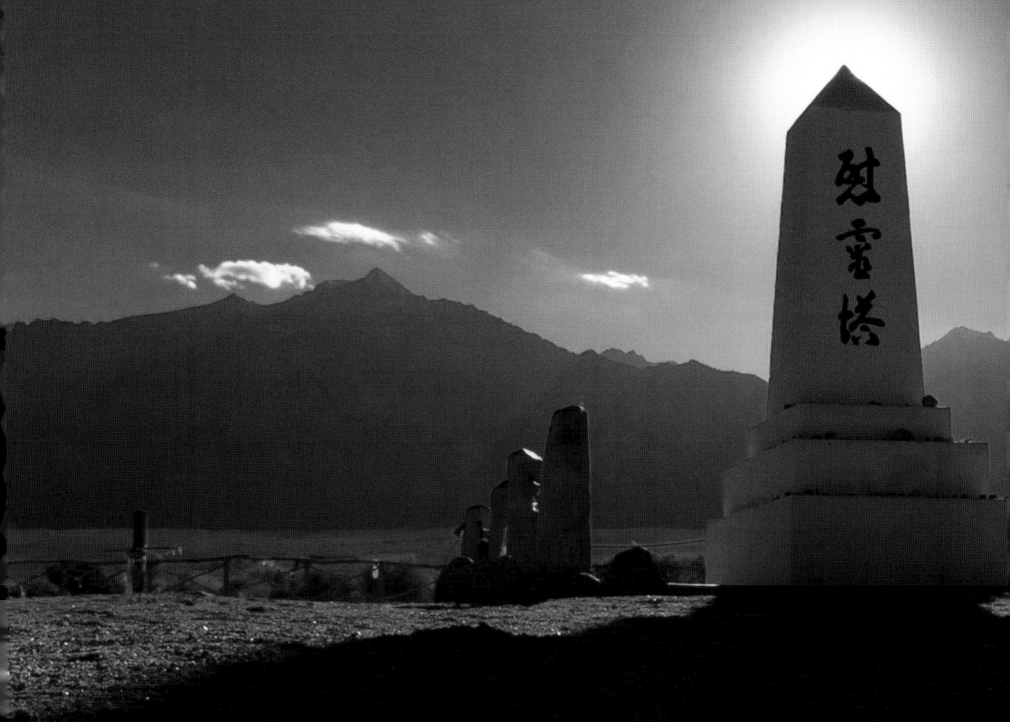

3

MONUMENT AT MANZANAR CEMETERY, OWENS VALLEY, CALIFORNIA

It's the brutal wind and unrelenting light that strike you at the Manzanar Relocation Center. They make you think of the challenges faced by 10,000 Japanese Americans banished there and the 100,000 more at the nine other camps.

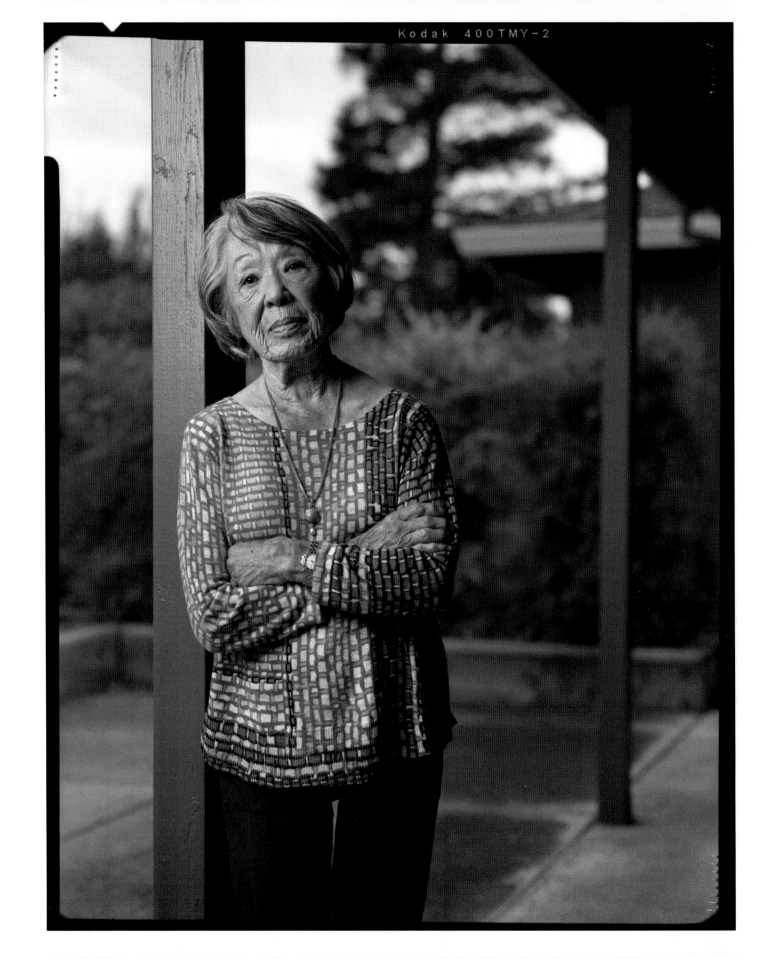

Dorothy Takii Hiura, 93 in 2017, at her home in San Jose.

'I didn't understand what the whole thing was about.'

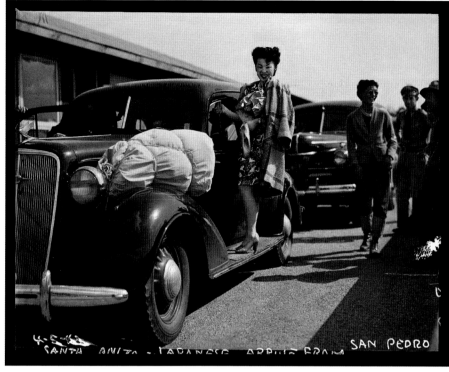

Dorothy Takii, 18, arrived at the detention camp in high spirits.

The photograph of Dorothy Takii arriving at the temporary detention center at the Santa Anita horseracing track seems incongruous. In high heels and a carefully styled hairdo, Dorothy rode into the detention center on the running board of her family's Chevrolet.

"I felt like something exciting was happening," she recalls. "I didn't understand what the whole thing was about, but it was interesting. I was going to change places to live."

The young woman uprooted from San Pedro, California, found life at the racetrack near Los Angeles to be "quite a comedown." But Dorothy says she remained upbeat and resilient during World War II as she and her family were sent to the Jerome Relocation Center in Denson, Arkansas.

The incarceration allowed her to live in a Japanese community for the first time, which she found comforting, and to leave California, another first. One more advantage: Dorothy's strict parents became lax about her dating life. They figured camp posed no dangers. There were dances and bands and pop music—songs like "Don't Fence Me In."

Dorothy especially loved USO events, where she would socialize with Japanese-American soldiers from the 442nd Regimental Combat Team training at Camp Shelby, Mississippi, a long bus ride away from Jerome. She was also part of a letter-writing campaign for troops overseas.

Born in Alameda, California, near Oakland, in 1923, she moved with her family to almost 400 miles south to San Pedro seven years later. Dorothy was a freshman at Compton Junior College and on her way to church with her family when they heard that Japan had bombed Pearl Harbor.

Dorothy left Jerome for Chicago in 1943. Like others, she was allowed to leave camp for the Midwest and East if sponsored— and Dorothy got sponsorship letters from her sister and brother-in-law, a minister.

In Chicago, Dorothy met her future husband, Thomas Hiura, who grew up on an apple farm in California. The couple raised two children, and returned to California. Thomas opened a dental practice in San Jose's Japantown.

Dorothy never discussed the incarceration with her son and daughter.

"I never felt like it was something that they needed to know," says Dorothy, who assumed they would figure it out eventually.

Her daughter, Barbara, would sometimes hear Dorothy talk about camp with friends. "I was like, Girl Scout camp? Boy Scout camp? I had no clue," Barbara says. "But they wanted us to become Americans. They didn't want us to face racism or hatred of any kind."

And even though Dorothy enjoyed camp life, she is convinced the incarceration was wrong and is pained by the ordeal her parents went through.

"They lost everything," she says. "Everything that they had worked hard to build and buy."

Jeanne Konno, 19 (foreground), ironed at a detention camp.

'Then we got to camp and saw all this barbed wire and everything.'

Tomiko Jeanne Konno remembers driving to the Pacific International Livestock and Exposition Center, the temporary detention center for Japanese Americans in Portland, Oregon.

She was with her older sister and it was a gorgeous day in May 1942.

"I think things are beautiful where somebody might not think so," she says. "And so, I thought, 'Oh, the rhododendrons are blooming.' Then we got to camp and saw all this barbed wire and everything."

Jeanne graduated from high school in 1941. She hoped to go to college.

"I thought, well, if I worked and could earn enough money, I could go to school—and that's when the war turned up and turned everything upside down."

Pearl Harbor was a devastating day. Her family turned in their hunting guns and little box camera and spent years in camps. From Portland they were sent to Heart Mountain Relocation Center in Cody, Wyoming. Jeanne's sister left camp to work as a nurse and her stepfather was hired by the Spokane, Portland and

Seattle Railway. Jeanne and her mother relocated to the Minidoka camp in Idaho to be near him.

As the war wound down, Jeanne was released to work for the government's War Relocation Authority helping returning Japanese Americans resettle in Portland.

She married Sam Isamu Shioshi in August 1945, and raised six children in Portland. She didn't talk to them about being in camp.

"I felt it was a prison. It was a shameful event," she says. "But on the other hand, I always felt it was a learning experience, going on and getting to know people and broadening your own experience."

Before the war, Jeanne says, her family tried to be model Americans.

"My mother used to say, 'When you're in Rome, you do like the Romans.' So, actually, we really didn't have very much Japanese culture going on for us. So when we went to camp, it was quite a change. It was really a shock, a little different."

There was no sense of outrage when the family learned they would be forced into camps. "We trusted the government. We believed, you know, that probably was the best. We were law-abiding citizens, so we didn't question things."

Her husband's father owned a nursery in Portland, which was not damaged during the war. "It was really, really quite nice, because it was all kind of fenced in, and the plants were still there when he came back," she says.

Despite the anti-Muslim sentiment that has surfaced in the United States since 9/11 and other terrorist attacks, Jeanne does not think a mass incarceration could happen again.

"I think people are a little more assertive today than we were," she says.

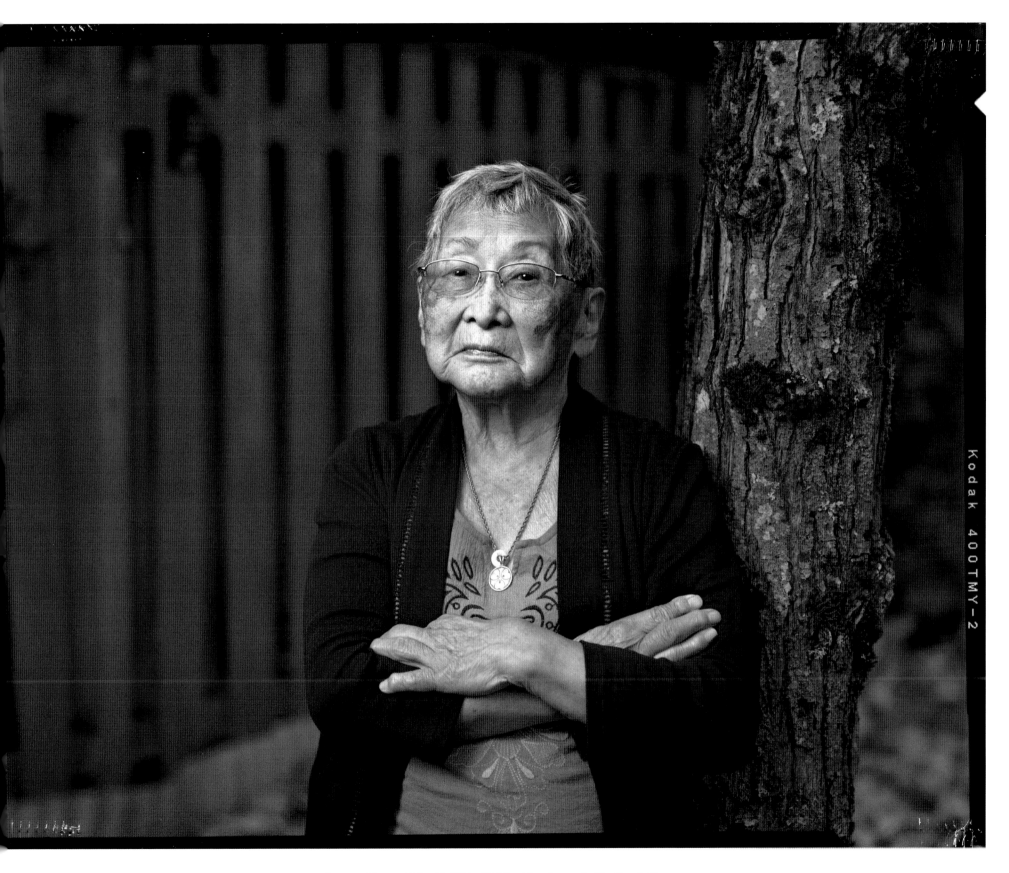

Jeanne Konno Shioshi, 92 in 2015, at her home in Portland, Oregon.

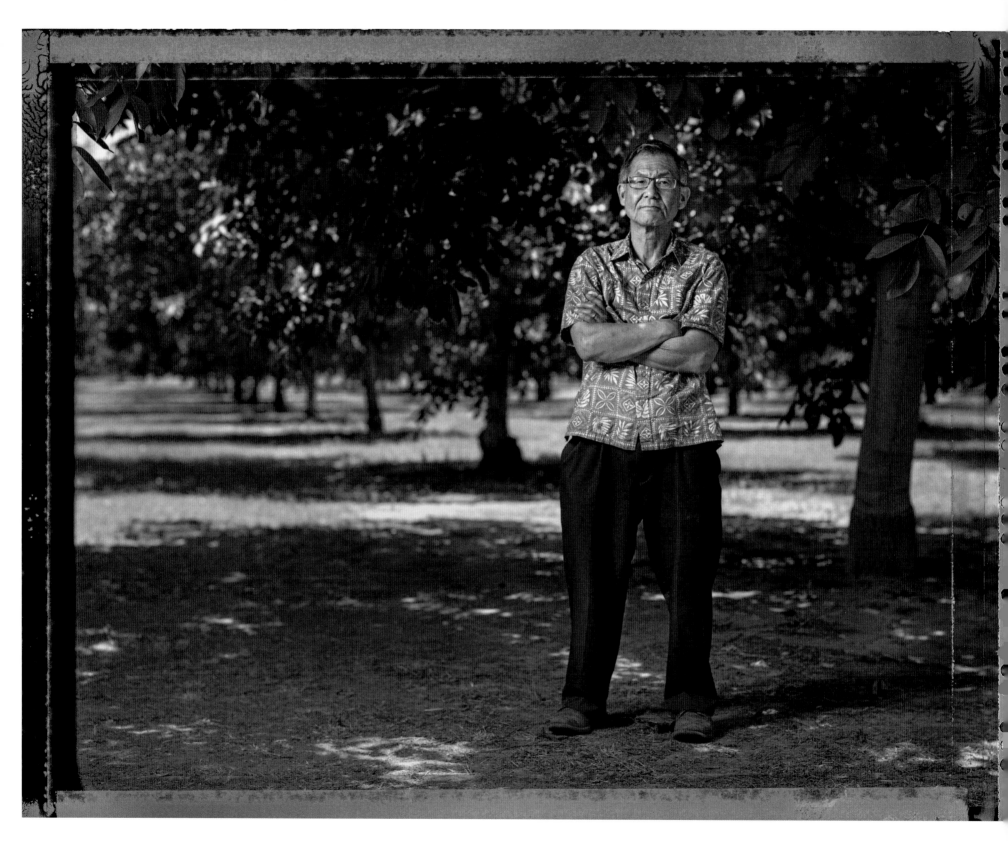

Mike Kato's son Howard Kato in Winters, California, in 2015.

'People don't talk about how difficult it was after they were released.'

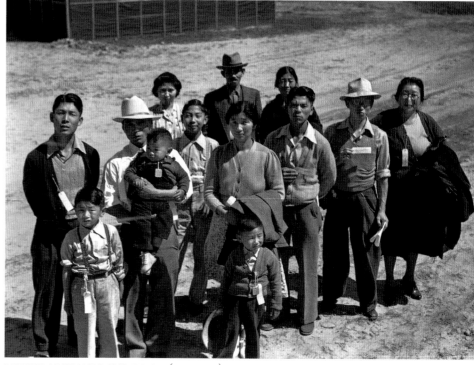

Mike Kato (third from the right) stood with his family and neighbors after arriving at a detention center.

Tadakazu Mike Kato was 24 years old when he arrived by train at the Turlock Assembly Center. He was in one of 43 Japanese-American families living in Winters, California, before the start of World War II—and was among only a handful that returned after the war.

Mike was born in 1918 after his parents emigrated from Wakayama, Japan. They eventually owned a 50-acre farm, growing peaches, apricots, almonds and walnuts. Decades later, they helped pioneer prune farming in that area.

Mike served with the legendary 442nd Regimental Combat Team and received a Purple Heart. His parents, meanwhile, were sent to the Gila River Relocation Center in Arizona.

"My uncle on my mom's side feels that was a real injustice, to have the government throw their families into camp and then expect people to volunteer and leave their family in camp and fight for the country," says Mike's son, Howard Kato

Howard's mother, Misao Takimoto Kato, was incarcerated with her family at the Tule Lake Segregation Center in California. When they were released, the household goods they stored in a building before the war were gone.

"People talk about how sad it was, or how bad it was going into camps," Howard says. "But people don't talk about how difficult it was after they were released."

Howard Kato, a third-generation Sansei born in 1951, was the first in his family to get a college education, earning a degree from the University of California, Davis. He went on to graduate studies at the University of Southern California and works as a computer programmer.

Howard says the subject of the incarceration came up a few times in family talks. Once, he recalls, his mother said the family paid $500 in legal fees to get their citizenship back. In 1944, the United States passed a law that permitted U.S. citizens to renounce their citizenship. The law was meant to encourage citizens in the camps to disavow their rights as naturalized Americans so they could be deported to Japan.

"My parents never discussed what happened when they were in camp and after they came out of camp," Howard says. He's not sure why, but he suspects "they didn't want any sort of tone of racism for me to experience."

His mother never voted in any election, Howard says. "I think she was bitter at the system."

In 1988, President Ronald Reagan signed a law that offered an apology for the incarceration and authorized a payment of $20,000 to each camp survivor.

"The reparations raised people's awareness of what happened," Howard says. "That's the good thing. But I don't think it's enough."

Tadao and Yukio Yoshikawa, almost 7, at a detention camp. Both brothers were wearing overalls, with Tadao standing in front of Yukio.

'So when we first got back, they put mattresses up against our bedroom windows so that if somebody threw rocks we wouldn't get injured.'

Who could have guessed on that sunny day at the Stockton Assembly Center in central California that the Yoshikawa twins would grow up to be rocket scientists.

Tadao and Yukio Yoshikawa were the youngest of five children. Their father, Nisuke Yoshikawa, was born in 1888 in Japan and remembered helping to clear the rubble in San Francisco after the 1906 Earthquake. His wife, Masaho Nakamura, arrived in the United States as a picture bride in 1919.

By the early 1940s, the elder Yoshikawas owned and ran a barbershop in Stockton. After Executive Order 9066, they had to sell their business and their car. But they kept their house because a family friend, who was white, moved into it during the war.

From Stockton, the family was sent to the Rohwer Relocation Center in McGehee, Arkansas.

"There was a central area where a lot of the people would congregate because there was nothing to do," Tadao says. "And they would be working on their hobbies or crafts. They would make a lot of objects from melting the plastic from toothbrushes, to make different sculptures or things."

The Yoshikawas were luckier than most when they returned to Stockton in 1945, Yukio says. "A lot of people didn't have places to return to, but they would be sleeping in our house, on the floor or wherever, until they were able to find a place to move into."

Nisuke Yoshikawa opened up another barbershop, but it was much smaller than his previous one.

The Yoshikawas were aware of the wave of violence directed toward returning Japanese Americans in California. "My parents were still afraid there might be some backlash," Tadao says.

"So when we first got back, they put mattresses up against our bedroom windows so that if somebody threw rocks we wouldn't get injured."

Yukio served almost three years in the Army after graduating from college in 1958. He worked for Lockheed Martin as a spacecraft thermal design engineer. He devoted much of his career to the Hubble Space Telescope.

"When I was at White Sands Missile Range, my sister came out with my parents, and they would be talking to me in Japanese. And I would always have to ask my sister, 'What did they say? What did they say?'" After being away from them for so long, he lost the little Japanese he knew.

Tadao became an aerospace engineer with Philco-Ford and worked on Project Gemini, NASA's second human spaceflight program.

Tadao's family assimilated.

"We never really tried to go and congregate with the Japanese community. I don't know if that was a backlash to wanting to be more American or what, but part of it could be that we were Christians in a predominantly Buddhist culture that Japanese are in."

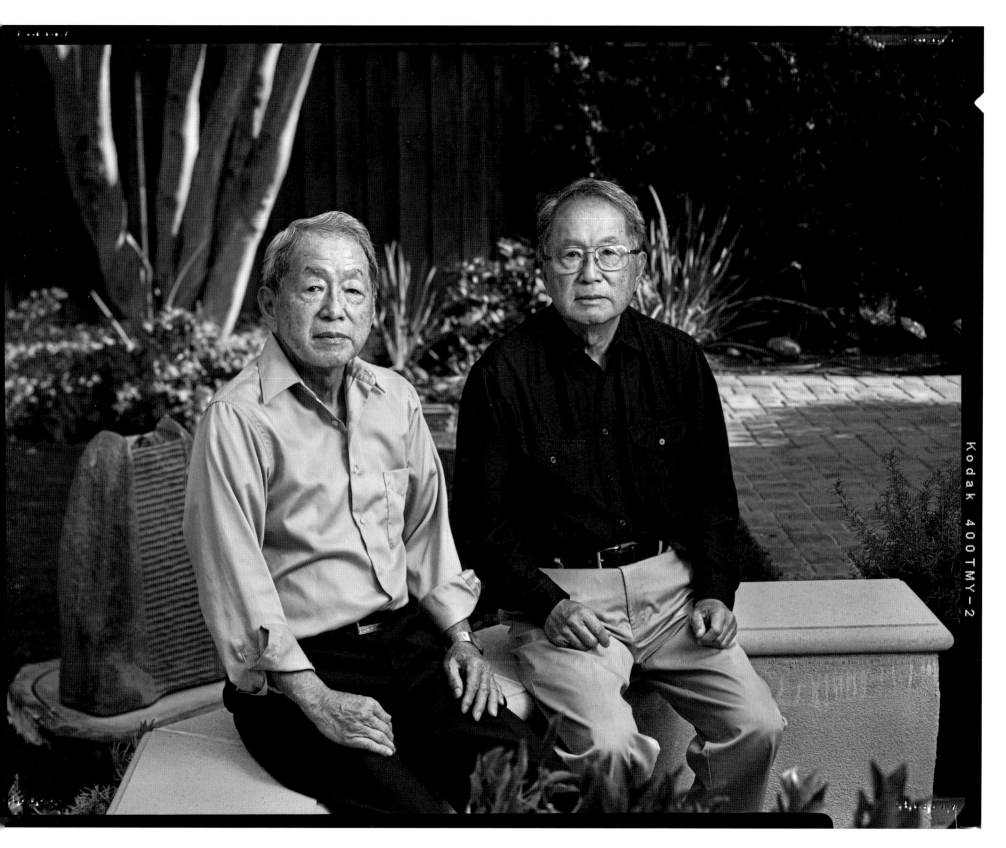

Both 80, Tadao (left) and Yukio Yoshikawa at Tadao's home in Sunnyvale, California, in 2015.

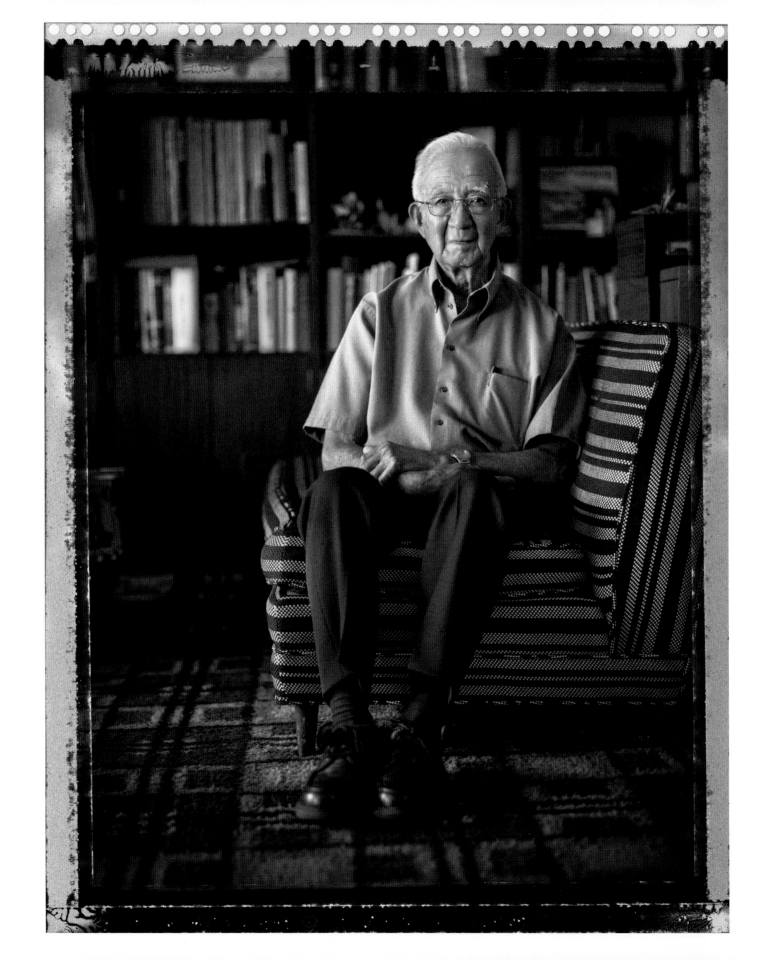

Dr. Harvey Itano, 85 in 2007, in his living room in La Jolla, California.

He was among the first of several thousand detainees to be released to attend college away from the West Coast.

Harvey Akio Itano excelled at UC Berkeley. In his final year as an undergraduate, Itano received the highest marks in his class and was honored by the faculty as the University Medalist of 1942.

Just after earning a bachelor's degree in chemistry, he was incarcerated at the Sacramento Assembly Center.

University president Robert Gordon Sproul told the graduating class, "He cannot be with us today. His country has called him elsewhere."

Harvey was born in 1920 in Sacramento, the first of four children, and graduated from Sacramento High School before entering UC Berkeley. Harvey's father, Masao Itano, sailed to America from Japan's Okayama Prefecture, finished high school in Mill Valley, California, and then graduated from college in 1917 with a degree in agriculture.

The elder Itano moved to the Sacramento area to farm, and later started an insurance business. Considered a community leader, he was taken to a Justice Department internment camp in North Dakota after Pearl Harbor. He was eventually allowed to join his family at the Tule Lake Relocation Center in Northern California.

Harvey was transferred to Tule Lake, but soon received permission to leave camp to continue his studies. He was among the first of several thousand detainees to be released to attend college away from the West Coast. On the Fourth of July 1942, Harvey boarded a train bound for medical school at St. Louis University.

Harvey finished medical school in St. Louis in 1945, and interned in Detroit, where he decided to focus on research. An admirer of Dr. Linus Pauling's use of chemical research to explore biological questions, Harvey entered the California Institute of Technology as a graduate student. He studied sickle cell disease,

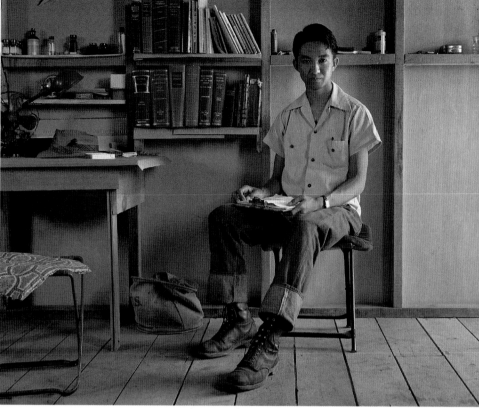

DOROTHEA LANGE, MAY 20, 1942, SACRAMENTO (CALIFORNIA) ASSEMBLY CENTER

Harvey Itano, 21, filled his room with books.

and in 1949 co-discovered the hemoglobin abnormality that causes it. In a paper in the journal *Science,* he and his colleagues showed the difference between hemoglobin in sickle cell and normal blood cells. It was a signal achievement in a four-decade career in medical research.

That same year, Harvey married Rose Sakemi, who he met in college. Her education, like his, took an unplanned turn because of the war. After being taken to the Poston Relocation Center in Arizona, she was released to finish her studies at Milwaukee-Downer College, where she graduated in 1944. Rose went on to become a dietitian.

Harvey earned his doctorate in chemistry and physics at the California Institute of Technology in 1950, and then moved to the National Institutes of Health where he continued to study the molecular and genetic basis of blood diseases. In 1970, he joined the University of California San Diego School of Medical as a professor of pathology, a post he held until his retirement.

He became the first Japanese American elected to the National Academy of Sciences.

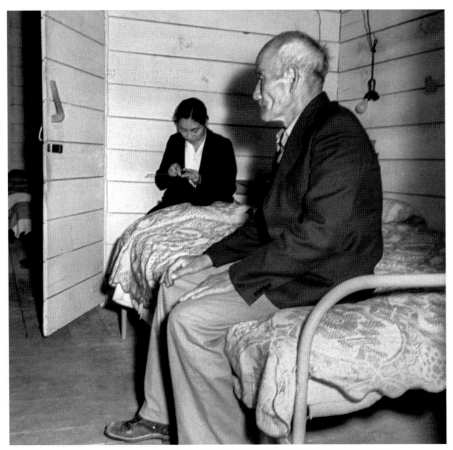

Kumataro Konda sat in a horse stall barracks with daughter Asako Mary Konda.

'It was hot and dry and dusty. There was nothing there.'

One of the few photographs taken inside the horse stalls that were turned into living quarters at the Tanforan Assembly Center showed 72-year-old Kumataro Konda and his 29-year-old daughter, Asako Mary Kondo.

An immigrant from Wakayama, Japan, Kumataro Konda came to the United States looking for opportunity. He settled on a farm in what is now Fremont, California. After he and his family were taken to Tanforan, they moved on to the Topaz Relocation Center in Delta, Utah.

As one of the oldest of those incarcerated, Kumataro served as an interpreter, helping those who were conversant only in Japanese understand what was happening.

His son, Harry, who was 33 when the family was imprisoned, was a leader of the Japanese-American community in Centerville after the war broke out. At Topaz, he helped build and manage a tofu factory.

Three decades after Harry, Kumataro and Asako left Topaz,

Harry took his family, including son Richard, on a side trip to the location of the camp. By 1976, only the foundations of a few buildings were left, and the area was surrounded by barbed wire. The Kondas passed through the barbed wire to see where the family had been imprisoned.

After the war, Kumataro and Harry moved to Chicago, where Harry met his wife. Then the family moved to the San Francisco Bay Area, where Harry worked for the Simmons Mattress Company.

In part, the knowledge of what happened to Japanese Americans during World War II led Harry's son Richard to seek a legal career. Richard grew up in the Bay Area, got a law degree, and founded the Asian Law Alliance, of which he is the executive director.

In 1981, Harry testified before the Commission on Wartime Relocation and Internment of Civilians, a group appointed by Congress to study the impact of the incarceration on Japanese Americans.

"He said his piece about how this was unfair, whatever, and I mean, that's the first time I ever saw him speak publicly about it, really," Richard says. "I was somewhat perplexed a little bit because I had never really heard him speak about it in that way. I just remember thinking, 'Wow. He's talking about this in public.'"

Richard remembers that 1976 stop in the Utah desert.

"It was hot and dry and dusty. There was nothing there," he says. "To imagine thousands of people in these small little places, with no privacy and all the dirt and the wind and cold and everything. . . . Yeah, it was one of those things you don't forget."

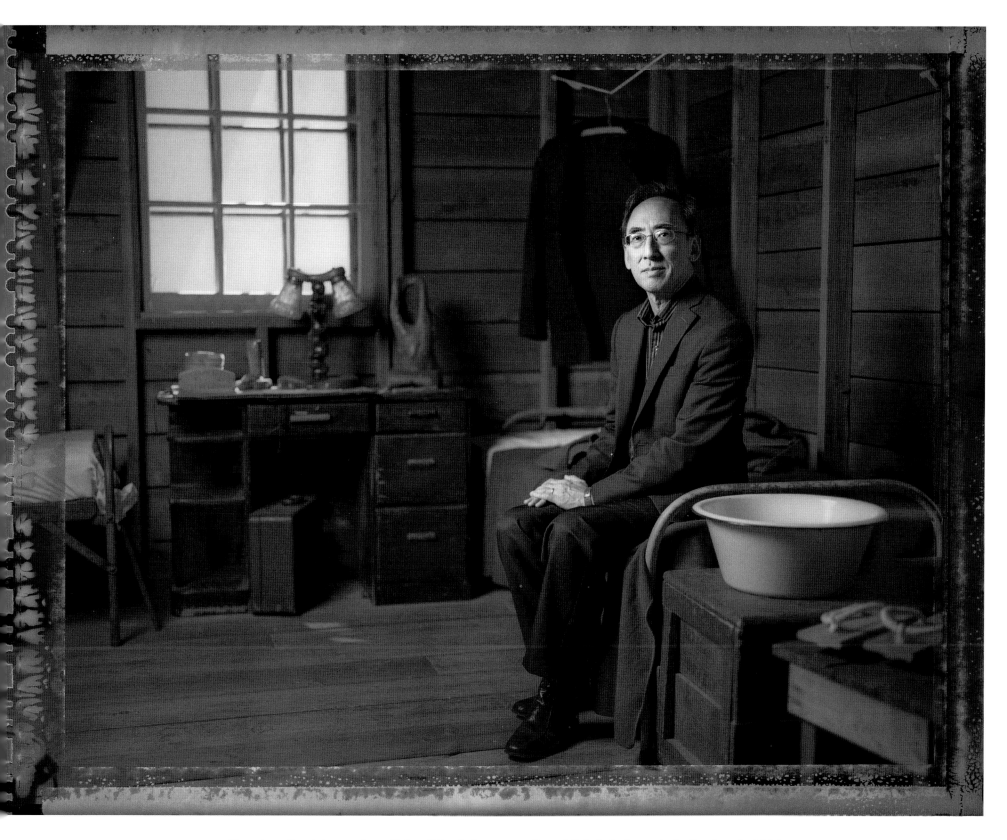

Kumataro Konda's grandson Richard Konda in a re-creation of Tule Lake barracks in San Jose in 2014.

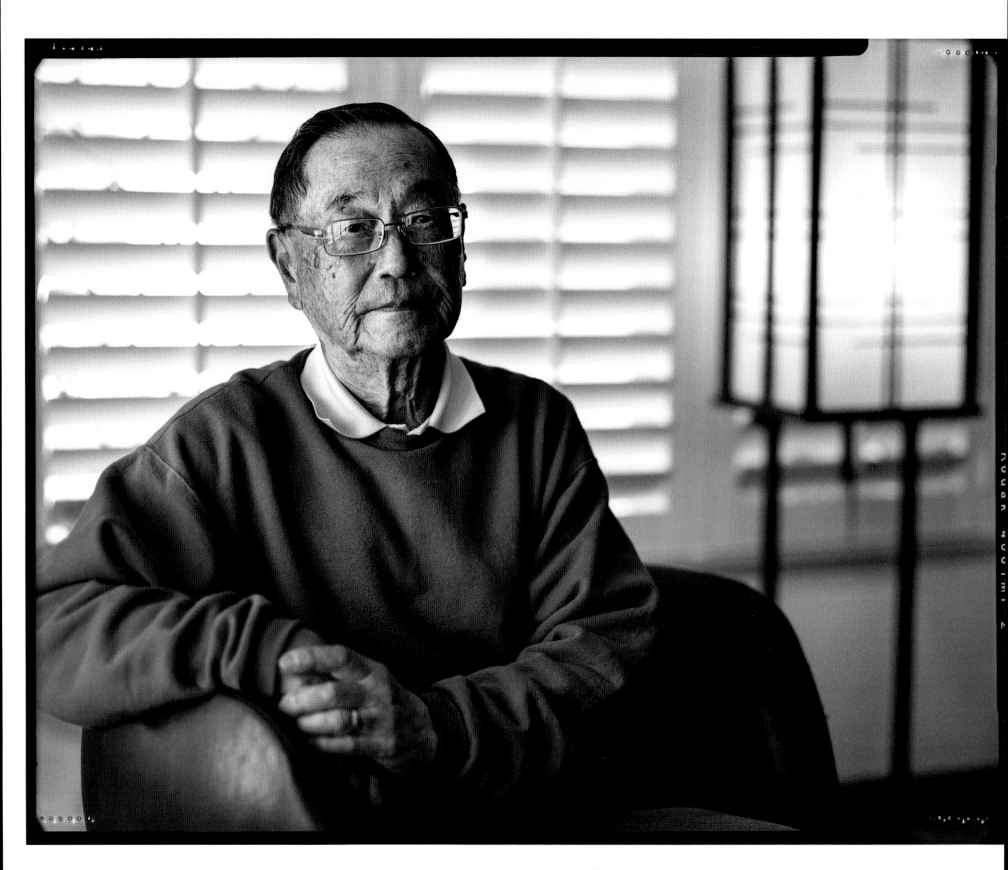

Fred Shinoda, 83, in his home in San Leandro, California, in 2017.

'I was one of the few people that had a bicycle in camp.'

Fred Shinoda, 9 (right), in an class taught by Berkeley artist Chiura Obata, who helped create a popular art school at Tanforan.

Fred Shinoda also returned to Topaz.

While on a golf trip to Salt Lake City he rented a car and headed to Delta, Utah.

"I actually found where our block was," he says. His memories resurfaced: windstorms, red ants, sagebrush, arrowheads, scorpions. And the utter lack of privacy. "I just kind of sat there and said, 'Geez, how could they have possibly put us in a place like this?'"

Born in 1933, Fred grew up in San Leandro, California. His father, president of the Eden Japanese Society, was arrested after Pearl Harbor and sent to a Department of Justice camp in Bismarck, North Dakota.

"Unfortunately, I was home when they came knocking on the door," says Fred. "I was only 8. So these three FBI men, I swear, must have been at least 6 feet tall. And actually, I cried, you know, because he was told to just grab his toiletries, and they took him away."

When the forced removal order was issued, white people came by the house knowing that the Shinodas would be getting rid of things. One woman spotted Fred's brand-new Sears bike and asked his older brother, who was handling negotiations, if she could buy it.

"My brother turned to me, and she could see that I was starting to get teary-eyed. And he looked at me, looked at the woman, and said, 'What do you want to do, break the kid's heart?'

That's one incident I will always remember. It was a red bike I had just got for my birthday."

Fred and his bike stayed together. It was shipped to him in captivity. "I was one of the few people that had a bicycle in camp," he says.

Fred and his family returned to San Leandro just before the war ended, when he was in seventh grade.

He wasn't sure how he would be greeted at school. "Actually, I was kind of terrified, so I asked my older brother to accompany me that first day. I had visions of getting beaten up. But it wasn't too bad."

He was drafted while a student at UC Berkeley and spent two years in Korea. Then he went to work at the family nursery.

Like other Japanese Americans who lived through the camps, Fred received a $20,000 reparations check from the U.S. government. He donated it to local Japanese senior housing.

"I was just more interested in the letter of apology, which I framed and is still hanging in my family room," he says.

Joseph Yoshino (wearing a hat) waited for supper. His wife, Jean Yoshino, was directly behind him.

The lines for food at the Tanforan temporary detention center were long, and the meals weren't always worth the wait. Inmates were told to carry dishes and cutlery to the giant mess halls. Life in the camp was basic.

Jean Yoshino, 26, was pregnant when the picture was taken. She was a native of Texas. Her husband, Joseph, also 26, was born in Alameda, California. He was in the Merchant Marine, working at Pearl Harbor when Jean, his fiancée at the time, urged him to come home. A few days after he landed in San Francisco, Pearl Harbor was bombed.

They lived in a horse stall at Tanforan.

Jean gave birth to Diana, the first of four Yoshino children, in the Topaz Relocation Center in 1943. The family left camp later that year. Joseph volunteered for the 442nd Regimental Combat Team, but during training he was ordered to return to the Merchant Marine. Son Milo says his father attended officers'

The U.S. government's apology and reparations for the incarceration meant a lot to the family.

school and was one of few Japanese Americans who participated in D-Day in 1944. After the war, Joseph became a stationary engineer and later a loan officer.

The U.S. government's apology and reparations for the incarceration meant a lot to the family. "My dad was a real advocate, proponent, supporter of the Japanese American Citizens League, because the JACL played a major part in that movement," Milo says. "He was, indeed, very proud of that, too."

Diana Jew, the Yoshinos' daughter, had no idea what being born at Topaz meant until she was 16. A history teacher explained that it was an internment camp for people of Japanese ancestry. She asked her parents, but found out nothing.

"All I was left with was a feeling that something was not good about my birth," says Diana. Thirty-three years ago, she bought five books about the internment. She didn't look at them until she was getting ready to be photographed for this book.

"Now instead of seeing my birth as something shameful, it is something to be proud of and grateful that I survived it," Diana says. "I feel proud of being who I am, what I had to go through, of what the whole generation before us sacrificed for us. And it just has opened up a life for me."

Milo, born in New York in 1944, went to Vietnam as a commissioned officer and later became a certified public accountant.

When he visited Topaz, he got a private tour with camp historian Jean Beckwith. "You're standing at the apartment for your parents," she told him. She pointed to a steel-frame bed lying nearby in the dust and the sand. "That's probably their bed," she said.

"I was just struck really pretty speechless for a couple of minutes, because it's almost, almost like they were there," Milo says.

Two Yoshino children: Diana Jew and Milo Yoshino in Mill Valley, California, in 2016.

Lillian
Matsumoto,
95 in 2006,
in Albany,
California.

'I could see tears running down his face, overcome by this little girl singing.'

Lillian Ida Matsumoto founded and ran Manzanar's Children's Village, a home for incarcerated orphans of Japanese ancestry.

Lillian was born in Salt Lake City, where her father, Shiro Ida, a native of Nagano Prefecture, started a Japanese-language newspaper, *Rocky Mountain Times.* With the region's Japanese population shrinking, he sold the business and moved the family to Berkeley, California, in 1929.

Lillian entered the UC Berkeley, that year, earned her bachelor's degree, then decided to pursue graduate study in social work. Admissions officials tried to dissuade her, warning that she wouldn't be able to find a job because of her ethnicity. But Lillian responded that she wanted to serve the elderly in the expanding Japanese American community.

Her argument prevailed; she became the second Japanese graduate of Berkeley's school of social welfare.

In 1939, Lillian moved to Los Angeles, where she served a different demographic: orphaned children. A home called Shonien hired her as assistant superintendent. After Pearl Harbor, she was elevated to superintendent when Shonien's founder, Rokuichi Joy Kusumoto, was arrested by the FBI.

With Executive Order 9066 came a problem the government did not anticipate: what to do with children cared for at Shonien, the Maryknoll Catholic Home for Japanese Children and the Japanese Salvation Army home of San Francisco. Lillian and Harry Matsumoto, who were on Shonien's governing board, proposed construction of a children's center at the soon-to-be-completed Manzanar camp. Authorities agreed.

"With our future so uncertain," Lillian wrote years later, "Harry and I married on February 15, 1942."

Three months later, Lillian, her staff members and 62 orphans boarded buses in Los Angeles for the trip to Manzanar and the new Children's Village that she and Harry would run.

To keep the children entertained during the four-hour ride, grownups organized a program of songs and storytelling. At one

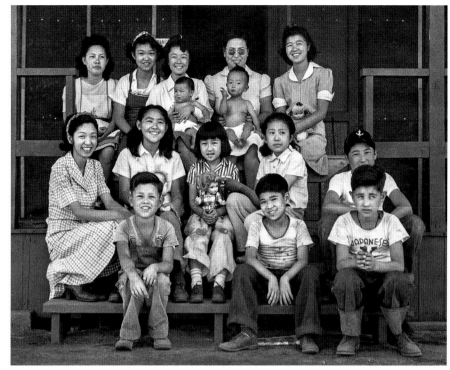

DOROTHEA LANGE, JULY 1, 1942, MANZANAR RELOCATION CENTER, OWENS VALLEY, CALIFORNIA

Lillian Matsumoto, 29, (bottom left), ran the Manzanar Children's Village.

point, a 4-year-old girl stood at the front of the bus and sang "God Bless America." Lillian watched one of the armed soldiers onboard. "I could see tears running down his face, overcome by this little girl singing."

At Manzanar, the Matsumotos and their charges settled into a complex of three buildings, larger and sturdier than the regular camp barracks, in a former apple orchard with a view of Mount Whitney. At its peak, the village held 105 children ranging in age from 3 months to 17 years. They attended school and church and formed a baseball team. "We encouraged them to have as normal a life as any other child in the camp," Lillian wrote.

The Matsumotos left Manzanar in September 1944. They adopted an orphaned baby girl from the village, Karyl Matsumoto, who went on to become the mayor of South San Francisco, California.

The Children's Village closed in September 1945. Its residents were reunited with relatives or placed in foster care. In 1992, children from the village organized a fiftieth anniversary gathering, and Lillian was there.

"Despite the unhappy beginnings in their lives, what wonderful adults they have grown up to be," she says. "It gave me great satisfaction."

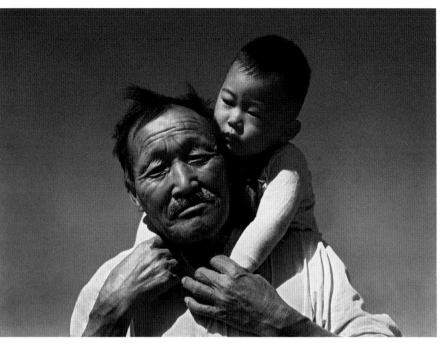

Walter Sakawye sat on the shoulders of grandfather Torazo Sakawye.

One of the most admired photographs taken during the incarceration was a picture of a tiny boy on the shoulders of an elderly man.

Lange's caption was as incomplete. "Manzanar Relocation Center, Manzanar, California," she wrote. "Grandfather and grandson of Japanese ancestry at this War Relocation Authority center."

For decades, the identity of the grandfather and grandson remained a mystery.

The boy, 17 months old at the time, was Walter Yoshiharu Sakawye. His paternal grandfather was Torazo Sakawye, who died ten months later in the camp.

Torazo was a truck farmer who immigrated to the United States from Japan in 1902.

"He passed away, I think, more or less of a broken heart," Walter says. "In the picture, he just appears to be saying, 'What'd I do? Why am I here?'"

Walter's father was a trucker in Venice, California, hauling produce. The family owned a double lot with a house and three trucks. When they returned after the war, the trucks and all their tools were gone.

Walter has no recollection of Manzanar. Growing up, he says, "We'd just hear tidbits, about how bad the camp was and the deplorable conditions. Tarpaper walls and winds blowing like crazy

For decades, the identity of the grandfather and grandson remained a mystery.

out there in the desert. Dirt flying in all the time."

The family resettled in Denver. Walter's brother died there of diphtheria in 1946, and his father passed away later that year, after the Sakawyes returned to Venice. That left Walter and his mother, Aki, whose brother was killed in action serving in the Army's 442nd Regimental Combat Team.

Aki Sakawye did clerical work as the sole support for herself and Walter. Still just a boy, he had lost his grandfather, brother, father and uncle in a short period of time.

Walter was born in a Japanese hospital in East Los Angeles in 1941. He graduated from Los Angeles High School in 1958, attended college and then trade school, and was drafted into the Army in 1961.

Walter always loved anything mechanical—he took a job at a gas station when he was 13. After he left the military and returned to Los Angeles, he was an auto mechanic and owned his own shop. He worked on cars for about 35 years until it became too physically taxing. He switched to motorcycles for another 26 years. In late 2016, Walter retired.

In the late 1940s, he went to Washington, D.C., for his uncle's burial at Arlington. There, he chanced to see Dorothea Lange's picture in a government building. "The picture was hanging there in the hallway," he says. "My mom and my aunt told somebody that was me, so they had the janitor pull the thing down, and I had to sign it and autograph it." It's essential to keep telling the story of the incarceration, Walter says.

"If you talk to people nowadays, especially the younger people, they don't know what you're talking about. 'What internment camp? What's that?'"

But Walter does not fear that history will repeat itself. "I don't think they could pull it off now," he says. "There would be civil unrest."

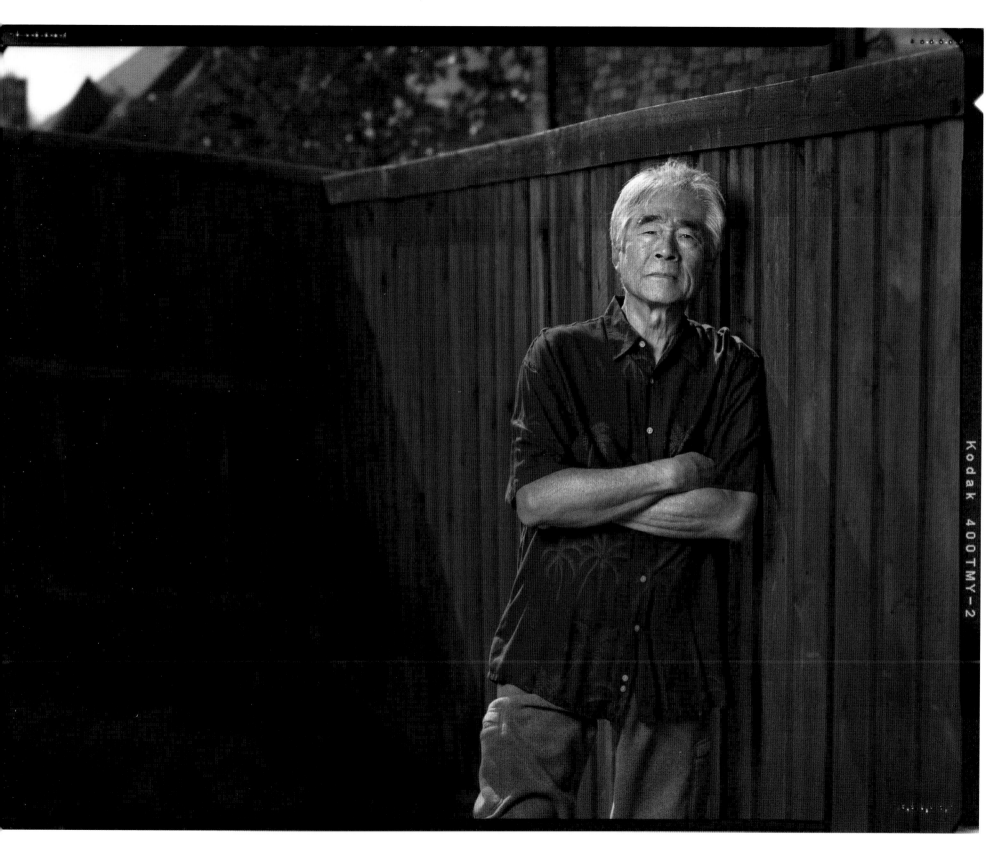

Walter Sakawye, 76 in 2017, at his home in McKinney, Texas.

Karl Yoneda's son Thomas Yoneda at his home in Santa Rosa, California, in 2015.

He was a 'red-diaper baby,' the child of communists or communist sympathizers.

Goso Karl Yoneda, who was photographed by Dorothea Lange on one of her last days at Manzanar, was a radical.

Born in 1906 in Glendale, California, he was sent to Japan to be educated, and returned to the United States at age 20. In the 1930s, he organized agriculture and cannery workers, and was among the first Japanese Americans to run for political office. Goso, who ran as a member of the Communist Party, changed his first name to honor Karl Marx.

He met Elaine Black, daughter of Russian Jewish immigrants, in the early 1930s after he was beaten by the police and jailed. Black, another radical labor activist, bailed him out and nursed him to health. They married, but had to travel to Washington state for the ceremony because of California's anti-miscegenation laws.

Their son, Thomas Culbert Yoneda, was born in 1939 at San Francisco's St. Francis Hospital, which he says didn't want to allow a "mixed-blood" birth there. Thomas had another strike against him: He was a "red-diaper baby," the child of communists or communist sympathizers.

Soon after the Pearl Harbor attack in 1941, Karl Yoneda was picked up because he was on an FBI list. He was sent to Manzanar. His Caucasian wife insisted that she go, too, along with their three-year-old son Thomas.

"She was not going to let me be babysat by the Maryknoll nuns," says Thomas, decades later.

The Yonedas were at Manzanar for only six months. The Army's Military Intelligence Service needed linguists; Karl volunteered in November 1942. He passed a Japanese language test and performed intelligence work in the Pacific theater of war in China, Burma and India. Elaine, meanwhile, successfully petitioned to take her son out of camp because he suffered allergies from the dust at Manzanar.

After the war, Karl worked on the San Francisco waterfront as a longshoreman. Later, the family moved to a chicken farm in Sonoma County. Elaine died in 1988 and Karl died in 1999.

Thomas was quite young when he left Manzanar, but he does

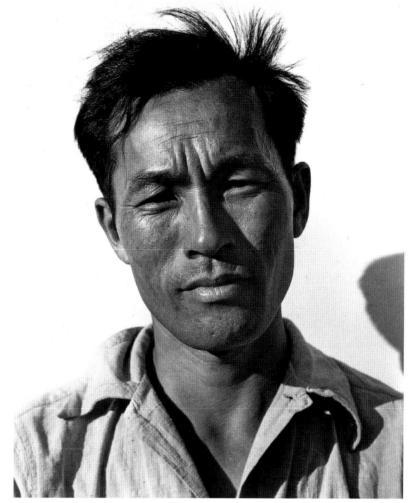

DOROTHEA LANGE, JULY 3, 1942, MANZANAR RELOCATION CENTER, OWENS VALLEY, CALIFORNIA

Karl Yoneda was one of the first inmates at Manzanar.

have a recollection from there. "The memory that I do have is waiting in line to get to eat," Thomas says. "Everybody didn't have individual kitchens. You had to go eat in the mess hall, military-style."

He says that although his mother got permission to take him away because of allergies, outside of camp she was required to report every month to the commanding officer of the military district to say that her toddler had committed no acts of sabotage.

He received a degree in Asian Studies from Stanford University and made his living as a carpenter.

He was in school in August 1945 when the news of the U.S. atomic bombing of Hiroshima came out. "It was the day after the atomic bomb was dropped," he says. "The teacher was making the announcement, and I was standing by myself. The kids are all yelling about Hiroshima. 'The Japs got it, blah, blah, blah.' And all I could think about was that my grandmother was in Hiroshima."

The family didn't find out until much later that she had survived.

Robert recalls exactly where they lived at Tule Lake: Block 51-03-D.

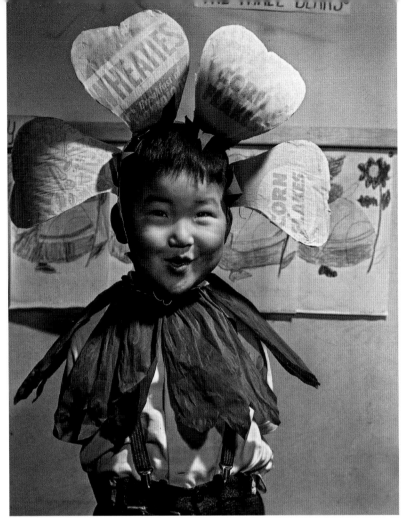

Robert Kaneko, 4, in a Labor Day parade.

Robert Kaneko was photographed wearing a headdress for a Labor Day parade at the Tule Lake Segregation Center. His nursery school class used "Mary, Mary, Quite Contrary" as a theme. Bobby was one of Mary's little flowers.

A Sansei, or third-generation Japanese American, Robert was born in 1938 in Berkeley. His father moved the family out of the military's first Exclusion Zone to Auburn, California, in the Sierra foothills before the zone boundaries were expanded and the Kanekos were picked up along with every other Japanese American in California.

Robert recalls exactly where they lived at Tule Lake: Block 51-03-D. He remembers the potbelly stove in each unit, the blanket separating the families, and leaving the living quarters to bathe and eat.

"Summertimes were hot and the winters were cold," he says. "I remember they used to have boiler rooms. I remember my cousins and I sitting in there reading, thumbing through the Sears catalog or the Montgomery Ward catalog, like a wish book."

Gangs roamed Tule Lake, he says, and he would give the gang members cigarettes he'd steal from his parents. "I don't know whether it was under the threat of getting beat up or wanting to be a part of the group or to seek favors."

Robert lived through the period at the end of World War II when thousands of the Tule Lake residents became disaffected with their chosen country. Tired of being mistreated by the U.S. government, they turned their attention and loyalty toward Japan.

He attended a regular school and a pro-Japanese school during the last months of the war.

"We had to write *kanji* and get up early in the morning before sunrise and march around," Robert says. "And then sun comes up, we sing the Japanese national anthem, we're bowing to the east and all this goose-stepping. Then you turn around; all of a sudden like this bad movie you're back in nursery school in La La Land learning to pledge allegiance to the flag."

Robert's family returned to California after the war, moving to Mount Shasta, Richmond and eventually Berkeley. He graduated from Berkeley High in 1956, joined the Navy, studied sociology in college and worked as a probation officer in Alameda County from 1965 to 1972, a period of intense political ferment. Later, he became a counselor in the Berkeley schools.

After the war, Robert and his family occasionally ran into prejudice. In his family, the prevailing attitude was to make the best of a situation. "There's *shikata ga nai*. It's like whatever happens, happens," he says.

"Because when people ask me about Tule Lake, they ask, 'Was your father a no-no boy?' Hardly. His concern was with his family and my mom being pregnant and a newborn baby."

Robert Kaneko,
78 in 2015,
in Berkeley,
where his family
eventually
returned.

Joyce Imazeki Yamamoto, 80 (from left), Denis Imazeki, 76, and Connie Suzuki, 78, in San Francisco in 2017.

'He remained loyal to the States, and apparently that wasn't very popular.'

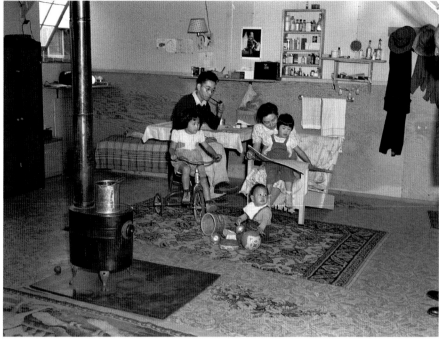

Howard and Yuri Imazeki with their children: Joyce, 5 (on tricycle), Connie, 3 (on her mother's lap), and Denis, 16 months.

Howard and Yuri Imazeki were spending a quiet evening in their barracks with their family when they were photographed just a few months after Tule Lake opened.

Howard, born in Japan in 1907, joined his father in the United States in 1918 and was an editor for the *Shin Sekai Asahi* newspaper before working in his family's poultry business. After Executive Order 9066, he and his family were taken to the nearby Sacramento Assembly Center and then to Tule Lake, where Howard was one of the editors of the camp newspaper *Tulean Dispatch.*

Daughter Joyce, now Joyce Matsumi Imazeki Yamamoto, says her father maintained a very Japanese-American attitude about the camp: "If they're going to do this to us, we're going to make the best of it. We can't do anything about it." He even thought about building an ideal community in the desert.

Daughter Connie, now Connie Yukari Suzuki, says, "He remained loyal to the States, and apparently that wasn't very popular. I remember them talking about him getting beaten up at one point because of his views."

Howard left camp in 1943 to teach at the Navy Japanese Language School in Boulder, and stayed in Colorado to work for the Office of War Information, doing broadcasts for the Voice of America. The family moved to Berkeley just before the war ended in 1945.

Connie recalls her mother's description of their early days in Berkeley: "A policeman said, 'Welcome home,' which made her feel really good."

In 1948, all three children moved with their mother to Japan to reunite with Howard, who started work there in 1946 as an interpreter and translator for the U.S. government.

After returning to the United States in 1954, Howard became editor of the English section of the *Hokubei Mainichi* newspaper in San Francisco, where he worked until he retired in 1982. He died eight years later.

Joyce says she realized what had happened to the Japanese community was wrong when she and her family left the camp. As an adult, she got involved with the Center for Japanese American Studies in San Francisco and took part in the redress campaign.

She started her letter to President Ronald Reagan: "I was 4 years old. My first real memory of life was being driven into the assembly center in Sacramento."

Connie studied business in college, raised two children and lived in Japan and China for 28 years when her husband worked there for Fairchild Semiconductor. Her daughter, Lea Suzuki, is a photojournalist with the *San Francisco Chronicle.*

Son Denis, a retired engineer with General Motors, believes that people need to do everything they can to prevent another incarceration, especially given President Trump's views regarding Muslims.

"I'm not sure that the public outcry will be so substantial that we'll be able to stop anything that the government might deem necessary," he says.

Arm-in-arm, Frank Kawai and wife Mary march in Harvest Day parade.

'They only called it "camp," which gave a different meaning to the word than as applied to a prison.'

The early photographs of parades and ceremonies at detention centers hint at how the camp experience jolted the identity of Japanese Americans who found themselves suddenly imprisoned.

One photograph shows Kazuo Frank Kawai and wife Kimiye Mary Kawai taking part in a parade a few months after entering Tule Lake.

The photograph was found by their son, Steve Kawai, who was born at Tule Lake. He was searching a digital library of pictures from different camps when he ran across Francis Stewart's photograph.

"I wanted to see if by chance I knew any of the people in the photographs and, lo and behold, [there were] my parents," he says. "I was somewhat shocked because they were in typical vaudevillian blackface. I think there was a variety show after the parade."

When the war broke out, Frank was a farmer and Mary was working for the California Department of Motor Vehicles. They were both 26. Son Steve was born in 1944, just before the Kawai family was shipped to the Granada Relocation Center in Amache, Colorado.

"I think it was because there was some fear that nearly everybody at Tule Lake would probably be shipped to Japan after the war," Steve says.

In 1943, thousands of Japanese Americans deemed "disloyal" by the U.S. government were sent to Tule Lake, which was renamed the Tule Lake Segregation Center.

After the war, Steve's father worked as a general contractor and gardener in Sacramento and then got government jobs. Steve's mother opened a beauty shop and later returned to the Department of Motor Vehicles.

"They didn't say anything about internment," Steve says. "They only called it 'camp,' which gave a different meaning to the word than as applied to a prison. But I call it a prison camp. It was called concentration camp by Franklin Roosevelt. He was the first one to use those words."

Steve Nobuo Kawai grew up on the outskirts of Sacramento's Japantown and worked as an information technology specialist for most of his professional life.

He remembers being forced to play "one of the Japs" during a game of war with friends, and recalls a day in downtown Sacramento when he was verbally attacked by a woman. "I've never heard anyone cuss like that. She was using the J-word left and right," he says.

"I was angry for most of my life," he says.

"It makes sense that you don't go to jail unless you've done something. But just for being alive isn't adequate.

"Everybody has a stereotype. They call Japanese students or Japanese Americans in the '50s the model Americans—quiet. But I wasn't like that. I would speak up."

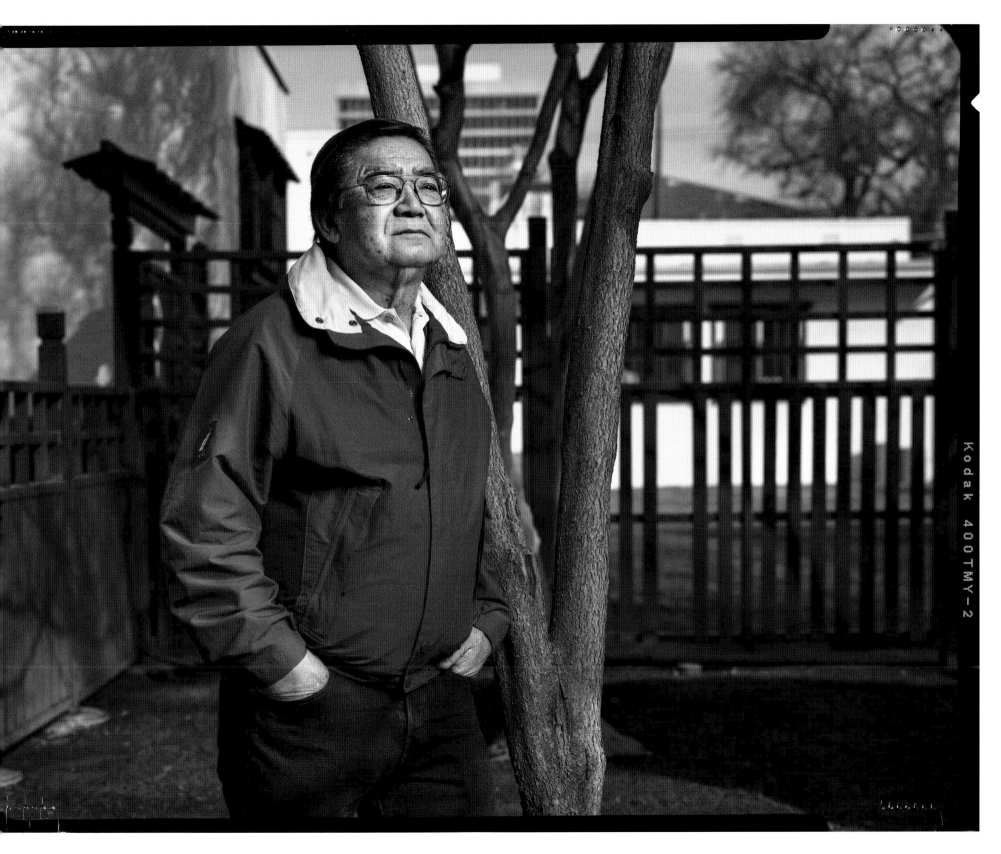

The couple's son Steve Kawai in Sacramento in 2016.

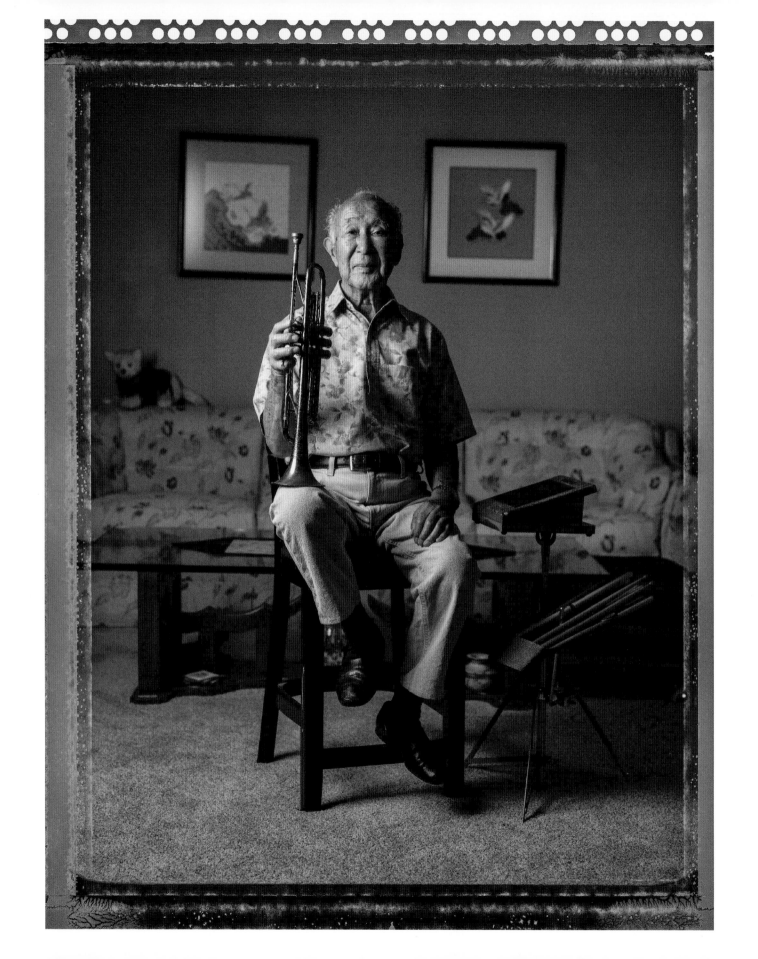

**George Sumida,
90 in 2015,
at home in
Monterey Park,
California.**

'Music really helped ease the pain of being in a big camp like that.'

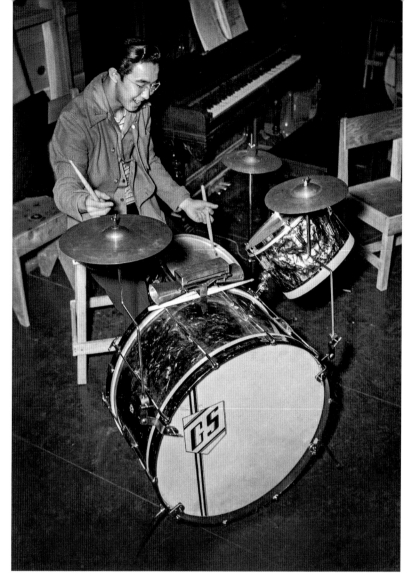

FRANCIS STEWART, NOV. 1, 1942, TULE LAKE RELOCATION CENTER, NEWELL, CALIFORNIA

George Sumida, 17, in the Woodie Ichihashi Band.

George Sumida remembers the day the FBI entered his bedroom looking for contraband.

They asked the boy if he had a picture of Hirohito on the wall. No, he told them. He had pictures of Artie Shaw, Glenn Miller, Benny Goodman and Gene Krupa—all jazz musicians.

The Sumida family was taken to the Sacramento Assembly Center and then to Tule Lake. Soon after, George's father was sent to a Department of Justice Internment camp in New Mexico. George did not see him again for several years.

His parents emigrated from Hiroshima before the war. They ran a hotel and pool hall in Sacramento, where George was born in 1925. George was sent to Japan for an education in 1934 and returned in 1939.

"When we went into camp and met lots of Japanese Americans from other places, it kind of made me open up to a lot of people," George says. "You get a lot of new friends, too. So it's good and bad, I guess."

George's father sent the boy's piano and drum set to Tule Lake. He played in a band and mingled with musicians. In May 1945, he moved to the Gila River Relocation Center in Rivers, Arizona, to marry his girlfriend.

After the war, he and his wife briefly settled in New Jersey before moving to Los Angeles and opening the Leland Hotel. George studied at night school and earned an engineering degree from California State University, Los Angeles, two decades after the war. He worked for Los Angeles Water and Power as a draftsman and later as an engineer. In 1989, not quite 65, he retired.

Music has been a constant. He played drums in many bands around Los Angeles. During the war, George says, "music really helped ease the pain of being in a big camp like that."

He used his $20,000 reparations payment to buy an organ. He's glad he got the money, but George is not that bitter about the war.

"I was a small-town guy," he says. "It gave me a chance to travel all over. For a lot of young kids, Nisei, it made a lot of difference. Because if they stay in their hometowns, they're going to be a farmer. After the war, they were able to do a lot of stuff they never thought they would do."

He says his father, in contrast, suffered quite a bit during the war and lost his business afterward. He was only 60 when he died.

TOM PARKER, MAY 18, 1943, DES PLAINES, ILLINOIS

Sakiko Shiga worked in a photo-processing lab.

The government went to great lengths to show Japanese Americans who were released from detention centers to work outside the West Coast Exclusion Zone during the war. Twenty-two-year-old Sakiko Shiga was photographed working in a photo-processing lab near Chicago.

Starting in 1943, inmates at the ten detention centers received "indefinite leaves" if they passed the loyalty questionnaire and could show they had a job lined up and a sponsor. About 16,000 left the camps in 1943 and another 18,500 left in 1944.

Sakiko, a second-generation Japanese American and accomplished violinist, met William Himel before the war. His brother, Robert Himel, invited Sakiko and about twenty Japanese Americans from detention camps to work for him near Chicago. He also found temporary lodging for them.

Sakiko and William married in the fall of 1944. Their son, Yoshinori Toso Himel, was born September 2, 1945, the day Japan surrendered to end World War II.

Toso says Sakiko felt a deep sense of obligation to his father's family. It was said to be why she married William, who worked as a Japanese language specialist for the military during the war.

Toso's grandfather, Juro Henry Shiga, moved from Japan to Seattle in 1904, and started a knitting company. He didn't lose his house during the war, but he encountered financial problems because his assets were frozen after Pearl Harbor. Soon after, the government shipped him to a Department of Justice internment camp in Bismarck, North Dakota. The family, knowing they couldn't stay in Seattle, moved to Montana to avoid being picked up.

Juro's application for release was granted in early 1945—but he died at age 57 just before his release date. "I think that all of these humiliations and disabilities contributed to his death," Toso says.

From 1975 to 2014, Toso worked as an attorney for the federal government. In 2015, he and his wife were among those who succeeded in thwarting the controversial auction of incarceration camp artifacts—including Tom Parker's photo of Toso's mother.

"Outside my family, I did not know any hapa children," says Toso, referring to children who are half-Asian and half-Caucasian. "They've become much, much more familiar now and have formed a movement."

Toso says his mother was traumatized by the war and always urged the safest course. Tosa studied math at Harvard University, but switched to law at the University of California, Davis because of law's potential to change society.

Echoing a common theme, he says Sakiko didn't talk about the war. "It was a source of great discomfort and tragedy and trauma for her, and so she avoided it."

Toso has taken the opposite approach. One year, Toso took his son to visit the former camps.

"Everybody has to say what they did during the summer," Toso recalls, "And all everybody talks about is the fun they had. And he would say, 'Well, I visited concentration camps.'"

Sakiko Shiga's son Yoshinori Toso Himel at his home in Sacramento in 2015.

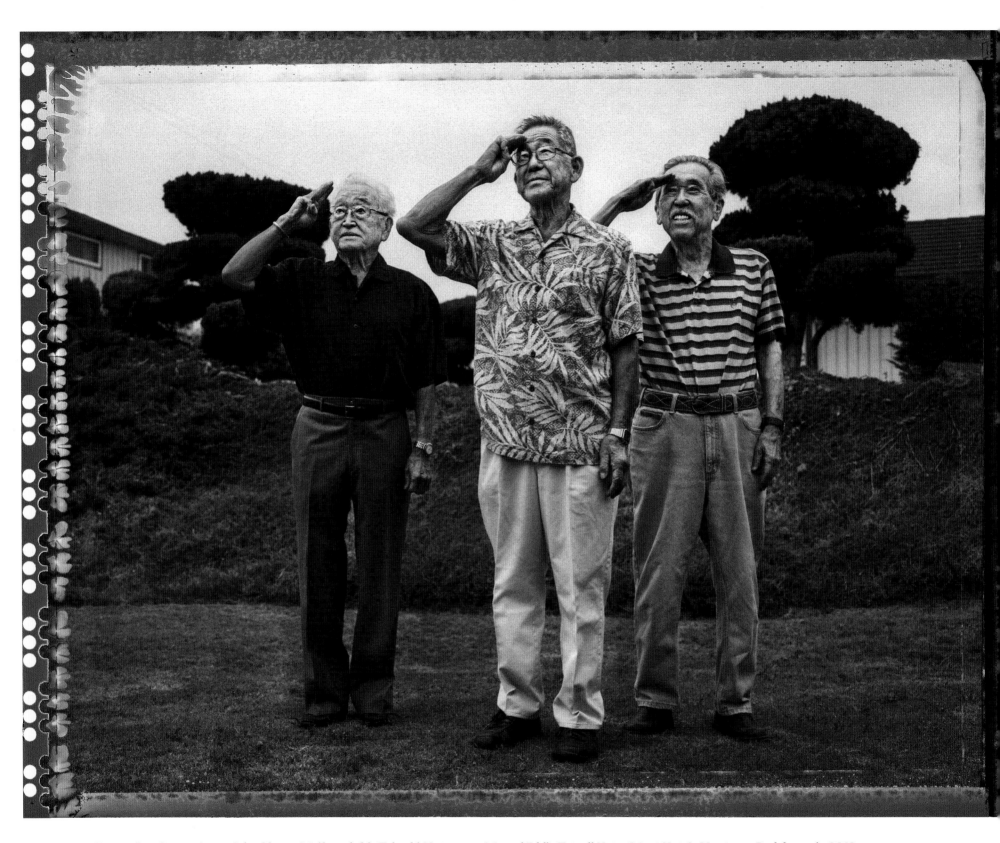

Former Boy Scouts Junzo Jake Ohara, 84 (from left), Takeshi Motoyasu, 84, and Eddie Tetsuji Kato, 86, at Kato's Monterey Park home in 2013.

'We knew it was a war, but we had no idea what was happening.'

Flag ceremonies were held almost every day during the incarceration. Junzo Jake Ohara, Takeshi Motoyasu and Eddie Tetsuji Kato would raise and lower the flag in front of the Heart Mountain administration building in Cody, Wyoming, five days a week.

Jake Ohara's family emigrated from Kumamoto, Japan, and started the Nagamoto Kamaboko Company in 1924 in Los Angeles' Little Tokyo neighborhood. His father, Shozu Ohara, a member of the Japanese chamber of commerce, was arrested shortly after Pearl Harbor, incarcerated in a Department of Justice internment camp and reunited with his family at Heart Mountain in 1944.

"We were scared. My brother and I were so scared," Jake says. "We knew it was a war, but we had no idea what was happening."

As a condition of his release from the camp, Jake's father was not allowed to return to the West Coast immediately, so he found work at New Jersey's Seabrook Farms, a major employer of workers released from incarceration. The rest of the Oharas returned to Los Angeles after the war. Jake attended the University of Southern California and became a pharmacist in Monterey Park.

Jake's father never recovered from what he saw and what he felt during and after the incarceration. "He had a mental breakdown," Ohara says, and "would walk the long way around, so he didn't have to see anyone he knew."

Takeshi Motoyasu's parents emigrated from Hiroshima. His father, Matsumi Hiroaka, had been in the Japanese army, so he was arrested on the evening of December 7, 1941. Matsumi was taken to a Department of Justice internment camp, but later rejoined the family at Heart Mountain. After the war, the family lived in a Burbank, California, trailer park with other Japanese Americans who were financially struggling. The family later was able to buy a hotel in Los Angeles. Takeshi was drafted into the

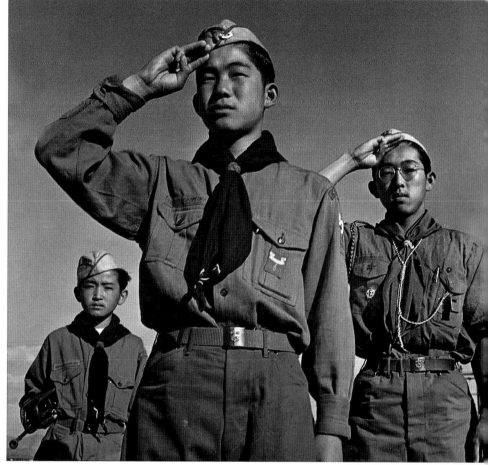

PAT COFFEY, JUNE 5, 1943, HEART MOUNTAIN RELOCATION CENTER, CODY, WYOMING

Members of Boy Scout Troop 379 honored the American flag: Junzo Jake Ohara, 14 (from left), Takeshi Motoyasu, 14, and Eddie Tetsuji Kato, 16.

military and served in the Korean War. He returned home to study electrical engineering and worked as an engineer at Bendix.

Eddie Kato's parents owned Sakura Sushi on First Street in Little Tokyo and lived with their children behind the restaurant before the war. Eddie's mother and children left Heart Mountain to work at Seabrook Farms during the war. His father cooked for the railroad crews.

When the Katos returned to Los Angeles after the war, his father worked at grocery stores and his mother as a housekeeper. They later opened an aquarium store. Eddie served two years in the military, earned a business degree from UC Berkeley and worked as an accountant.

"I never thought of myself as a Jap, you know," he says. "I just thought of myself as an American citizen, because that's how I was raised."

Although it was not an unhappy childhood, she used to tell her mother, 'I want to go home. Why can't we go home?'

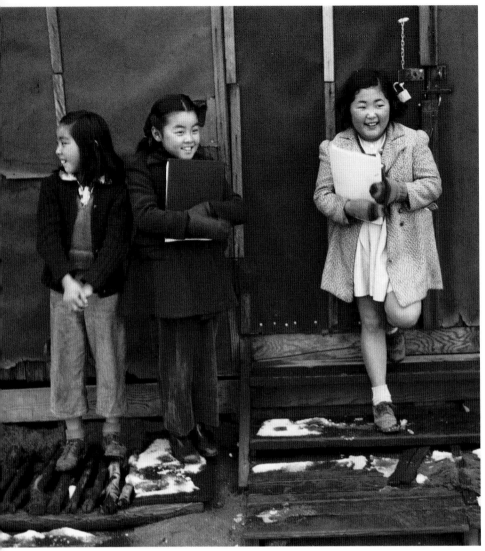

ANSEL ADAMS, WINTER 1943, MANZANAR RELOCATION CENTER, OWENS VALLEY, CALIFORNIA

Kaoru Nakanishi, 8 (middle), outside a classroom with friends.

Kaoru Nakanishi was 8 years old when Ansel Adams took her picture on the snowy paths of Manzanar.

Kaoru, born in Los Angeles' Little Toyko in 1935, describes herself as *nisei-han*—partway between generations—because her father was born in Japan and her mother in California.

Her parents always kept a picture of the emperor and empress of Japan in their kitchen, and Kaoru was given a complete set of Emperor and Empress Girls' Day dolls. Her family, fearing the worst, burned all of it after Pearl Harbor was bombed.

She remembers a lot about Manzanar: playing games such as prisoner's base, hopscotch, jacks and kick the can. And trying to roller-skate on the camp's tar roads.

"We had to line up for meals," she says. "We went to outdoor movies with our blankets, and we dug holes in the sand to make a little place to sit and put our legs out. We saved corn from dinner, and we used to eat it as snacks."

Although it was not an unhappy childhood, she used to tell her mother, "I want to go home. Why can't we go home?" In June 1945, Kaoru's father found work on a Japanese family's farm in Gunnison, Utah, so they went there and grew celery, cabbage and sugar beets. Her family later returned to Los Angeles, where her father resumed work as a gardener.

Kaoru became known as Karlene. She worked as an educator and was a mother of six. She recalled the time one of her daughters returned from school with a little mark on her skin. "A child stabbed her with a pencil and called her a Jap," Karlene said.

The incarceration has been a continuing thread in her life. In the sixth grade, she bonded with six other girls from different camps. They formed a social club and turned into lifelong friends.

Even the doll Karlene brought to Manzanar is still around. "Her name was Jo-Jo. Eighty-two years old. She had a polka-dot dress. One of our friends made me a little kimono for her, but I think I have her in her original dress."

In 1977, Karlene co-founded Suzume no Gakko, a summer program in San Jose where students learn about Japanese-American culture.

Unlike many, Karlene has talked to her children about the experience.

"It was something the government did to us," she says. "That's why I feel like we need to keep teaching it—so that it doesn't happen again."

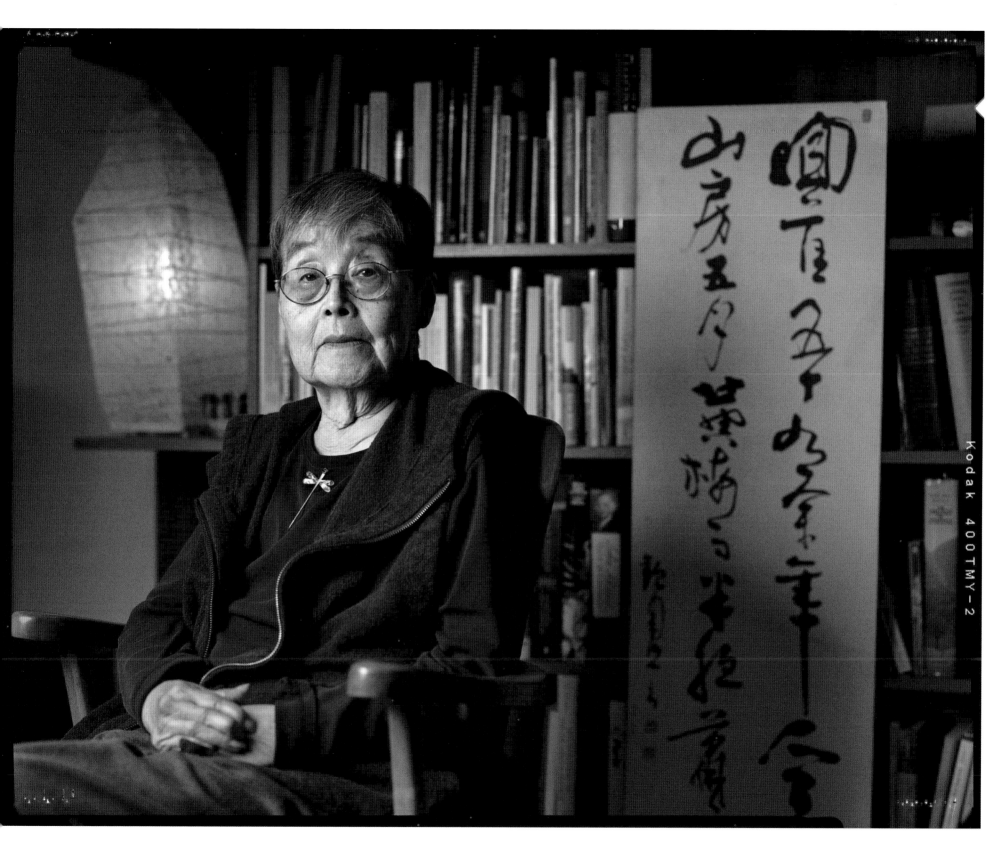

Kaoru Nakanishi, now Karlene Koketsu, 81 in 2016, at her home in San Jose.

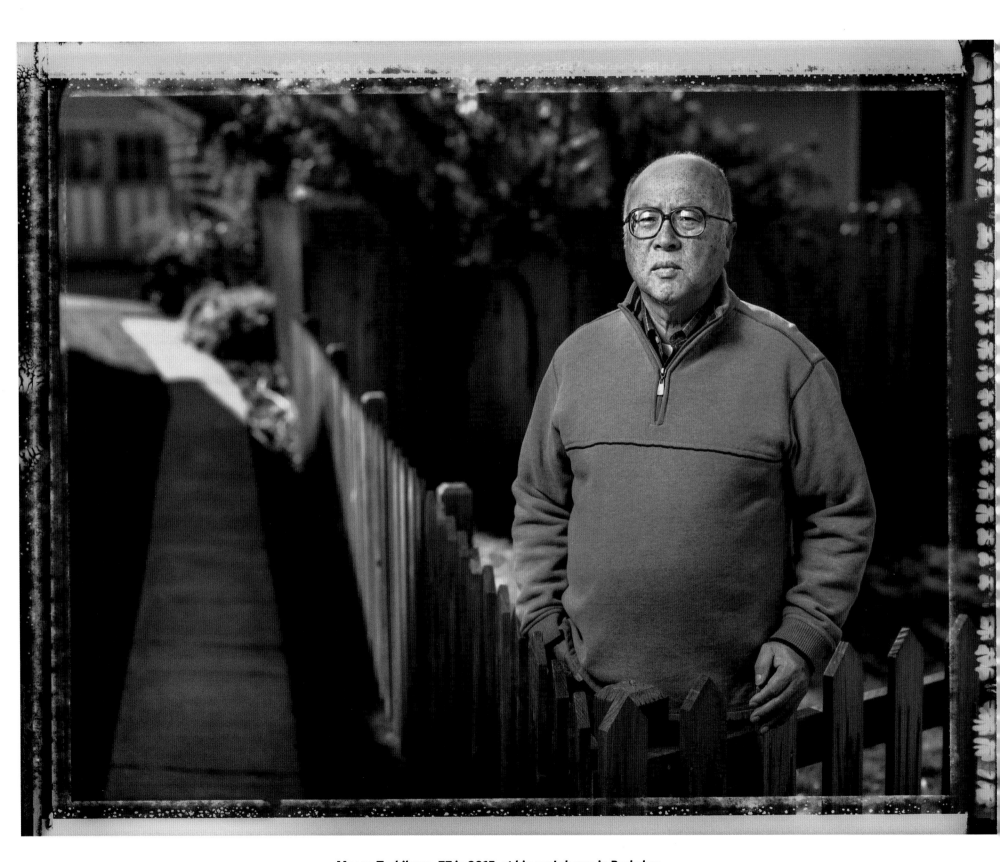

Mason Tachibana, 77 in 2015, at his son's home in Berkeley.

'I was only 7 when I went in, but I knew something was wrong with the whole deal. What are they doing to us?'

Masatoshi "Mason" Tachibana was Buddhist when he entered the Manzanar detention camp, but his father sent him to the Maryknoll Japanese Catholic Church to learn Japanese from two Japanese-American nuns.

"What they taught us there was a joy," he recalls of the Maryville Sisters Susanna and Bernadette. "I remember coming home on the bus, it was lighthearted. Then we went into the camps after that, and any kind of joy, good times, just stopped."

It was a dark period.

"I just remember the first day; I don't remember the second day," he says. "But that first day, I was 7 years old, a little kid wandering around. It was pitch black; there was no light. There was dirt, and every building looked like the other."

The only thing that kept Mason going was sports. He read sports magazines, listened to the radio and studied statistics.

"I was only 7 when I went in, but I knew something was wrong with the whole deal," he says. "What are they doing to us?" Mason's father, Ichijiro, was 61 when sent to Manzanar. Before the war, he had run a trucking business as well as farm and dry cleaning businesses. But he never fully recovered financially after the incarceration. The family lived for several years in huge trailer parks, first in Burbank and then in Los Angeles. Ichijiro could not find a job and the family went on welfare, something Mason says brought great shame to his father. Always skilled with his hands, he eventually made a living building tool cabinets for Japanese gardeners' pickup trucks.

Mason Tachibana put himself through college and became a social worker for Los Angeles County. He earned a master's degree

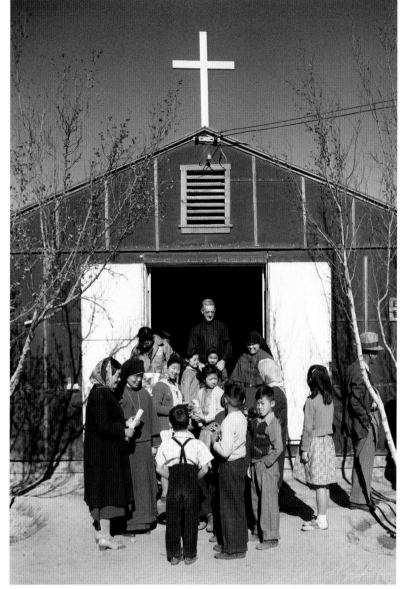

ANSEL ADAMS, 1943, MANZANAR RELOCATION CENTER, OWENS VALLEY, CALIFORNIA

Mason Tachibana, 8, looked toward the camera at Manzanar's Maryknoll Japanese Catholic church.

in social work at the University of Hawaii, returned to Los Angeles and worked for 22 years in child protective services and 11 more in a residential facility that helped abused girls.

"Maybe I saw myself in some of the kids," Mason says. "Maybe it was meant to be that I came to do that work. I loved that work. Manzanar made me what I am today. I never said that it ruined me or made me a wreck in any way. I went through primal therapy."

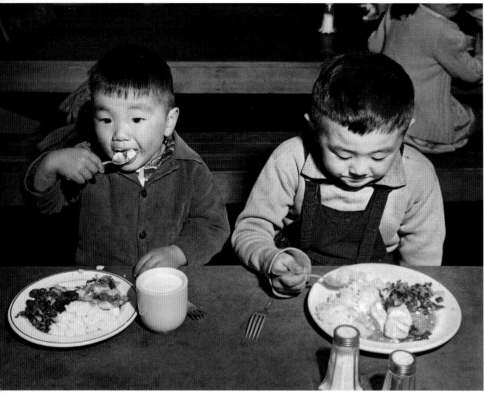

ANSEL ADAMS, 1943, MANZANAR RELOCATION CENTER, OWENS VALLEY, CALIFORNIA

Willie Hayashida (left) and Takashi Uchida shared a meal in the mess hall.

Willie Hayashida remembers a night in 1956 when he was 16, looking through a book about the incarceration of Japanese Americans.

He and his family were at the dinner table when Willie announced, "Now I know why we went to Tule Lake."

In a moment, his father, Arata, pounded on the dining room table.

"Bam," Willie says. "Never a word after that."

Willie Fusao Hayashida was only 3 when he was photographed with 4-year-old Takashi Uchida in the Manzanar mess hall.

Willie grew up on a farm in French Camp, California, to parents Arata and Chizuko Hayashida, both of whom were born in the San Francisco Bay Area.

Before the war, the Hayashidas joined others in the Merced area to form the Yamato Colony, a 3,200-acre agricultural community in central California. "Growing up on a farm, I had nobody to play with," he says. "I was an only child. So you go to camp, there are all kinds of kids to play with."

But life got complicated at Manzanar and later Tule Lake for the Hayashida family.

Like more than 5,000 other Japanese Americans stuck in the camps, Arata renounced his U.S. citizenship during the last year of the war. Willie and his mother were able to return to the farm, but Arata's return was delayed.

The Yamato Colony was left in the stewardship of Hugh Griswold, a local lawyer. He returned control of the farms to the rightful owners after the war so the Hayashida family was able to return home. Willie's father, Arata, returned home six months later.

Arata went full circle. He left farming behind to become a gardener, and became a naturalized American citizen in 1959, a year after Willie graduated from high school.

Chizuko encouraged their three sons to push on to college. Willie got a degree in electrical engineering from California Polytechnic State University after attending Stockton City College (now San Joaquin Delta College).

From college he got a job at Lockheed, doing research into semiconductors and designing silicon chips. He finished his career at Intel.

But the memory of the camps is never far.

"I believe it was a concentration camp," Willie says. "It was an Americanized concentration camp. You are a citizen; you are locked in. The guns are pointing in, not out."

Willie Hayashida in Sacramento in 2012.

Gladys Matsumoto Katsuki at her home in Sacramento in 2012.

The incarceration and aftermath changed her father, an entrepreneur in his youth who never worked again.

"The wind was terrible," says Gladys Matsumoto about Manzanar. "The sand would come up suddenly, and we had to wash our hair a lot."

But there were things to enjoy as well—such as dances and sports—and a young life filled with friends like Shizuko Sakihara and Judy Nakao (now Tanaka).

Gladys was born in Elk Grove, California, the youngest of nine children in a farm family that raised strawberries, plums and lettuce.

Her parents emigrated from Hiroshima. Her father, Shigeroku, landed in Seattle, worked on the railroads and started a grocery store in Newcastle, California, before turning to farming. He kept a hand in retail, though, owning a market in West Sacramento that sold his farm's produce. Gladys' mother, Ine, and her siblings helped in the fields.

At the time of Pearl Harbor, Gladys was a 14-year-old high school freshman. The farm was in full production, she says, when her family was forced to "just walk away."

The family was split up, but after several camp transfers the Matsumotos were reunited. Gladys was sent first to the Fresno Assembly Center in California, then to the Jerome detention camp in Denson, Arkansas, then to Manzanar in California, and finally Granada in Colorado.

After the war, the Matsumotos moved to Chicago, where her father found work as a janitor and maintenance man. There, Gladys met Henry Katsuki from California. They married in December 1946, and moved back west, to Dinuba, California, where they were confronted by "No Japs wanted" warnings. "Felt awful," Gladys says. "I can still remember those signs."

The couple farmed in Madera, California, then moved to

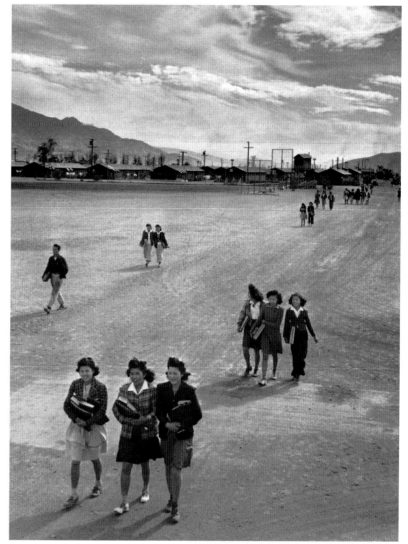

ANSEL ADAMS, 1943, MANZANAR RELOCATION CENTER, OWENS VALLEY, CALIFORNIA

Gladys Matsumoto (center), Shizuko Sakihara (left) and Judy Nakao walked home from school.

Sherman Island in the Sacramento–San Joaquin River Delta, where they raised tomatoes, sugar beets, corn and safflower.

Gladys' siblings dispersed, some settling in Chicago, others in California and Las Vegas.

The incarceration and aftermath changed her father, an entrepreneur in his youth who never worked again after he and his wife returned to California.

But the experience brought an unexpected benefit for the Matsumotos. "It brought the family much closer," Gladys says. "We were all separated at one time. We felt like we needed each other more."

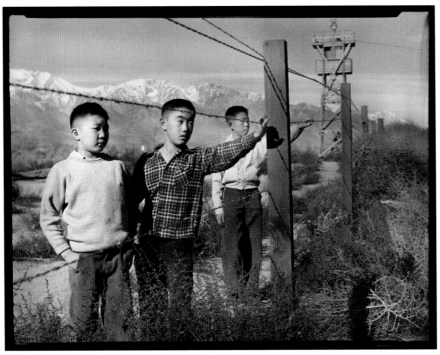

Robert Takamoto, 9 (far left), and friends at the barbed-wire fence surrounding Manzanar.

After a while, the inmates at Manzanar were allowed to venture outside the barbed wire. Manzanar was in a huge valley, and there was nowhere to escape.

One of the most powerful photographs of the incarceration was taken by Toyo Miyatake, a professional photographer from Los Angeles who was an inmate at Manzanar. Miyatake photographed three boys—Norito Robert Takamoto, Albert Masaichi and Hisashi Sansui—standing just outside the detention center at the barbed-wire fence that surrounded Manzanar.

Robert Takamoto, far left, was born near downtown Los Angeles in 1934. His family lived close to a wholesale produce market where his father worked. Both of his parents were from the suburbs of Hiroshima.

"Anything Japanese was verboten" after Pearl Harbor was bombed, Robert says. "My parents had beautiful sets of Japanese dolls that were displayed during special holidays. They were all burned."

Other belongings were buried in the backyard. And his father sold his new Chrysler Imperial for a penny on the dollar. "There was a real fear, but my parents shielded the kids from most of that," Robert says. "I didn't really comprehend the gravity of the situation and what was happening to us. They minimized it." The family was sent to Manzanar: Block 22, Barrack 4, Unit 1.

After a while, the inmates at Manzanar were allowed to venture outside the barbed wire. Manzanar was in a huge valley, and there was nowhere to escape. Robert and his friends frequently left camp, sometimes hunting birds with slingshots.

The camp actually opened doors for the family. Robert's older brother, Iwao Takamoto, learned illustration at Manzanar and found a job after the war in the animation department for Walt Disney Studios. He later worked on the film *Lady and the Tramp,* and helped create *The Jetsons, The Addams Family,* and *Scooby-Doo* at Hanna-Barbera Productions.

Most of Robert's family moved to downtown Los Angeles after the war. They stayed at a Buddhist temple and then moved south to a motor court.

Robert's father opened a produce stand before becoming a gardener. He loved the United States and became a naturalized citizen. His mother took care of the family and then worked in a sweatshop, sewing in the garment district.

Robert graduated from UCLA in engineering, and worked at Hughes Aircraft for about 35 years.

When reparations were authorized in 1988, Robert says the first thing that struck him was that his father died before that happened.

"I felt he's the one that really earned it, not me," Robert says. "I didn't spend a penny of it, but I put it into an annuity to figure out what would be a good way to utilize it, like scholarships or something like that for Japanese Americans. So it's still sitting there. I felt like I kind of owed it to my folks to put my part of it to good use."

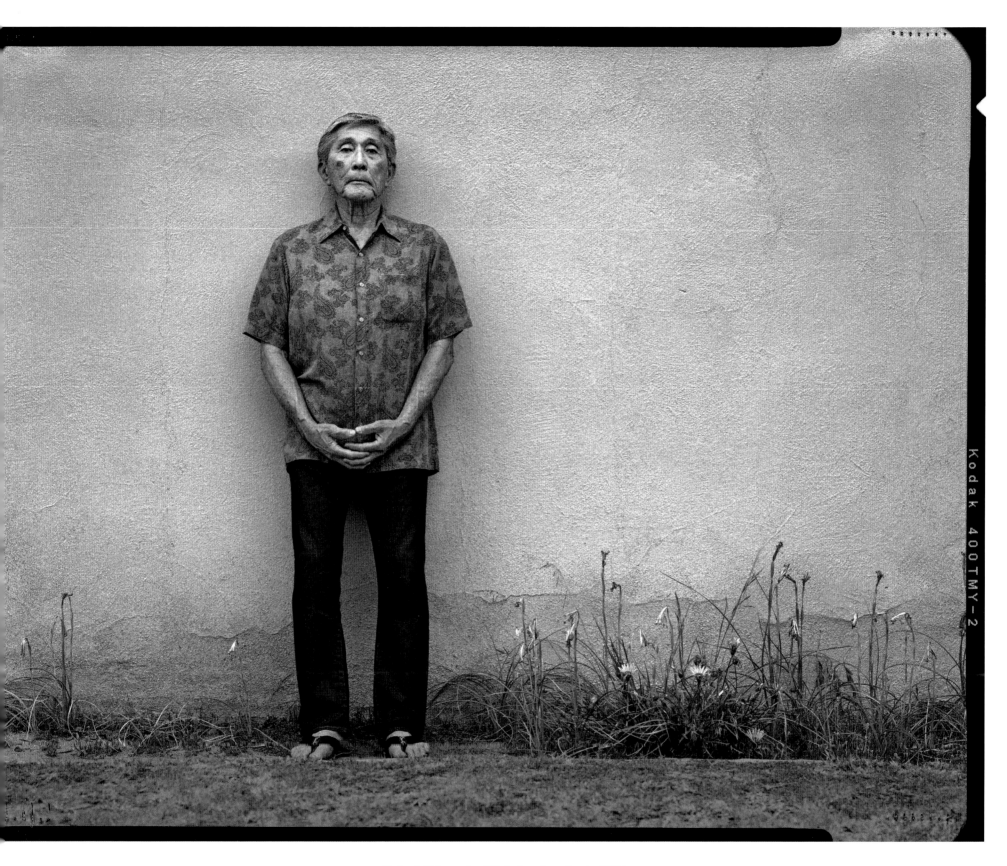

Robert Takamoto, 82, in Los Angeles in 2016.

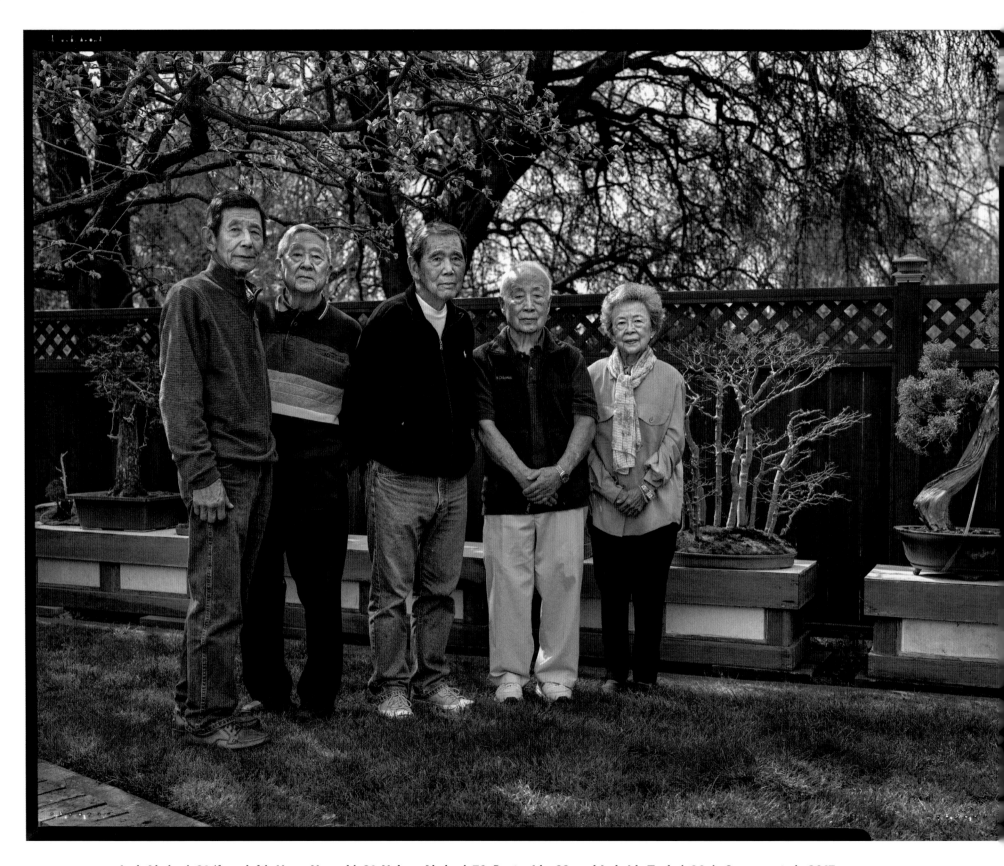

Jack Akabori, 81 (from left), Harry Noguchi, 81, Nelson Akabori, 70, Buster Ide, 83, and Judy Ide Tsuboi, 80, in Sacramento in 2017.

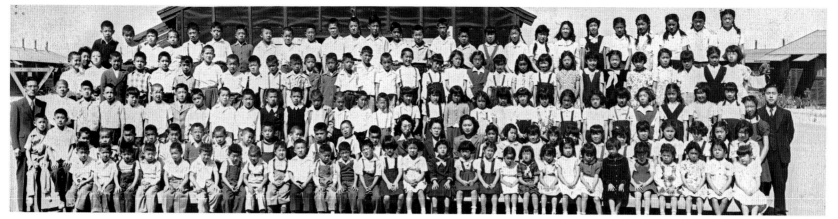

'America didn't want us, Japan didn't want us either.'

A school photo included classmates Jack and Nelson Akabori, siblings Buster and Judy Ide, and Harry Noguchi.

Small children experienced the incarceration in different ways. Their days were devoted to school, homework and play—baseball, hunting for arrowheads, waiting outside the mess hall kitchen for afternoon snacks of burned-rice crusts from the bottom of the pot.

"A lot of us kids, we just took it in stride," says Tamayo Judy Ide. "We had fun."

Yet as distant as the outside world could seem—"We didn't even know where Japan was," says Judy's brother, Yoshiharu Buster Ide—the reality of war seeped into their lives. As a second-grader, Judy recalls, "I would draw pictures of American planes attacking Japanese ships, and the teacher said, 'Oh, Judy, I don't think this is a proper picture,' and she made me stop."

One reality that the young experienced up close was the hardship of camp life: overcrowded barracks, punishing weather, the lack of privacy in toilets and showers. They also saw how their families resisted. The parents of Seigo Nelson Akabori cut a hole in the floor to hide their cooking knives—"something that you weren't supposed to have, like radios and cameras."

Beyond physical privation, the toll of imprisonment was emotional. Because the mess hall was small, children were fed first and adults later. "So there was no family communication," says Haruki Harry Noguchi. "The only time I remember seeing my parents was in the evening time."

Shielded from the full impact of incarceration as children in camp, the former Tule Lake classmates realized only later how much their parents' generation endured.

Harry's father, Sampei Noguchi—trained in medicine in Japan but unlicensed to practice in the United States, where he instead became a farmer—hoped to take the family to his native Kumamoto after the war. But his relatives told him, "Please don't come back, because we're starving ourselves."

"America didn't want us, Japan didn't want us either," Harry says, "so it was a very lonely feeling for my parents."

The parents of Nelson and Jack Akabori separated at Tule Lake, in part because the father, Keiuchi, an immigrant from Wakayama, was drinking heavily. For many, the loss of livelihood after incarceration took a heavy toll.

"I think that's the reason my father started drinking," Jack says, "because there was so much pressure of not doing the things he wanted to do." For his American-born mother, Ayako Alice, "It was just too much, and she couldn't take it."

The ex-classmates took diverse paths as adults. Judy worked as a stenographer, and later became an executive secretary. Brother Buster worked a draftsman. Harry served in the Army and became a draftsman and cartographer. Nelson served in the Navy and became an electronics technician and pharmaceutical representative. Jack served with the Army and became a carpenter and contractor.

Former detainees often reflect on their wartime plight with the phrase *sho ga nai* or 'It can't be helped.' "But it goes beyond that," Jack suggests. "It's more like *mottainai*—'It's a waste.'"

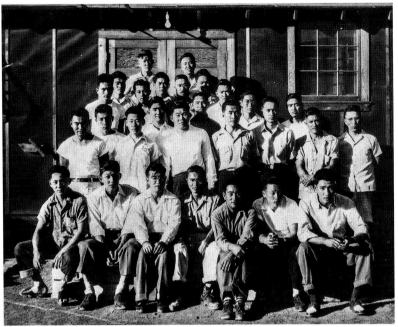

Jim Tanimoto, 20 (front row second from right), with other inmates.

'We're the enemy now—we thought we were going to get shot.'

Jim Tanimoto joined 35 other young men in Block 42 of Tule Lake in refusing to sign the government questionnaire asking them to swear allegiance to the United States and agree to serve in the military.

"I'm a prisoner here," he once told an interrogator. "Unless you release me, I'm not signing."

The consequence of their resistance was immediate. The men of draft age who refused to sign were sent to jails or other camps. One night, Jim and his fellow detainees were awakened and ordered outside, where bright lights were trained on them and they faced a line of soldiers loading their weapons.

"We're the enemy now—we thought we were going to get shot," Jim says.

Instead, they were sent back inside. Eventually Jim was returned to his old barracks at Tule Lake. The last surviving resister from Block 42, he recognizes the government's hard line was an attempt to intimidate the captives into subservience.

"But this had the opposite effect," he says because others "started saying, 'We're going to do the same thing.'"

The sixth of seven Nisei children born to Hiokochi and Rewa Tanimoto, emigrants from Hiroshima, Jim was working in his family's peach orchard in Gridley, California, on December 7, 1941. Before Pearl Harbor he experienced little racial hostility. "I think I was accepted as just another American citizen," he says. But

afterward, even acquaintances "wouldn't talk to you on the street. If they were seen talking to you, they were called Jap lovers."

Jim tried to join the military. But after Pearl Harbor through 1942, Americans of Japanese ancestry were not allowed to enlist. That changed in 1943, when the army asked for volunteers from the camps and in 1944 when they started drafting camp inmates.

In July 1942, the Tanimotos were shipped off to Tule Lake.

Released from Tule Lake three years later, the Tanimotos returned to Gridley and took up farming again, though anti-Japanese sentiment was still in the air. "Most people that we knew, even they wouldn't talk to us," he says. After awhile, peaches weren't as lucrative a crop as before, so the family took a chance on a fruit that was new to the States—the Chinese gooseberry, better known as the kiwi—and helped pioneer its cultivation here in the 1960s.

When Japanese Americans were compensated, Jim, like many others, considered Washington's formal apology more important than the cash reparations. But accepting the apology didn't mean forgetting history. Jim made a point of visiting all ten War Relocation Authority camps. He also broke his silence on the incarceration with his two daughters, spoke in public, and remains concerned that others could face the same unjust treatment even now.

"Is this going to happen again? This happened before. Even if it's unconstitutional, it happened. What will happen if some other nationality or some other minority has to go through the same thing?"

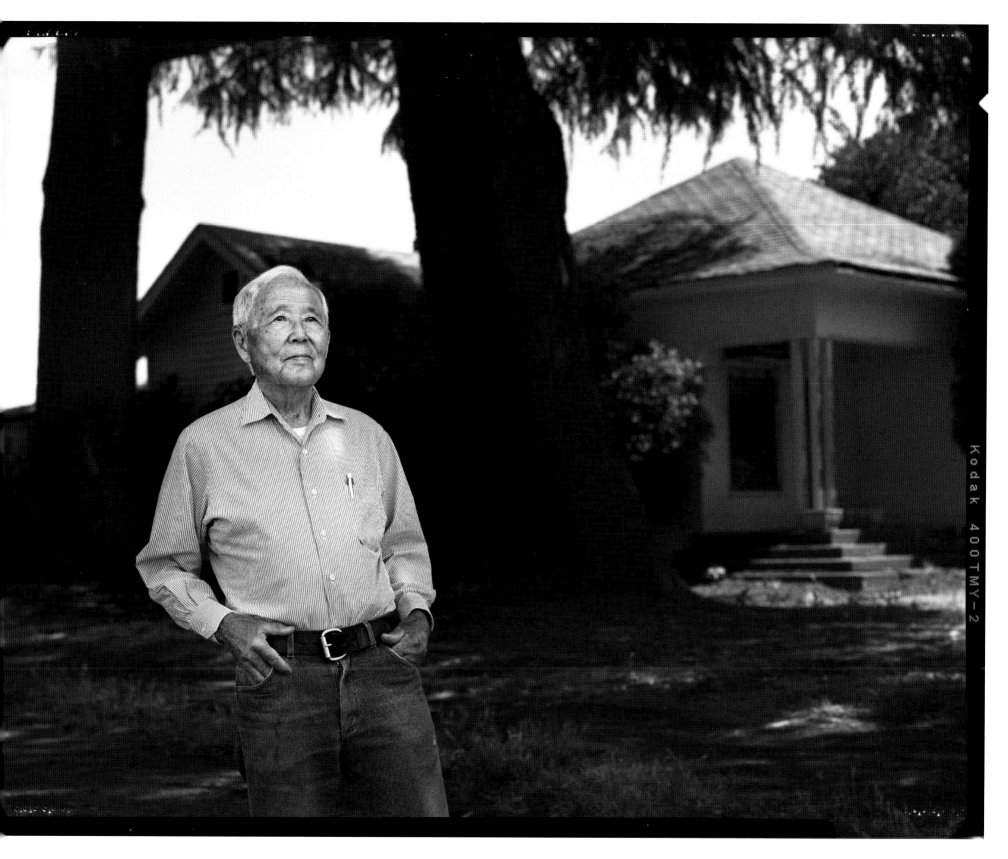

Jim Tanimoto, 94 in 2018, at the home in Gridley, California, where his family lived before they were incarcerated.

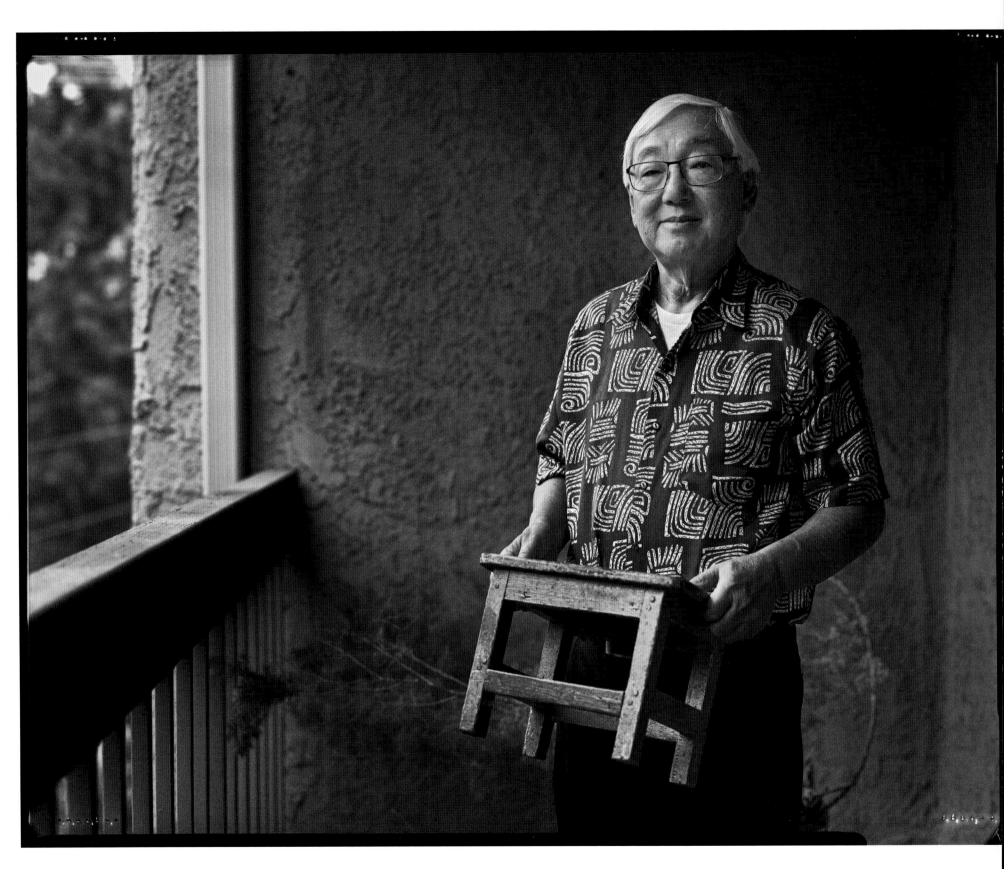

Bruce Tsurutani, 76 in 2017, at his home in Glendale, California.

'They told us to get rid of everything written in Japanese.'

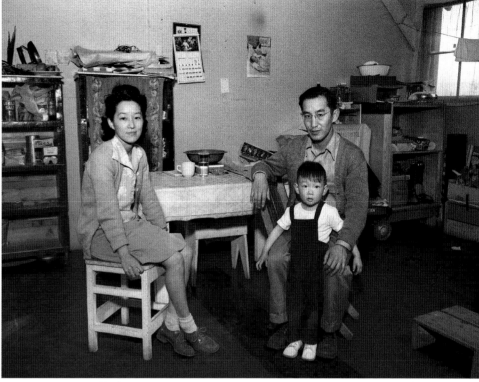

ANSEL ADAMS, JANUARY 29, 1944, MANZANAR RELOCATION CENTER, OWENS VALLEY, CALIFORNIA

Bruce Tsurutani celebrated his birthday with parents Aya and Henry.

The picture that Bruce Tsurutani prizes most from his Manzanar experience is one taken by Ansel Adams of his family on his third birthday.

Bruce's parents, Henry and Ayako "Aya" Imai Tsurutani, were born only a few doors from each other in San Francisco. His father earned a law degree from UC Berkeley and worked as a lawyer in Los Angeles' Little Tokyo neighborhood.

After Pearl Harbor, Aya said, "They told us to get rid of everything written in Japanese or even pictures. My mother had a big picture that my father had taken of the prince in Golden Gate Park. She gave it to the consulate right away."

At Manzanar, Henry worked with camp director Ralph Merritt.

Decades later, when Bruce asked his father why he hadn't tried to fight the incarceration, Henry's answer was terse and pragmatic: He thought it was hopeless.

Henry and his family were released from Manzanar early so he could work for the Office of Strategic Services, a wartime intelligence agency, in Washington, D.C., that was a forerunner to the Central Intelligence Agency. He interrogated Japanese prisoners and also worked in a program to send messages to Japan using psychological warfare. After the war, he was part of a group that flew to Japan to study the psychological impact of the bombings of Hiroshima and Nagasaki.

When he returned to his practice in Los Angeles, he helped his Japanese American clientele try to recover property they had lost during the war.

Bruce Tsurutani became a senior research scientist at NASA's Jet Propulsion Laboratory in Pasadena. He was honored for "original research and technical leadership in geomagnetism, atmospheric electricity, aeronomy, space physics and related sciences."

Although his parents seldom talked about their experiences in camp, Bruce returned decades later with his mother and other family members to Manzanar, where they had lived in Block 18, Building 1, Room 2.

"We went back so she could tell the story to them," he says. "And she knew everything. Her memory is fantastic. I thought that this was a great experience for my sister and my two daughters, so they could see it and hear it firsthand from the grandmother."

Bruce was bilingual as a boy, but he lost his ancestral tongue after the war. "My parents thought there was so much prejudice that it would be best for me to dis-learn Japanese," he says. "They claim that my Japanese was perfect when I was in Manzanar."

The photograph by Ansel Adams of the Tsurutani family appeared in *Born Free and Equal,* his 1944 book about Manzanar. In the 1980s, Bruce told the renowned photographer that he wanted to use the $20,000 he hoped to receive in reparations to republish the long out-of-print book. Bruce did a lot of work to set this in motion before learning that plans were already underway by another publisher.

More than seven decades since the incarceration, many things have changed in the United States. "But I still have this feeling," Bruce says, "that it could happen again."

Mits Mori, 9, received a buzz cut in the barbershop.

Mits Mori was one of the last to leave the detention centers. He was released with his family on March 16, 1946, four days before the closure of Tule Lake, the final camp to shut its gates.

Mits was 7 when his family was shipped to the Salinas Assembly Center in California and then to the Poston camp in Arizona.

His father, Harry Megumi Mori, arrived in 1920 from Fukuoka, one of three sons in a family that took up farming in Watsonville, California. Harry left the farm to work for a dry cleaner in Salinas, then moved to San Francisco and bought his own cleaning business.

Ohio Cleaners (spelled like the state, pronounced like the everyday Japanese greeting ohayo) sat near the bay and a train station where office workers arrived in the city. It grew into a thriving business, but came to an end after Pearl Harbor. Harry sold the laundry at a deep loss along with his prized new DeSoto. The family moved back to Watsonville, where he and his wife, Momoe, had family. They all wanted to go into detention together.

At Poston, Mits' parents answered "No" to question 27 ("Are you willing to serve in the armed forces") and question 28 ("Will

'I used to run away from home. I would get pissed off and tell my mom I'm getting out of here, and she would say, go ahead.'

you swear unqualified allegiance to the United States") on the government's so-called loyalty questionnaire. That got the family moved to the Tule Lake Segregation Center.

Mits wanted out. "I used to run away from home. I would get pissed off and tell my mom I'm getting out of here, and she would say, go ahead. I would be walking along and then think, where in the hell am I going? It's all fenced, no place I could go, the sun would be going down, and it would get kind of spooky. I'd think, I better go home."

After the war, the family returned to the Watsonville area, where Harry worked on a farm. He never got back into the laundry trade. "He was a pretty quiet guy," his son says, invoking the Japanese term *gaman*—"Keep it within yourself."

Mits had his own struggles, because his education at the camps was incomplete. But at his father's insistence, Mits continued his education—at San Jose State University and later at Heald College in San Francisco, where he studied architecture and graduated as an architectural engineer. He became a non-licensed architect.

In camp, Mits attended the Buddhist church. Its lessons stayed with him. "I like that philosophy, based on your inner self. Strong inside, not relying on outside forces, show responsibility for your acts. It gave me a better reputation, as far as my job goes."

The government's apology and reparations, when they finally came, were "not equal to what they had lost," Mits says. And for his father, who died in the 1970s, they were too late.

"My dad lost out in a big way and never got back on his feet."

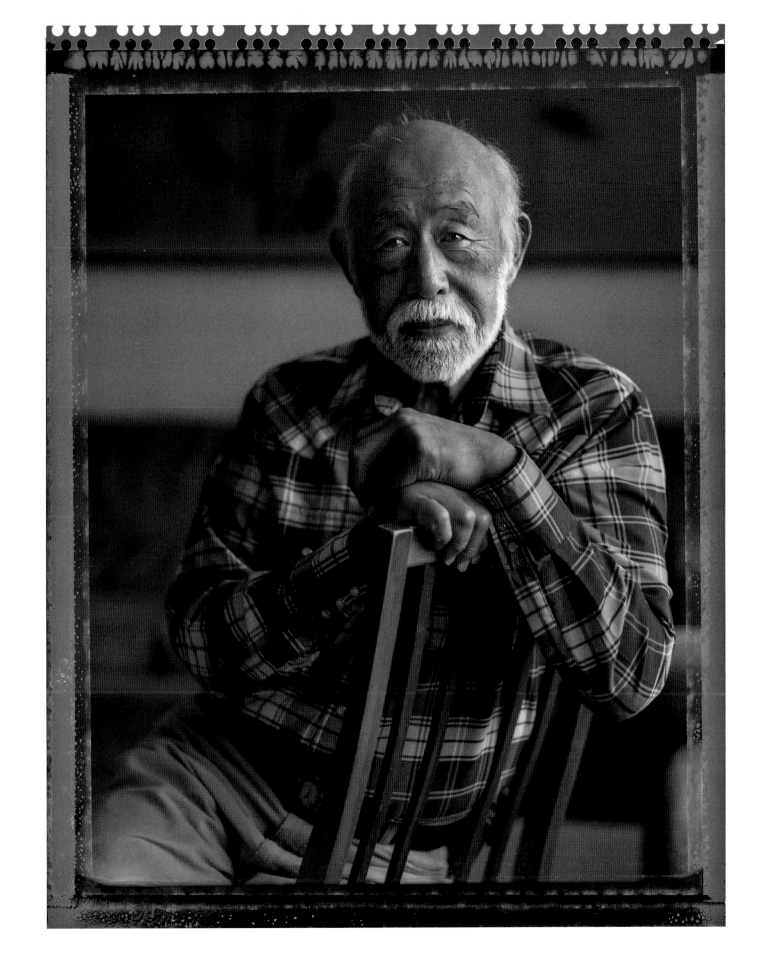

Mits Mori, 77 in 2012, at his home in San Francisco.

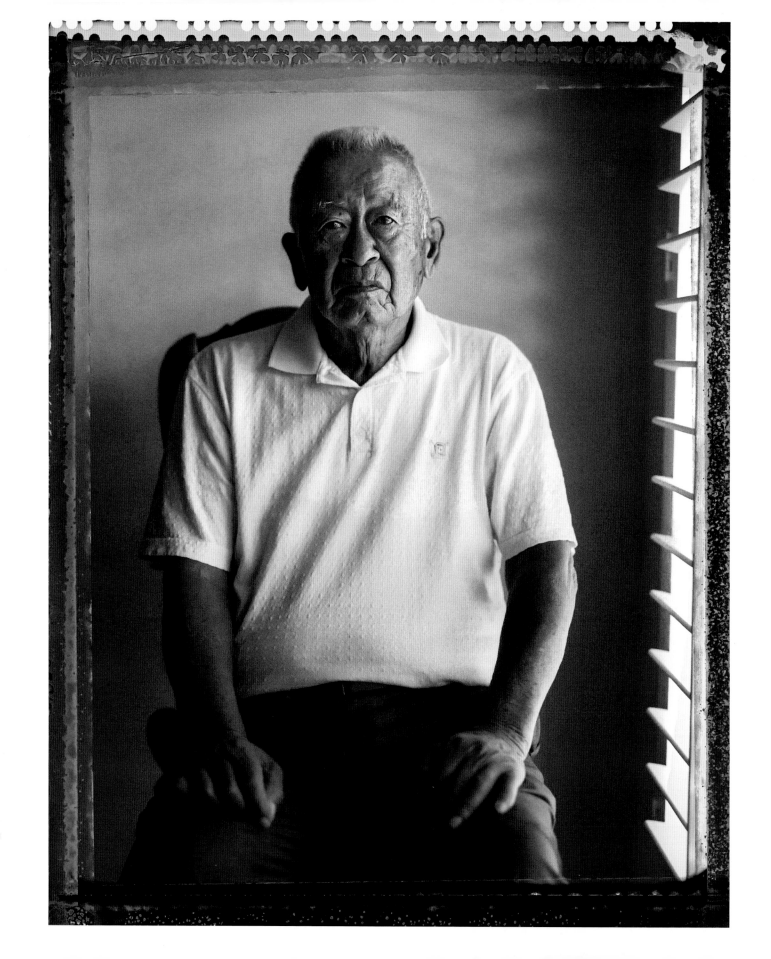

Ben Kuroki, 90, at home in Camarillo, California, in 2007.

Nicknamed 'Most Honorable Son' by his crewmates, Ben flew 30 missions in Europe and North Africa.

"I had to fight like hell for the right to fight for my own country," says Ben Kuroki, who became a military hero during World War II.

Encouraged by his father, who was "waving the American flag harder than anybody," Ben tried to enlist in the Army but got the runaround. He eventually succeeded in joining the Army Air Corps. He and his brother, who were both living in Nebraska, were among the first Nisei accepted after Pearl Harbor.

Although he wanted to fight and volunteered for gunnery school, Ben was assigned to be a clerk. Eventually, he earned his way onto a B-24 bomber. More than once he was inexplicably dropped from the combat roster, reinstated only after begging his squadron adjutant to let him fight. Nicknamed "Most Honorable Son" by his crewmates—a moniker that was painted on his plane's turret dome—Ben flew 30 missions in Europe and North Africa.

He later fought in the Pacific after overcoming another obstacle: a military policy prohibiting Japanese Americans from serving on the B-29 bombers deployed against Japan. To get around the ban, he recruited a long list of prominent Americans—including a Nebraska congressman and the president of Stanford University—to support his cause. It worked. Secretary of War Henry Stimson exempted him from the policy, and he flew 28 missions over Japan.

Ben suffered his most serious injury of the war on Tinian Island in the Pacific, at the hands of a drunken fellow serviceman who called him a "damned Jap" and slashed him in the head with a knife at the end of the war.

Returning stateside, Ben left his family's business. "I knew I didn't want to go back into farming," he says. But even after 58 combat missions, he wasn't done fighting. He took on what he called

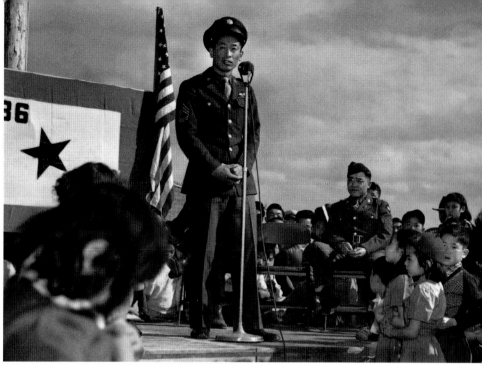

BUD AOYAMA, APRIL 4, 1944, HEART MOUNTAIN RELOCATION CENTER, CODY, WYOMING

War hero Ben Kuroki, 27, on a speaking tour in incarceration camps.

his "59th mission": a campaign against discrimination at home.

It started when he was still in uniform, between assignments in Europe and the Pacific. "Loyal Americans of Japanese descent are entitled to the democratic rights Jefferson propounded, Washington fought for and Lincoln died for," he declared in a well-received 1944 speech at San Francisco's Commonwealth Club.

He faced a tougher reception when the military scheduled him to address fellow Japanese Americans behind barbed wire. Ben, whose family was never incarcerated because Nebraska was outside the West Coast Exclusion Zone, had mixed feelings about this assignment. He was opposed to the resistance to military service but also troubled by the injustice meted out to Japanese Americans along the West Coast.

After the war, he studied journalism at the University of Nebraska. He ran weekly newspapers in Nebraska and Michigan before moving to California. He joined the *Ventura County Star-Free Press,* where he started on the copy desk and retired in 1984 as news editor. "Wouldn't trade it for any other profession," he says.

Yet the war remained a defining episode of his life, earning him White House invitations and the Distinguished Service Medal, one of the nation's highest military honors. It was due to his decision to enlist.

"I didn't want to be called a Jap, and I wanted to prove my loyalty."

Paul Chihara, 6 (in necktie), in front of his brother Theodore (in white cassock) at the Catholic chapel.

'I felt more protected in Minidoka than when we were released.'

Internationally known composer Paul Chihara's first gig was at Minidoka Relocation Center in Idaho.

He would perform at the incarceration center's mess hall, where residents from his block would gather every Saturday for movies and live entertainment.

"I used to sing pop music, and I had the kind of hat that General MacArthur wore," he says. "That experience of being five or six and performing is what made me go into show business. I'm still a ham from that. I never get nervous. I always want applause. And I'd like to get paid as well."

Paul's parents were from Wakayama, Japan. The youngest of four children, he was born in 1938, in Seattle, where his father owned a jewelry store, taught martial arts and imported Japanese popular records. As a prominent community leader, Paul's father was arrested right after Pearl Harbor and put in a Department of Justice internment camp. His family didn't see him again for years.

Paul's family was taken to the Puyallup Assembly Center in Washington before being sent to the Minidoka camp. Paul's mother brought much of the family's record collection. The Chiharas were released from Minidoka in 1945 and went to Spokane, Washington.

"I felt more protected in Minidoka than when we were released," Paul says. "I know that for the first two or three years, I was saying, 'Mom, when can we go back to Minidoka?' To me, that

was home. That's where I grew up."

The people of Spokane were hostile to Paul and his family. "The kids would throw rocks at us. And walking home from St. Patrick's School, a kid rolled by on a bicycle with a peashooter and shot me. It hurt and it was scary."

Paul and his mother returned to Seattle to reopen their boarded-up jewelry store. Thanks to their Jewish landlord, the store survived intact along with prewar merchandise like Bulova watches, Parker pens, diamonds and rubies. It thrived after the war, and Paul's father soon became, once again, a leader in the Japanese community.

Paul, who went to Catholic school, decided he wanted to play the violin. The Maryknoll nuns found one for him and provided lessons, too.

"Music gave me a new home," Paul says. "I know that's why I'm so devoted to it." He began teaching at UCLA in 1966, and became an artist in residence at New York University. He left academia to compose music for Hollywood films. In 1975, he wrote the score for the TV movie *Farewell to Manzanar*. Since then, he has worked on about 100 movies including *Prince of the City, The Morning After* and *Crossing Delancey*.

Paul says he's a rarity in both academia and Hollywood.

"I don't think this is racism so much as self-imposed segregation," he says. "The Japanese just don't seem to want to become composers."

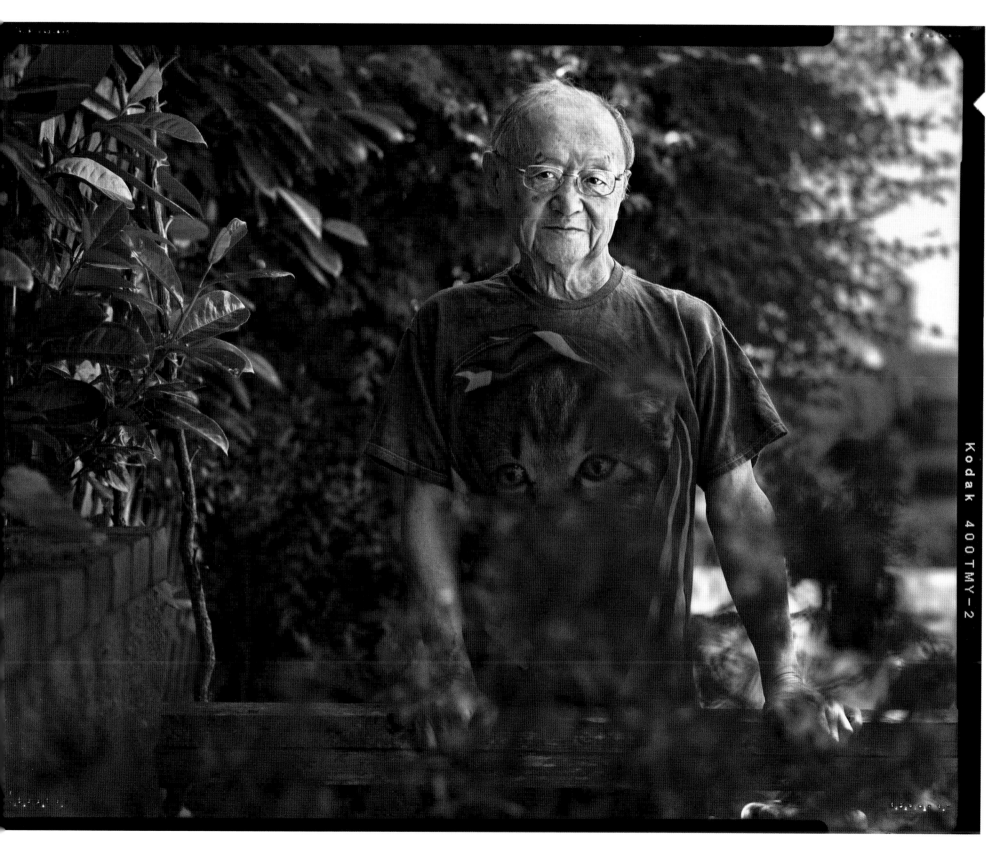

Paul Chihara, 78, at his brother's home in Berkeley in 2017.

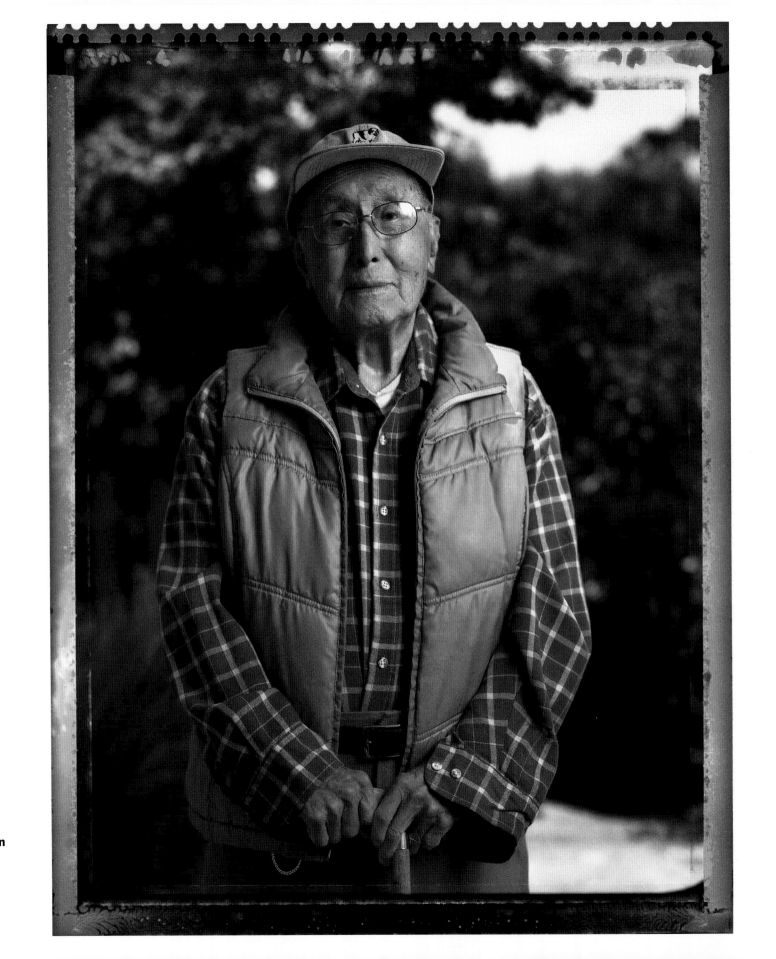

George Hirano,
87, in Half Moon
Bay, California, in
2012.

Life behind barbed wire left George feeling adrift. 'I didn't feel like going to school.'

A patriotic family portrait captured Hisa and Yasubei Hirano and their son George imprisoned at the Poston Relocation Center near Parker, Arizona.

George was born in Watsonville, California, one of six children of emigrants from Fukuoka Prefecture. After Executive Order 9066, his family was held first at the Salinas Assembly Center in California and then shipped by train to Poston, where they arrived on Independence Day 1942. George remembers mesquite trees, rattlesnakes and desert heat so intense that prisoners covered their heads with wet towels.

Life behind barbed wire left George, then 16, feeling adrift. "I didn't feel like going to school. I should have went but I didn't. We are in prison camp. We didn't know what was going to happen." He passed the time playing sports. "I took the easy way out," he says.

Soon after the family photo, George left camp for New Jersey, where he worked on a farm before getting drafted. He was a cook in a Signal Corps unit in the Army.

For his brother, Shigeru, it was a different war. With the 442nd Regimental Combat Team, he saw action in Europe, including the Nisei soldiers' celebrated rescue of the Lost Battalion, an infantry unit trapped by German forces in the Vosges Mountains in France. The 442nd suffered more than 800 casualties in its brave rescue of 211 men in 1944.

"The 442nd did a good job," George says. "*Hakujin* people can't say 'Jap' anymore."

When the war ended, George returned to Watsonville, California, and joined his family.

"We had to start a new life," he says. Before the incarceration, the Hiranos had locked their belongings in a house they had rented: furniture, bedding, a refrigerator, a washing

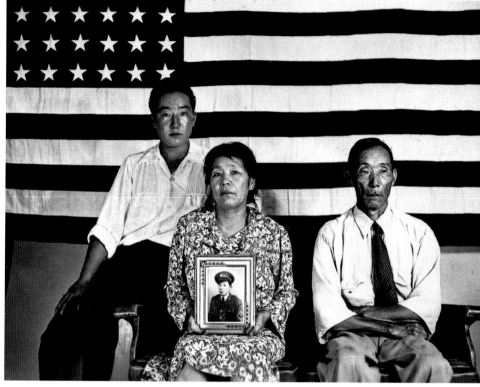

PHOTOGRAPHER UNKNOWN, 1944, POSTON RELOCATION CENTER, PARKER, ARIZONA

George Hirano, 18, posed with parents Hisa and Yasubei at Poston. His mother held a photo of son Shigeru, who joined the Army earlier.

machine. "Nothing there when we came back. Gone."

George enjoyed the farmer's life. "You do it yourself. Nobody tells you what to do." But he moved on and started a nursery in San Jose that he owned for three decades until his retirement. "I worked my butt off. I saved my money and bought property, had a nursery, and everything like that."

Looking back, he expresses no bitterness over his wartime incarceration. "We were young. We got to meet a lot of people. If I would have stayed in Watsonville, all I would have known was Watsonville. Now, since I went to camp, I know more people, I go see them."

His view of the world continued to expand later in life as he traveled to Russia, England, Germany. "Your eye gets more broad-minded."

George says the government was right to apologize and pay reparations for the incarceration. And for him, as for many Japanese Americans, the words counted more than the money.

"You get that 20K—*Arigato.* Thank you. That's all. I think the apology was more important."

Anna Kaku, 7, sang with Hajime Mizuta at Topaz.

'My parents used to say it would bring a tear to old people's eyes because I would be singing songs from old times.'

Anna Kaku sang Japanese songs for her fellow prisoners at Topaz Relocation Center in Delta, Utah, accompanied by her teacher, Hajime Mizuta, on the *shakuhachi,* a bamboo flute.

Anna was born in 1938 in San Francisco, the daughter of a cabinetmaker who immigrated in 1902. She was only 4 when she was imprisoned with her parents at the Santa Anita Assembly Center. They lived in a horse stall there before their transfer to Topaz.

Her mother met Mizuta, the musician, at the camp and arranged for him to teach and accompany Anna. She grew her repertoire to 200 Japanese songs, which they would perform around the camp. "My parents used to say it would bring a tear to old people's eyes because I would be singing songs from old times. For me, it was just, 'Hey, I have a job.'"

Anna remembers her parents as creative and cosmopolitan. Her father, a calligrapher, was an assistant to muralists and sculptors on public art projects commissioned by the Depression-era Works Progress Administration. Her mother, the daughter of a prosperous shipping company owner, worked as a dressmaker. "We didn't associate with that many Japanese families," Anna says. "They chose to be more international."

This choice was expressed in the kitchen, where Anna's mother would cook corned beef or spaghetti as well as Japanese dishes. But, Anna recalls, "No matter whether we had spaghetti or potatoes, we always had to have rice."

The incarceration didn't hurt the Kaku family as badly as it did many others. "We were really living a very modest life before the war," Anna says. "We just went from being poor to continuing to be poor. It wasn't as if we had mansions and yachts."

After the war, the family settled in Bridgeport, Connecticut. Her parents "had nothing to return to in San Francisco." The move—to a town with just three other Japanese families—was not without culture shock. "In the supermarket, kids would point at us, as in 'Oh, look at those people.'"

Her father found work as a carpenter. Her mother struggled at first, but took housecleaning jobs and eventually started a business as a tailor.

The incarceration was an injustice, Anna says, but also an "opportunity maker" for her family, opening avenues for her and her two brothers to pursue higher education and professional careers. Anna graduated from Wellesley College. Over the years, she worked for a college, a publisher and the YMCA of Greater New York.

Anna no longer remembers the Japanese songs she performed as a girl. But she maintains a cultural connection to Japan, having taken up the martial art of aikido and the flower arrangement tradition of *ikebana,* which she teaches. "When I was taking aikido, I asked the sensei, 'So what is this really all about?'

'It's not all about doing holds and making moves,' he said, 'it's about the *kokoro,* the soul, your spirit.' I find this in ikebana, and this is how I teach it. I teach the inside of the art."

Anna Kaku Nakada, 76, at home in Morristown, New Jersey, in 2014.

Jimi Yamaichi, 83, at his home in San Jose in 2006.

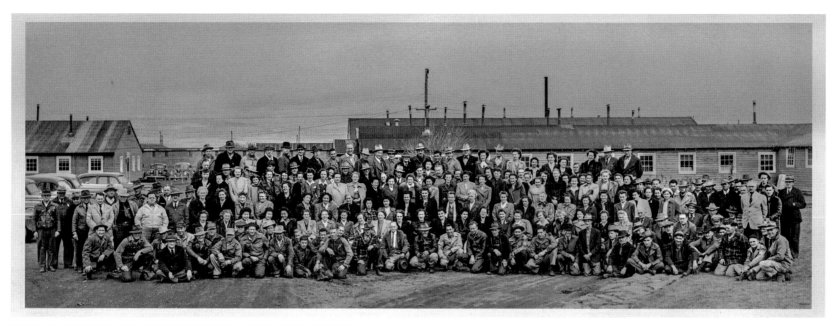

Jimi Yamaichi, 23, stood in the fourth row, left of center.

'So here I cannot vote, yet they want me in the Army.'

Jimi Yamaichi built the cement jail that held some of his fellow inmates at Tule Lake.

"That's right," he says. "It's a crazy thing."

Yamaichi was head of the construction crew at the camp. He built a canal to bring water to the camp, the jail and a stockade that was put up after martial law was declared at the camp in late 1943. Yamaichi understands the significance of the jail and stockade, and gave detailed tours during pilgrimages back to the camp starting in the 1990s.

A second-generation Japanese American, Jimi was born in 1922 in San Jose's Japantown. By the time war broke out, his family owned a 21-acre farm that produced beans, cucumbers, squash, bell peppers and celery.

Jimi was shipped to the Pomona Assembly Center near Los Angeles and later sent by rail to the Heart Mountain camp in Wyoming and to Tule Lake in Northern California.

Although a brother served with the 442nd Regimental Combat Team, Jimi resisted the draft in 1944. "So here I cannot vote, yet they want me in the Army. And my brother is in a segregated army," Jimi recalls. "So I said, 'Well, I won't go.'"

He went on trial with 26 other Tule Lake resisters in 1944. A sympathetic judge, Louis E. Goodman, dropped the charges, saying that only free Americans could be drafted. After the trial, Jimi and the others were returned to the camp.

Jimi always wanted to be an engineer, but the war got in the way.

When he got back to California in 1946, Jimi tried to join the carpenters union. A business agent told him, "You know darn well we don't give cards to people like you." But Jimi persevered, returning several times and finally forcing the agent's hand by finding a job with a union shop. He still has the card he got from August 1946. "I think I was the first *nihonjin* [Japanese person] to get a union card," he says.

He built houses and did construction on restaurants and a theme park. He was also deeply involved with the Japanese-American community, supporting San Jose's Nikkei Matsuri festival, the Fuji Tower apartment building for senior citizens and the Japanese American Museum of San Jose. He also organized and led pilgrimages to Tule Lake.

"Who in their right mind would go back to this jail you were in, right?" he says. "But to me, it's got a lot to do with the way I think today. All the suffering that went on—the Issei, how they had to cope with the problems. And what little problems I have, I think it's tough but not that tough."

Jimi says camp changed him. "We are such a small minority, and if we don't help and support each other along and leave a legacy— that's why I'm so strong on the museum."

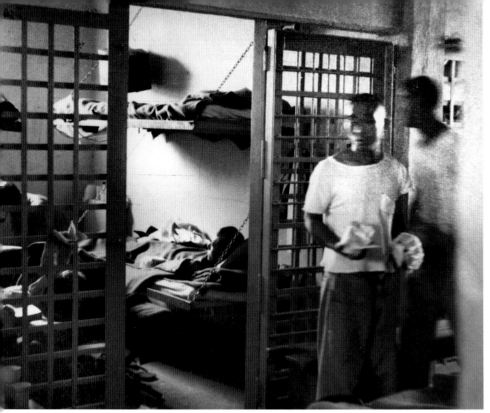

Itaru Ina in a Tule Lake stockade before he was shipped to a Department of Justice prison camp in North Dakota.

'The language has been modified to look like the government took care of us, but it was an arrest.'

One of the most provocative photographs of the incarceration shows a man in front of the metal gates of a crowded jail cell. The photograph was probably never meant to be made public.

The man was Itaru Ina, a 32-year-old U.S. citizen who had been incarcerated for more than three years.

Itaru and wife Shizuko spent the war years in a horse stall at Tanforan, in the desert prison camp called Topaz and—after answering "No " to the loyalty questionnaire—at the Tule Lake Segregation Center.

Daughter Satsuki, born at Tule Lake, suggests that her parents' answers did not reflect a crisis of loyalty, but rather a crisis of faith in the country of their birth.

By 1945, Itaru was hopeful of making a new life for his family in Japan, and joined a pro-Japan political group. He had seen his family suffer enough, and he renounced his U.S. citizenship. Camp authorities considered Itaru a resistance leader. He was arrested and placed in the "jail within a jail" before being sent to a federal prison for "enemy aliens" at Fort Lincoln in Bismarck, North Dakota.

Itaru was neither an enemy nor an alien.

Many inmates still imprisoned in Bismarck and Tule Lake were deported to Japan at the end of the war. With the help of an attorney and remarkable luck, the Ina family was released after four years and eventually regained their citizenship.

Six decades later, the couple's daughter Satsuki returned to the cell that held her father.

Satsuki, who became a trauma therapist, academic and filmmaker whose documentaries *From a Silk Cocoon* and *Children of the Camps* explore the psychological legacy of the incarceration, says the emotional cost of the incarceration has been underestimated.

The identification numbers assigned to families began a process that forever altered the men and women who were forcibly removed from their homes.

"To become a number means to no longer be known," she says. "Many felt this loss of identity and meaning as America turned its back on us.

"The story of the incarceration has been whitewashed," she says, "by the use of words like 'evacuation,' 'relocation' and 'assembly centers.' These words give a false impression. U.S. citizens were incarcerated without due process. Japanese Americans were forcibly removed from their homes and held in American-style concentration camps."

"The euphemistic language makes it look like the government took care of us," she says.

"I am seeing people who were young adults when they were incarcerated who now in old age are trying to make sense of what happened."

While a student at UC Berkeley in the 1960s, Satsuki's mother warned her against taking part in the Free Speech protest movement because "bad things can happen."

"I was in a prison camp with my children," she told Satsuki, tears in her eyes, "and we never did anything wrong."

In 2006, Itaru Ina's daughter Satsuki Ina visits the same stockade where her father was held.

Japanese American families incarcerated during World War II were given identification numbers in early 1942. They were told to affix tags with the numbers on their clothes and their luggage on the day they were forcibly removed from their homes. Those numbers remain a part of family history.

Chapter 1

Wanto store families: page 22
Masuda 40492, Shigematsu 40493
and Tanisawa 40419

Tatsuno family: page 24
22381

Mune family: page 26
21384

Pledge of Allegiance families: page 28
Itashiki 19033 and Nakamoto 19074

Yamasaki family: page 30
22458

Kuruma family: page 32
14737

Suzuki family: page 34
14830

Fukuda family: page 36
14727

Grocery store families: page 38
Ouchida 22072 and Ogata 22083

Miyata family: page 40
07748

Naito family: page 42
07727

Chapter 2

Bainbridge Island families: page 46
Hayashida 0014 and Kitamoto 0008

Hayashida family: page 48
0014

Hayashida family: page 50
0014

Okinaga family: page 52
01106

Kojimoto family: page 54
01504

Nozaka family: page 56
13611

Shimada family: page 58
06350

Kitagaki family: page 60
21570

Fujii family: page 62
20326

Mochida family: page 64
21585

Aso family: page 66
21537

Yanagi family: page 68
21578

Yanagi family: page 70
21578

Takeuchi family: page 72
21570

Hibi family: page 74
21474

Centerville families: page 76
Otsu 20375 and Ushijima 21367

Katsumoto family: page 78
21365

Takeuchi family: page 80
21393

Chapter 3

Takii family: page 84
0311

Konno family: page 86
15112

Kato family: page 88
06157

Yoshikawa family: page 90
02604

Itano family: page 92
27271

Konda family: page 94
21392

Shinoda family: page 96
21530

Yoshino family: page 98
20212

Matsumoto family: page 100
18661

Sakawye family: page 102
03083

Yoneda family: page 104
Karl 00668 and Thomas 01152

Kaneko family: page 106
39011

Imazeki family: page 108
27853

Kawai family: page 110
28201

Sumida family: page 112
28188

Shiga family: page 114
No number

Boy scout families: page 116
Ohara 05658, Motoyasu 09650
and Kato 05653

Nakanishi family: page 118
05135

Tachibana family: page 120
01080

Hayashida family: page 122
31638

Matsumoto family: page 124
08571

Takamoto family: page 126
03535

Tule Lake families: page 128
Akabori 20045, Ide 12386
and Noguchi 17022

Tanimoto family: page 130
27175

Tsurutani family: page 132
03002

Mori family: page 134
12413

Kuroki family: page 136
No number

Chihara family: page 138
12055

Hirano family: page 140
12374

Kaku family: page 142
14750

Yamaichi family: page 144
32420

Itaru family: page 146
14911

IDENTIFICATION TAG GIVEN TO SHIZUKO INA
BEFORE SHE WAS FORCIBLY REMOVED FROM HER
SAN FRANCISCO HOME.

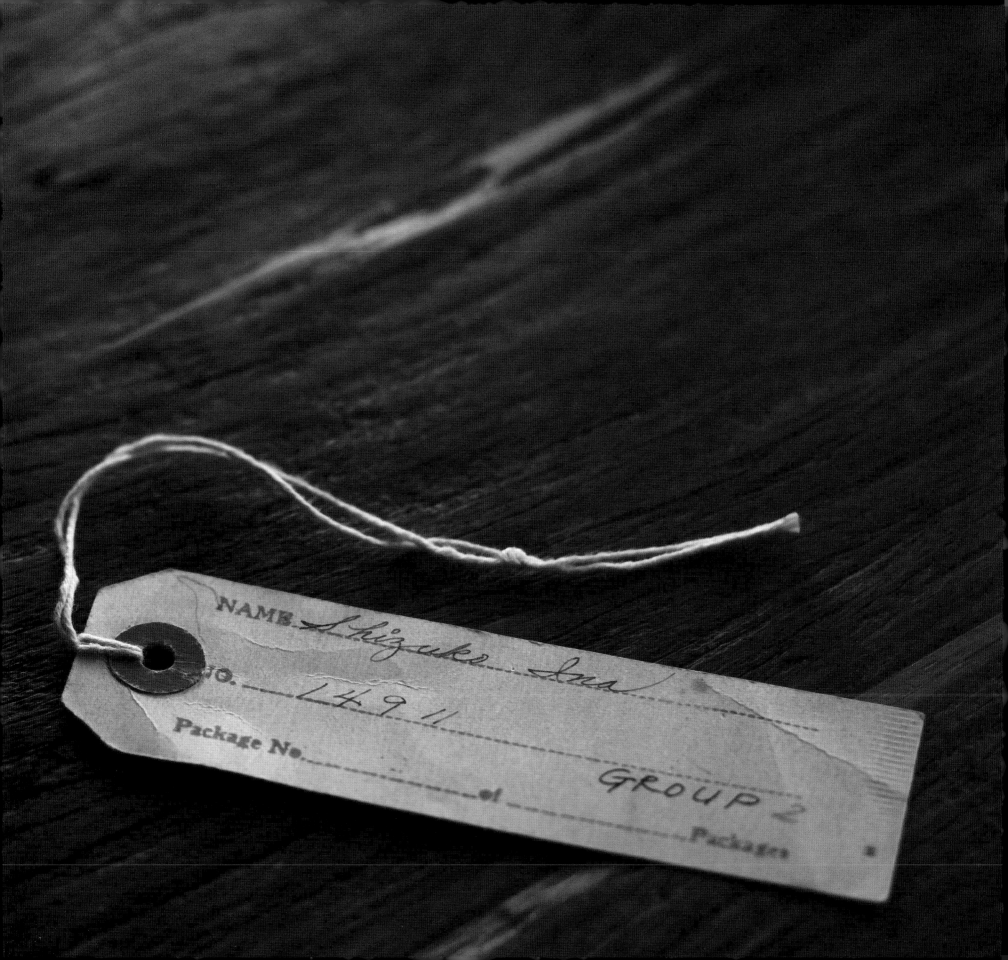

Acknowledgments

I want to express thanks and humblest gratitude to all of the subjects who generously allowed me into their lives to share their stories and their images before the stories are lost.

Also, to the many people who helped me find survivors of the incarceration centers, including Barbara Takei, Judy Tachibana, Gloria Imagire, Marielee Tsukamoto, Andy Noguchi, Bob Matsumoto, Lester Ouchida, Christine Umeda, Motoe Yamada Foor, Bob Oshita, Masako Murakami, Lynda Lin , Marie Matsumoto, Kimiko Fujii Kitayama, Grace Emori, Yasukazu Suzuki, Renée C. Byer, Susan Isola, Robbin Kawabata, Wendy Hanamura, Steve Nakajo, Steven Fukuda, Kayoko Ikuma, Lea Suzuki, Richard Cahan and Sharon Okada.

To Richard Oba and Doug Yamamoto with the Tanforan Assembly Center Memorial Committee and the Contra Costa Japanese American Citizens League, two organizations that believed in the project and found funding to help create a national traveling exhibition. Members include Steve Okamoto, Gail Weimann, Sidney Pucek, Ben Takeshita, Esther Takeuchi, Karyl Matsumoto, Don Delcollo and Richard Sekiguchi.

To friend and mentor Andrew Schneider, who won two Pulitzer Prizes pursuing truth. Always inspiring, he gently but persistently offered support and kept pushing me to finish. And to his wife, editor Kathy Best, who helped edit my words.

To friend Chris Hardy, for his expertise and patience scanning and toning these images, and to photographers Hardy, Peter DaSilva, Michael Rondo, Craig Lee, Andrew Seng and Smiley Pool for making the photo sessions successful.

To artist Sharon Okada for her attention to detail and great ideas.

To visual editor Mark Morris, who believed when it was just an idea and gave me the freedom to chase a dream.

To printer Patrick O'Kane for his support, and for producing beautiful exhibition prints.

To Dorothea Lange's granddaughter, Dyanna Taylor, who welcomed me into the tribe with her extended family of artists Elizabeth Partridge and Ronal Partridge.

To Maisie and Richard Conrat for their book, *Executive Order 9066,* the first visual representation of the Japanese incarceration during WWII that inspired me as a teenager when I was hungry for information. They generously offered their research material from their 1972 book and exhibition.

To the National Park Service's Manzanar Historical Site staff members Patricia Biggs, Rosemary Masters, Alisa Lynch and Richard Potashin.

To Amanda Meeker and Brenna Hamilton of the California Museum in Sacramento, which debuted the exhibition, and to those who shared it nationally: Roddrick Lee of BART at the Tanforan BART station; Carol Charnley of the Tucson Desert Art Museum; Todd Mayberry of the Oregon Nikkei Endowment; Alisa Lynch and Katherine Bush of the Manzanar National Historic Site; Susan Carlson and Nicole Restaino of the International Center for Photography; Ara Oshagan of the Burbank Main Library ReflectSpace; Rebecca Gregg, Judy Yemma and Roberta McClellan of the Viewpoint Photographic Art Center; Twin Cities JACL members Cheryl Hirata-Dulas, Carolyn Nayematsu, Sally Sudo, Janet Maeda Carlson, Rosie Iversen, Yuichiro Onishi, Steve Ozone, Gordon Nakagawa, Masami Suga and Leslie Suzukamo; Tom Pfannenstiel of Historic Fort Snelling in Minnesota; Dani Whitmore, Tony Natsoulas and Patrick O'Kane of Blue Line Gallery; William D Nitzky of the Valene L. Smith Museum of Anthropology at Chico State University, and Ann Burroughs, John Esaki and Clement Hanami of the Japanese American National Museum.

To Jeffery Kimoto, editor of *NikkeiWest;* Kengi Taguma, editor of *Nichi Bei Times;* Allison Haramoto and Linda Lin of the *Pacific Citizen;* Tom Ikeda at Densho: The Japanese American Legacy Project; Crystal Miles of the UC Bancroft Library; Mike Adams of the Sacramento Valley Historical Railways and Kara Miyagishima of the National Park Services, Japanese American Confinement Sites.

To Pat Yollin, Mark Hokoda, John Hickey, Anita Creamer, Jose Luis Villegas, Shelia Kern, Peter Basofin, Rita Bloomster, Kathy Morrison, Julie Fleece Owens, Leigh Grogan, Loretta Kalb, Diana Lambert, Sue Morrow, Joyce Tehaar, Cheryl Dell, Steve Gibbons, Anna Nakao, Julie Thomas, Noriko Sanefuji, Margie O'Clair, Don Shoecraft, Rick Loomis, Liz Baylen, Celia Fushille, Sharon Young, Robin Ishikata, Bruce Morimoto, Debbie Morimoto, Howard Goldbaum, Harry and Peg DiOrio, Jeff and Kathryn Cox, Deborah Lattimore, Mike Zacchino, Anne Stabile, Beth Ruyak, Kelly Grant, Scott McKiernan, Thomas Frail, Dan Okada, Mickie Enkoji, Michael Rhinehart, Richard Murai, Rick Smolan, Jeff Campagna, Sharon Yamato, Abby Ginzberg, Delphine Hirasuna, Teresa Tamura, Stan Honda, Molly Roberts, Jennifer Samuel, Yunghi Kim, Judy Walgren, Mary F. Calvert and Paula Bronstein for supporting the project and generously offering help.

To CityFiles Press editors Mark Jacob and Caleb Burroughs, publishers and designers Michael Williams and Richard Cahan for believing in and sharing this important and tragic part of U.S. history with their powerful and beautiful presentation. And to Jonathan Logan and Judy Appeal with

the Jonathan Logan Family Foundation for their generous support of the book and work.

To my wife, Renée C. Byer, a passionate and compassionate photojournalist whose humanistic work was honored by a Pulitzer Prize. Her love, support and understanding has been invaluable.

Finally, I want to thank all Issei, Nisei and Sansei for their perseverance in overcoming hardships. Without their struggles and successes, my generation and the generations of my children and their children would not have the opportunities our ancestors won with their sweat, tears and quiet strength.

These are a few of their stories.
So that we will all remember—always.

Reading List

Adams, Ansel, Toyo Miyatake, and Graham Howe. *Two Views of Manzanar: An Exhibition of Photographs by Ansel Adams and Toyo Miyatake.* Exhibition: Nov. 21, 1978 -Jan. 14, 1979.

Armor, John, Ansel Adams, Peter Wright, and John Hersey. *Manzanar.* New York: Vintage Books, 1988.

Asahina, Robert. *Just Americans: How Japanese Americans Won a War at Home and Abroad: The Story of the 100th Battalion 442d Regimental Combat Team in World War II.* New York: Gotham Books, 2007.

Bosworth, Allan R. *Americas Concentration Camps.* New York: Bantam Books, 1968.

Burton, Jeffery F., Eleanor Roosevelt, and Irene J. Cohen. *Confinement and Ethnicity an Overview of World War II Japanese American Relocation Sites.* Seattle: University of Washington Press, 2002.

Cahan, Richard, Michael Williams, Dorothea Lange, and Ansel Adams. *Un-American: The Incarceration of Japanese Americans during World War II.* Chicago: CityFiles Press, 2016.

Conrat, Maisie, and Richard Conrat. *Executive Order 9066: The Internment of 110,000 Japanese Americans.* Los Angeles: UCLA Asian American Studies Center Press, 1992.

Hirabayashi, Lane Ryo, Kenichiro Shimada, and Hikaru Iwasaki. *Japanese American Resettlement through the Lens: Hikaru Carl Iwasaki and the WRAs Photographic Section, 1943-1945.* Boulder, CO: University Press of Colorado, 2009.

Hirasuna, Delphine, and Kit Hinrichs. *The Art of Gaman: Arts and Crafts from the Japanese American Internment Camps, 1942-1946.* Berkeley: Ten Speed Press, 2005.

Houston, Jeanne Wakatsuki, and James D. Houston. *Farewell to Manzanar: A True Story of Japanese American Experience during and after the World War II Internment.* Boston: Houghton Mifflin, 2017.

Lange, Dorothea, Linda Gordon, and Gary Y. Okihiro. *Impounded: Dorothea Lange and the Censored Images of Japanese American Internment.* New York ; London: W.W. Norton Et Company, 2008.

Nakagawa, Kerry Yo. *Through a Diamond: 100 Years of Japanese American Baseball.* San Francisco: Rudi Pub., 2001.

Niiya, Brian. *Encyclopedia of Japanese American History: An A-to-Z Reference from 1868 to the Present.* New York: Facts on File, 2001.

Okada, John, and Karen Tei Yamashita. *No-No Boy.* New York: Penguin Books, 2019.

Okihiro, Gary Y., and Joan Myers. *Whispered Silences: Japanese Americans and World War II.* Seattle: University of Washington Press, 1996.

Reeves, Richard. *Infamy: The Shocking Story of the Japanese American Internment in World War II.* New York: Picador, 2016.

Robinson, Gerald H., Ansel Adams, Clem Albers, Dorothea Lange, and Toyo Miyatake. *Elusive Truth: Four Photographers at Manzanar.* Nevada City, CA: Carl Mautz Publishing, 2007.

Russell, Jan Jarboe. *The Train to the Crystal City: FDRs Secret Prisoner Exhange Program and Americas Only Family Internment Camp during World War II.* New York: Scribner, 2016.

Stewart, Todd, Natasha Egan, and Karen J. Leong. *Placing Memory: A Photographic Exploration of Japanese American Internment.* Norman: University of Oklahoma Press, 2008.

Takaki, Ronald. *Strangers from a Different Shore a History of Asian Americans.* Toronto: Penguin Books, 1989.

Takei, Barbara, and Judy M. Tachibana. *Tule Lake Revisited: A Brief History and Guide to the Tule Lake Internment Camp Site.* Sacramento, CA: T & T Press, 2001.

Tamura, Teresa. *Minidoka: An American Concentration Camp.* Caldwell, ID: Caxton Press, 2013.

Tateishi, John. *And Justice for All: An Oral History of the Japanese American Detention Camps.* Seattle: University of Washington Press, 2017.

The author and publishers thank the Still Picture Branch of the National Archives and Records Administration and the Prints & Photographs Division of the Library of Congress for archiving and providing photographs taken during the early 1940s by the War Relocation Authority.

Where Americans Were Imprisoned

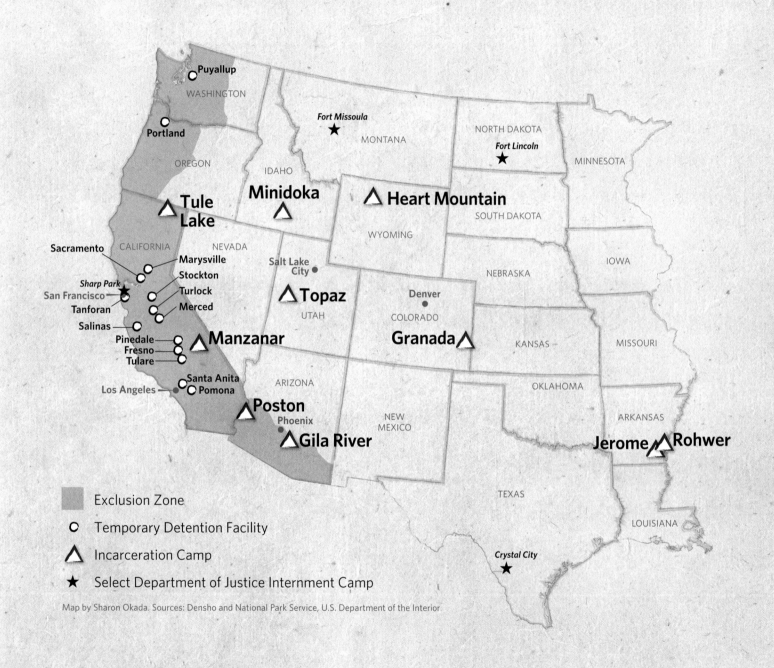

Puyallup

WASHINGTON

Portland

OREGON

Fort Missoula

MONTANA

NORTH DAKOTA

Fort Lincoln

MINNESOTA

IDAHO

Minidoka

Tule Lake

Heart Mountain

SOUTH DAKOTA

WYOMING

Sacramento

CALIFORNIA

NEVADA

Marysville

Stockton

Turlock

Merced

Salt Lake City

Denver

IOWA

NEBRASKA

Topaz

UTAH

COLORADO

Granada

KANSAS

MISSOURI

Sharp Park

San Francisco

Tanforan

Salinas

Pinedale

Fresno

Tulare

Manzanar

Santa Anita

Pomona

Los Angeles

Poston

Phoenix

ARIZONA

Gila River

NEW MEXICO

OKLAHOMA

ARKANSAS

Jerome Rohwer

TEXAS

Exclusion Zone

Temporary Detention Facility

Incarceration Camp

Select Department of Justice Internment Camp

LOUISIANA

Crystal City

Map by Sharon Okada. Sources: Densho and National Park Service, U.S. Department of the Interior

152